Dear Maine

Also from Islandport Press

This Day in Maine
By Joseph Owen

Stories of Aroostook
By Kathryn Olmstead

Wild! Weird! Wonderful! Maine.
By Earl Brechlin

Take It Easy
By John Duncan

The Ghosts of Walter Crockett
By W. Edward Crockett

Hauling by Hand
By Dean L. Lunt

Hunt Like a Girl
By Chrisiti Holmes

Moon in Full
By Marpheen Chann

Available at www.islandportpress.com

Dear Maine

The Trials and Triumphs of Maine's 21st Century Immigrants

By Morgan Rielly and Reza Jalali

ISLANDPORT PRESS

ISLANDPORT PRESS

Islandport Press
P.O. Box 10
Yarmouth, Maine 04096
www.islandportpress.com
info@islandportpress.com

First Islandport Printing, November 2021

ISBN: 978-1-952143-19-9
Library of Congress Control Number: 2021932276

Dean L. Lunt, Publisher
Trevor Roberson, Book Design
Printed in the USA.

For those I interviewed, thank you for sharing and
trusting me with your stories.
—Morgan

For Azad and Setareh, born in Maine.
—Reza

Contents

Authors' Note

Dear Maine is the culmination of six years of hard work, long interviews, late-night edits, and lasting memories. We are grateful for this opportunity to work alongside each other as colleagues and friends on this project and journey, which has made us better writers, listeners, and storytellers.

The beautiful portraits created by photographer Lilit Danielyan, an immigrant from Armenia, beautifully capture the individuals we interviewed. More importantly, they elevate the stories, helping tell them in a way that words cannot fully describe. Her photos fulfill the old adage that a picture is worth a thousand words.

The men and women we interviewed come from five continents and eighteen countries, from El Salvador to South Korea and from Azerbaijan to Rwanda. Today, they are small-business owners, artists, activists, public servants, and students. Many have faced, and overcome, seemingly insurmountable odds. They inspire us, and we hope they inspire you as well.

Unfortunately, in recent years we have seen an increase in attacks on the principles and foundations of our multicultural democracy. When that happens, we find faith and inspiration in our neighborhoods and are reminded that we can be uplifted by our better angels—as personified by the men and women profiled in these pages. These Mainers help make our state and our country exceptional, give us hope, and provide ongoing examples of the promise of both Maine and America.

Each chapter in *Dear Maine* profiles an individual or family. The stories are as varied as the individuals' home countries. Filip and Gordana, originally from Bosnia, fled war and genocide in the former Yugoslavia, only to lose a husband and father when they arrived in Westbrook. Tae from South Korea overcame depression and racism in his youth to become Portland's first Asian American city councilor and a man who fights to ensure that other immigrants are welcomed and not treated as outsiders. Natália from Brazil found love in America and realized her dream of owning a business and working as a chef. Kifah from Iraq, a "hippie" conscripted during the Iran–Iraq war, can finally share his love of poetry. And Safiya, who came from Somalia as a child, inspired Mainers and the nation with her successful campaign to become the first Muslim woman to sit on the Lewiston

City Council. Safiya is pictured on the cover of this book.

These are just some of the stories in *Dear Maine* that we felt must be shared.

As a state, we must do more to attract and retain new Mainers. Culturally and economically, we need new Mainers. Unfortunately recent immigrants, like many young people who were born here, have been forced to leave because they could not find the job or the home they sought here in Maine. Some people whom we interviewed have since left our state seeking other opportunities, but we hope they return. As a state, we can do a better job of warmly welcoming immigrants and helping to create a more diverse, accepting, and inclusive Maine. We hope that this book will play at least a small role in highlighting and celebrating the common goals and dreams we all share, and shine light on the different paths our friends and neighbors have taken to get here. Each immigrant's story is unique and valuable, creating an ever-evolving tapestry.

Our book is not meant to serve as an academic study of immigration to Maine. We recognize that *Dear Maine* does not fully capture the breadth of the diversity that can be found in Maine's immigrant population. That is an impossible task, no matter how many pages we write. Think of this book as a local dinner party: We are introducing you to some of our neighbors. We hope that you leave this party with a new perspective, an appreciation of the people you've met, and, hopefully, with some new friends. We also hope you leave inspired.

Our goal is that you enjoy these stories and share the same sense of awe that we experienced while interviewing and writing about these new Mainers. We believe they embody the ideals of what makes our state, and this country, great. They make both of us proud to call ourselves Mainers and Americans.

Morgan Rielly and Reza Jalali
October 2021 | Maine

Foreword

America.

Patriots.

Refugees.

Immigrants.

Citizens.

Love it.

Leave it.

Go back to your country.

There is tension in my family when we talk about living in America. My parents, who fled (with me) to America when Sài Gòn fell in April 1975, are deeply patriotic. They have eternal and profound gratitude for President Ford's executive order to evacuate South Vietnamese civilians who worked alongside the United States military, gratitude for all the government officials who helped them along the way, and of course, gratitude for our sponsors in Carlisle, Pennsylvania, who took in our large family—a tired, huddled, yearning mass of refugees.

My grandparents, who worked for the United States Embassy, secured the necessary paperwork for my family in the final days of the Vietnam War (I am aware that I call it the Vietnam War when it is called the American War by my family),

so that some of us were able to escape Sài Gòn. We narrowly avoided an exploding transport bus; my father was conscripted by the South Vietnamese army while trying to leave Sài Gòn (but found us two weeks later at a refugee camp on Wake Island). During our escape, I was struck by shrapnel and developed a fever that my mother treated by submerging me in an ice bath. We skipped across the Pacific all the way to Fort Indiantown Gap, Pennsylvania, where the federal government had set up a relocation camp for thousands of Vietnamese refugees. By the time we arrived in Carlisle, my parents were happy just to worry about mundane things like learning how to drive in the snow or how to pronounce Montgomery Ward.

They were happy to start over.

The Hookes and the Burkholders were our family sponsors in Carlisle. They brought us on board and helped the Trans navigate the new (and ironically vast) shores of small-town America. We are all eternally indebted to the kindness and generosity of our sponsors—Americans who saw the moral imperative to help strangers from a strange land, Americans who knew that the right question was not about what they themselves

stood to gain from their actions, but what would be lost by their inaction. My parents believe that our sponsors' magnanimity represents the best of America, and they are right. That open-armed kindness is the best of America.

My brother and I, reared and raised in the farm-girded heartland of Pennsylvania, are patriotic too, but our patriotism unfurls itself with banners different from my parents' unflagging, star-spangled pride. Our patriotism is the kind of love that measures itself by its high expectations (something that we know firsthand from our parents themselves). I love America, and that is why I expect it to be better for everyone—or at least to be as good as advertised. When I memorized and recited "with liberty and justice for all," I believed it. Especially the "for all" part.

My father in particular feels that my criticism of America—of its racism, its patriarchy, its consumptive capitalism, its imperialism, its hypocrisy—is embarrassing to him in light of how well we've been treated. I daresay he is aggravated by my perspective because it smacks of ingratitude and a privileged hostility. My father's patriotism is not quite "love it or leave it" jingoism, but it's the refugee equivalent—it's "don't rock the boat" Americanism. In short, it's conservative.

I recognize that, because of the trauma of war and the upheaval of the refugee experience, my parents are stuck in the bottom rung of Maslow's hierarchy of needs. Because they came to America with nothing, they are grateful for everything, and they are in

constant survival mode—whether they know it or not. They save plastic bags and wash old food containers. They reuse and repurpose boxes and bottles. They buy everything in bulk at Sam's Club. Their bar for success seems to be acquiring the essentials in Maslow's bottom tier: paper towels and cartons of Frito-Lay products (preferably a month's supply).

When I memorized and recited "with liberty and justice for all," I believed it. Especially the "for all" part.

My brother and I, by privilege of growing up here, have different expectations—expectations built upon our parents' sacrifice and work and scrimping. We expect more from our country and community because we started out, securely, on a higher tier of Maslow's hierarchy. We never had to worry about food and shelter in the same way that our parents did. The gap in our family's dueling Americas lies in that gulf between where we feel we fall on Maslow's hierarchy of needs and for what we're scratching. I want a sense of community and love and self-actualization. My parents want food and a roof over their heads. My parents want me to lower the bar. I want them to raise theirs.

And in our own dysfunctional, familial way we play out the tensions of American democracy

itself. We wrangle with the best way to be citizens in our country. We argue about what it means to be patriotic. We excoriate each other for our votes during Thanksgiving dinner, which is a mix of turkey, mashed potatoes, and a side of *bánh cuốn*. We draw lines in the sand to indicate who is the political other in our country—in our America. It's a strange metaphor that I live in Maine and they live in California, as far apart geographically as we can live in our contiguous states of America.

Our America.

Go back to your country.

My father can remember when "your country" referred to a different place. He remembers when "Go back to your country" was not an insult, but an expression of his own deepest (and most unfulfillable) wish. He had just gotten here, not by his own choice but by no other choice. Go back to my country? I wish I could, buddy. I wish I could.

But my brother and I? As kids, we heard "Go back to your country" as a preamble to more insults and maybe a fistfight with bullies. That dual understanding is the very real gap in our small family unit, even as that gap plays out in ways large and small.

In short, my family is not a monolith—not as refugees, not as Vietnamese, not as Americans. We are as complicated, paradoxical, divided, united, aspirational, and multifaceted as our country. How do we explore and value the contours and fissures in our disagreements without breaking ourselves apart, cracking ourselves asunder? These are the questions that we wrangle with just, as it seems, as our friends and neighbors do.

We are our America.

—Phuc Tran
Portland, Maine

Phuc Tran was born in Vietnam and fled with his family to America in 1975. He earned a master's degree from the University of Massachusetts at Amherst. He moved to New York City in 1997, where he apprenticed as a tattoo artist while teaching Latin during the day. He continues to teach and tattoo, owning Tsunami Tattoo in Portland, Maine, where he lives with his family. His memoir, Sigh, Gone, *was published in 2020.*

Dear Maine

The Trials and Triumphs of Maine's 21st Century Immigrants

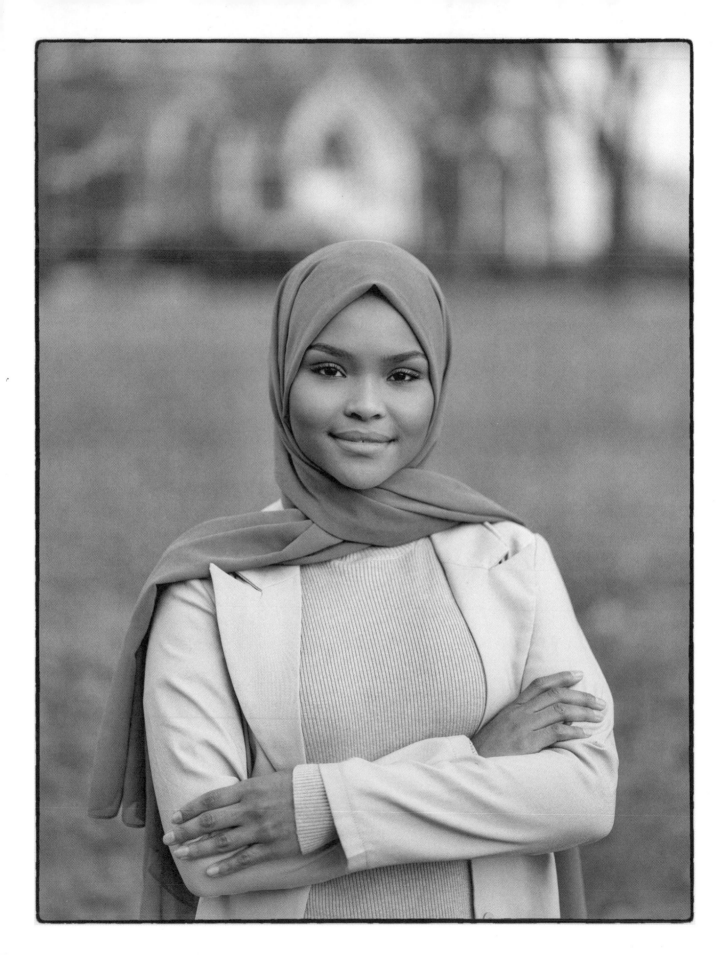

Safiya Khalid

Somalia
Population:
15.89 million
Distance from Maine:
7,172 miles

Seven-year-old Safiya Khalid, who had never been to a cinema in her life, was terrified when she first sat down to watch a 3-D movie in a New Jersey theater. She had only recently arrived in America from war-torn Somalia and the actors on the big screen looked like giants, while the 3-D technology seemed to bring them right into the theater. But while those special effects images may have been scary, the true story of her childhood and struggle for survival in a Kenyan refugee camp is as frightening as anything screenwriters can dream up.

Luckily, her remarkable story also features a feel-good Hollywood ending. Safiya, who arrived on American shores in the early 2000s speaking no English, found her way to a struggling old mill town in Maine and garnered national headlines by overcoming prevailing wisdom and vicious Internet trolls to become the first Somali American and Muslim to win election to the city council. And she was just twenty-three.

Such a plot seemed a fantasy when Safiya, who had fled violence in her home country, was a malnourished three-year-old, lying near death on an outdoor hospital cot, too weak to even lift her head. She was underweight, malnourished, and suffering from an undiagnosed intestinal bacterial illness. While her mother kept a steady vigil,

3

doctors and nurses put Safiya through medical procedures, including tests, injections, and blood transfusions. At one point, Safiya's body was so compromised, the nurses could not find a good vein. "They had to inject me on the sole of my foot," Safiya said.

That part of her story is not unique. According to the United Nations, malnutrition and disease were common in refugee camps, but Safiya could have been the poster child for the devastating problems of food insecurity and displacement created by the civil wars and famine in Africa.

"At one point, my stomach was even bigger than my mother's, who was pregnant with my baby brother," Safiya said.

Life in Somalia

The country of Somalia is located on the eastern side of Africa, bordering Ethiopia, Kenya, and the Indian Ocean. Safiya was born in 1996 in the port city of Kismayo, located in the southern Lower Juba, more than three hundred miles southwest of Somalia's capital city, Mogadishu. When she was born, Kismayo, which sits along the Indian Ocean and is the commercial capital of the autonomous Jubaland region, had a population of more than 150,000 people.

Safiya was born into a time of extreme chaos and violence. In the late 1980s, rebels rose up against the military junta that controlled the country. Across the countryside, Somali national forces battled the numerous armed rebel groups.

When the rebels overthrew the existing government, no one group filled the vacuum. The nation devolved into civil war, customary law collapsed, and at one point Somalia was declared a failed state. Overall, it is estimated that more than a half-million people died during the civil war, while millions more were displaced either internally or by fleeing to massive refugee camps in nearby countries. As part of all this fighting, violence exploded in Kismayo, and the city became the site of many battles.

"At one point, my stomach was even bigger than my mother's, who was pregnant with my baby brother."

By the late 1990s, as violence and its brutal ripple effects continued, young Safiya, just a toddler, and her family sought safety. They joined a larger group of people who decided to escape Kismayo and walked the three hundred miles to find safety in Mombasa, a coastal city in southeast Kenya, the closest African country. The family stayed in Mombasa for just a few months before heading out again on foot, this time looking to cover the four hundred miles necessary to reach one of the world's largest refugee camps, Hagadera, which is part of the Dadaab camp complex.

In 1992, the United Nations High Commissioner for Refugees (UNHCR) established

the Hagadera camp so refugees in Africa could escape violence and the famine that followed. Today, roughly thirty years later, the three camps in Kenya's Dadaab complex—Ifo, Dagahaley, and Hagadera—are still home to more than 200,000 refugees, according to the United Nations. This number now includes third-generation refugees, meaning refugees are being born in Dadaab to refugee parents who themselves were born in the camp. The camps were originally designed to host up to 90,000 people. Since 1991, violence, ongoing drought, and famine have left Somalia one of the world's least developed countries and displaced millions of people from their homes—many facing extreme poverty and malnutrition. More than 70 percent of the country lives in poverty, and in 2021 nearly 650,000 Somalian refugees still live at camps in four nearby African countries, according to the UN Refugee Agency.

Meanwhile, as Safiya and her family trekked across the countryside toward the camps, violence and danger trailed close behind. One time, a boy traveling with them was hit in the leg by a bullet. Another time they tried to hide in a cave, only to find a lion already living there. United Nations relief workers came to rescue the group of women and children, and took them the rest of the way to the refugee camp, where they would live for the next four years.

Safiya has few direct memories of her life at the camp.

"I was extremely sick," she said. "I only remember the hospital."

At one point during Safiya's four years at the refugee camp, her father, frustrated with her prolonged illness and slow recovery, sent Safiya to live with his brother on his cattle farm in a remote village. Safiya's father believed all she needed to heal was "good air."

"I was basically abandoned and left there by my father," Safiya says.

One time, a boy traveling with them was hit in the leg by a bullet. Another time they tried to hide in a cave, only to find a lion already living there.

Her mother had other ideas and set out to bring her back.

"My mother is incredible." Safiya's face, framed in a scarf that covers her hair, beams when she speaks of her. Her pregnant mother traveled a long distance, walking and changing crowded buses to get from the camp to her uncle's farm and rescue her from the faraway village.

Safiya was shocked when her mother arrived, crying, to get her. Safiya had come to believe that her thin body and bloated stomach were part of the natural look for kids her age. Her mother's teary eyes told her otherwise. She realized there was something wrong with her.

5

Her mother, although pregnant, carried Safiya back to the camp where she had a better chance of survival.

This time, once she returned to the camp and received proper care, her health gradually improved. Safiya credits the camp's doctors and nurses, many also refugees, and her mother for saving her life. "They went above and beyond to help," she said.

"My mother would stand on the sidewalk outside, greeting each person passing by in Arabic! She would say *As-salaam Alaykum* (Peace be upon you) to people, hoping to meet a Muslim."

America

In 2003, after spending nearly four years living in the overcrowded camp, seven-year-old Safiya and her family were accepted to enter the United States as refugees.

When the family landed in America, none of them knew any English. They had no connections in their new home in New Jersey, didn't know whom to call, and the local refugee resettlement agency didn't know when they were arriving, so they just sat in the airport's lounge, unsure of what to do next.

After a few hours, a curious airport security guard offered to help. He made a few calls, and finally a caseworker arrived to transport the family to their new apartment in Elizabeth City, New Jersey. The family felt lost and scared—just one part of the culture shock and the lonely and depressing new existence they would experience.

When they reached their new home, they found the worker had filled their refrigerator with pork products, unaware that pork was an off-limits food for Muslims.

At times, young Safiya would watch through the window as her mother tried to make new friends.

"We did not know anybody in Elizabeth City. With no Somalis there, we felt lost," says Safiya. "My mother would stand on the sidewalk outside, greeting each person passing by in Arabic! She would say *As-salaam Alaykum* (Peace be upon you) to people, hoping to meet a Muslim." Although a common phrase in Arabic, no one knew what she was saying.

Finally, one day, a North African man surprised Safiya's mother and responded to her in Arabic. Safiya's mother broke into tears, invited the stranger inside, and introduced him to the family. The man promised to return for another visit.

When he came back he brought a local Somali family he knew. Their new friends, immigrants themselves, suggested that Safiya's family settle in New York City. However, Safiya's mother wanted to live in a smaller city, where

she could find a community and live with a sense of safety and opportunity. Their new friends suggested Lewiston, Maine, and the next day they boarded a bus for Maine.

Lewiston, once a bustling mill town, is a small city of 36,000 located on the Androscoggin River and has a long history as a destination for immigrants. More than one hundred years ago, French Canadian immigrants arrived by the thousands to work in the Lewiston textile mills and the shoe factories in the neighboring city, Auburn.

Lewiston, the second-largest city in Maine, was struggling itself, but offered affordable housing, relatively low crime rates, and good schools. Safiya's mother was determined to build a new life for her family from scratch, and this seemed like a good spot to start. The city was already home to refugees from Somalia who had arrived during the previous few years. By the time Safiya and her family took that long bus ride from Elizabeth City to Lewiston, the city already boasted some Somali-owned and -run businesses, including halal food stores and mosques. Many people had some knowledge of Somali customs.

Such familiarity would help, especially when compared to Elizabeth City. For example, Safiya always covers her head with a hijab, a scarf that is part of the Islamic tradition of modesty, privacy, and morality. In Elizabeth City, a classmate once asked if Safiya could remove her hijab, which she did, spending the rest of the school day with her head uncovered. Later, Safiya's mother told her never to let others tell her what to do.

In Lewiston the family first lived downtown on Knox Street, in front of Kennedy Park, and later on Oak Street, before settling on Park Street. Safiya's mother found a job, but did not own a car, so she walked to work even in the winter. Safiya remembers her mother working all the time, trying to meet her family's needs.

> Lewiston, once a bustling mill town, is a small city of 36,000 located on the Androscoggin River and has a long history as a destination for immigrants.

Safiya and her siblings enrolled in school. Except for a bit of school bullying, life was normal for this family from Kismayo. Lewiston became the place where Safiya grew up into a young woman. She attended local schools, and when she was fourteen, she became a citizen. She remembers going to Walmart to get a photo taken for her citizenship certificate.

She graduated from Lewiston High School in 2014, and went on to attend the University of Southern Maine. While attending classes at the college's Portland and Lewiston campuses, she also worked full-time at Maine's iconic outdoor company, L.L.Bean, making boots. She lived a busy life.

"I did not experience the college life most young Americans have. I was rushing from work to classes and doing homework in between," Safiya said. She graduated from USM in 2018 with a bachelor's degree in psychology.

The Political World Beckons

Safiya's involvement in politics and public service started by accident, while she was still a senior in college.

"Out of nowhere, I get this message from a stranger asking if I was interested to run for public office," she said. "It was funny! I thought it was a prank, or spam!"

"Out of nowhere, I get this message from a stranger asking if I was interested to run for public office," she said. "It was funny! I thought it was a prank, or spam!"

Safiya did not feel qualified to run. Despite supporting a progressive candidate in a recent mayoral election, she was not into politics. "I'm nobody. I make boots. I have never spoken in front of people. Ever," Safiya argued with the stranger.

Later she found out they had friends in common, and decided to revisit the idea.

"Long story short, we met in person and talked," Safiya said. "Next thing I know, I am running for the Lewiston School Committee, against an incumbent!"

Safiya was twenty years old, a political novice, and had one month to convince residents to vote for her—all while working at L.L.Bean and studying as a full-time psychology student. She did not know how to canvass or talk to potential voters, and she lost the election by a wide margin. The experience did open her eyes. She felt immigrants and other minorities needed more representation and more voice in the local government.

She decided to run for the Lewiston City Council.

"I wanted to see everyone in the city feel the sense of community we experienced when we moved here after fleeing war-torn Somalia," she said. "Lewiston offered us a home where we felt like we belonged."

Safiya's mother was against the idea.

"She said, 'You are a young Black woman in a city of white people.' She was worried for me," Safiya said.

While the demographics of Lewiston have changed a bit in recent years, overall the city remains predominantly white. The latest data shows that the city is about 85 percent white, while Black residents make up about 6 percent of the overall population.

Nearly twenty years earlier, in 2002, the number of Somali refugees arriving to live in

Lewiston was at the root of a controversy and a national firestorm when Mayor Laurier "Larry" T. Raymond wrote an open letter to the city's Somali community, asking them to slow or discourage future arrivals, claiming the rapid influx of immigrants was overwhelming city services. The letter was divisive, angering newcomers and their advocates and drawing national media attention.

While some people agreed with the overall sentiment, others saw it as racist and misguided, believing that Lewiston desperately needed more immigrant families with young children to help to reverse the population decline and inject new energy and vitality into a tired city that was long past its glory years. The city's population peaked in 1970 and had been dwindling ever since, while the local economy withered. During the 1990s alone, the city's population declined by 10 percent. Today, roughly one in five city residents lives in poverty.

The memory of the Raymond letter lingered as part of the city's racial backstory in 2019 when Safiya mounted her campaign for city council, a seven-member governing body that oversees a budget of nearly $50 million. Unlike during her failed bid for a school committee seat, Safiya had some political experience and more organized help. Most days, after finishing her post-college job as a youth mentor, she canvassed in the traditional small-town way—going door to door, introducing herself to her constituents, and talking about policies. She discussed issues important to her, ones she felt would help the overall community, such as attracting young people, better housing options, improving the downtown, and encouraging owner-occupied housing.

"I think we're struggling the same way across the city," Safiya told a newspaper reporter during the campaign. "The key is to recognize we have the same issues, and that we should come to an understanding as to how to solve and face our challenges as a coalition."

She canvassed in the traditional small-town way—going door to door, introducing herself to her constituents, and talking about policies.

It was all going well. Unfortunately, her campaign came at a time of heightened tensions nationwide, as the country was seeing an increase in anti-immigrant, anti-Black, and Islamophobic sentiments, especially anonymously on the Internet.

As her prospects and her profile increased, her campaign attracted national attention from hateful online trolls. The social media firestorm, started by people from as far away as Alabama and

Mississippi, included threats and racist comments designed to derail her campaign and smear her personally. The online posters suggested she should go back to where she came from, and said Muslims were not fit to be in positions of power. Some claimed her goal was to institute Sharia law in Lewiston.

"I was attacked for being Black, Muslim, a woman, and a refugee," Safiya said.

She started to have second thoughts about her decision to run, and feared she might be in danger after someone posted her address.

"I just couldn't take it," Safiya told *The Washington Post*. "I was crying so bad. My eyes were completely red." But she kept moving forward.

Those targeting her proved to be nasty and loud, but as it turned out they represented a decided minority in Lewiston. She won the election in a landslide, collecting nearly 70 percent of the vote. She took office on January 6, 2020.

Safiya's victory made history and garnered national attention. She was the youngest person ever elected to the Lewiston City Council, as well as the first Somali American and the first Muslim. News of her victory was spread by newspapers in places like Kenya and England, among other countries. She appeared on national television news outlets.

In the moments after her win, she called it all unbelievable. But it did happen, and Safiya emerged as an inspiration, something that she takes seriously. She believes her original mission to mentor and support young people will continue. As a city councilor, she hopes to encourage more mentoring in Lewiston schools.

She also has a broader goal. At her day job, Safiya works as a case manager for Gateway Community Services, a nonprofit with centers in Portland, Lewiston, and Biddeford, with a goal of "meeting gaps in the lives of our immigrant and refugee clients and offering needed case management services to asylum seekers."

Those targeting her proved to be nasty and loud, but as it turned out they represented a decided minority in Lewiston. She won the election in a landslide, collecting nearly 70 percent of the vote. She took office on January 6, 2020.

It has been a long road from trekking across Somalia to escape violence and sickness to becoming an inspiration for fellow immigrants. Safiya uses her education, life experience, and very real story to help new Mainers find jobs, access educational opportunities, and navigate the community. She also works with youth on issues that cause intergenerational tension common

to every immigrant group new to America. She wants everyone to succeed.

"Now, I am able to give back," she said. "It is very rewarding."

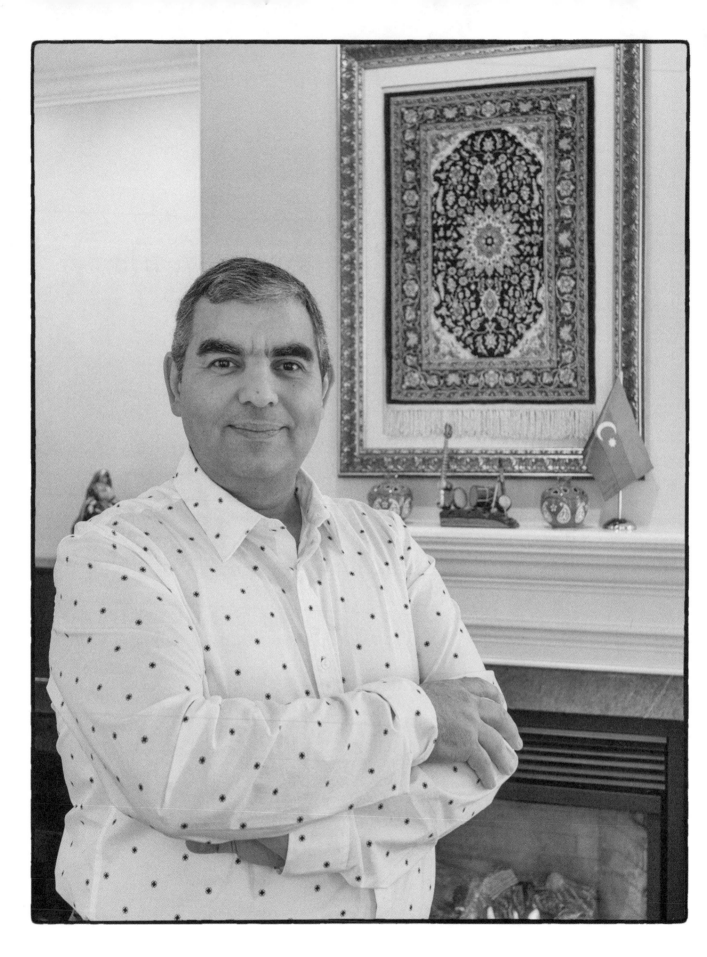

Tarlan Ahmadov

Azerbaijan
Population:
10.11 million
Distance from Maine:
5,364 miles

During the 1970s and 1980s, Tarlan Ahmadov grew up in the Soviet Republic of Azerbaijan surrounded by communist informers. And he kept a dark secret.

During the brutal rule of Soviet Union dictator Joseph Stalin, Tarlan's paternal grandfather was accused of being an "enemy of the state" by communist authorities. In the late 1930s, his grandfather's name surfaced in connection with military work he had done for the former ruling party. As a result, he was tagged as an anti-Bolshevik spy. Under Stalin due process did not exist, so the regime simply confiscated the family's properties and exiled Tarlan's grandfather to Eastern Siberia. He never came home again. Instead, he died in a Siberian gulag in 1942.

His grandfather's death in exile left Tarlan's grandmother as a single mother raising five children during World War II. Making her job more difficult, all of her children were blacklisted by the state because of the accusations against their father.

Tarlan was warned to be quiet.

"Never open your mouth and say anything about your grandfather," his grandmother would tell him.

There were other family secrets to keep, too.

Not long after his grandfather's death, Tarlan's young father was

13

also arrested and exiled to Siberia, where he lived from 1948 to 1951. Even before he was sent to Siberia, the Soviet government denied Tarlan's father access to an education because he was labeled "the son of the enemy." Instead, he worked as a fishmonger and in a factory, trying to make ends meet.

Stalin died in 1953 and was replaced by Nikita Khrushchev. As Soviet leader, Khrushchev loosened some rules. According to Tarlan, after Stalin's death the family received a letter of political rehabilitation, part of a government program of political and social restoration for people who had been repressed and criminally prosecuted without basis. In many cases, rehabilitation was posthumous, as thousands like Tarlan's grandfather had been executed or died in labor camps.

Despite Tarlan's dad's release and "political rehabilitation," his health suffered from his imprisonment. He died in February 1978, when Tarlan was just five years old.

"My childhood was very difficult because my father had passed away, and my mother was struggling," Tarlan said.

Over the next three decades Tarlan himself would directly feel the sting from accusations against his grandfather, and from overall Soviet oppression. He would struggle with his fellow citizens during the violence and chaos of the Soviet Union's collapse and its aftermath. It was a challenge, but ultimately, Tarlan found love in his homeland, got married in a traditional wedding, and worked his way to America, where he advocates for immigrants to Maine as the state's refugee coordinator.

Azerbaijan

Tarlan Ahmadov was born in the 1970s in Baku, Azerbaijan, an ancient city that was once considered sacred under Zoroastrianism, the old religion of Iran, formerly Persia. During the Soviet era the country, which was oil-rich and majority-Muslim, became one of the fifteen republics ruled by the communists starting in the 1920s. It declared its independence in 1991.

The country is located at the boundary of Eastern Europe and Western Asia, bounded by the Caspian Sea to the east, Russia to the north, Georgia to the northwest, Armenia and Turkey to the west, and Iran to the south. Azerbaijanis are ethnically Turkic people who speak a Turkic language, which is also spoken in neighboring Turkey and northern Iran. Unlike the Sunni Muslim nation of Turkey, Azerbaijan is a Shia Muslim country.

Despite the relaxation in politics, life in Azerbaijan under Soviet rule remained difficult. As a child, Tarlan remembers standing in food lines in Baku, the nation's largest city, carrying government-issued ration papers, coupons, and identification cards for all family members.

"Most food items, other than bread, were rationed," Tarlan said. "We could only get one kilo of meat and sugar and half a kilo of butter per person, per month."

As the youngest of four siblings, Tarlan was trusted with the responsibility of getting the items that the family needed and could receive. It was hard work. The lines were long. There were fights.

And there were women dubbed "hero" mothers, who, encouraged by the state, had given birth to many children. For that reason they received medals that they could display on their chests, enabling them to jump ahead in the lines. Before any coupons could be exchanged for food, families were required to settle any outstanding bills for water, electricity, and trash removal. Food was available in the open market; if you obtained it under the table, you needed to have money to afford the extra cost, Tarlan said.

Tarlan also remembers that some butchers would cheat desperate coupon holders by adding heavier bones. The meat was always frozen and mostly old. Toward the end of Soviet rule, rumors spread that the meat actually came from kangaroos and nutria, or swamp rats. Muslims, like Tarlan's family, declined to eat such meat. Pork and pork sausages, unpopular with the Muslim Azerbaijanis because of religious prohibition, were not rationed. Luckily for his family, Tarlan's mother managed the neighborhood's school cafeteria and was able to quietly bring home some hard-to-get food items. This came with another warning, this time from his mother: "Don't tell anyone I bring home food from the school."

Tarlan said his family members were not part of the ruling communist party.

"I remember my childhood and how misfortunate we were to be forced to learn, memorize, and recite songs and poems praising the country's idol, Lenin, and the ruling communist party," Tarlan said.

He described going to school dressed in a uniform and a red scarf, called *pionerskiy galstuk*, or the pioneer's neckerchief, common in most communist countries, and pledging to the former Soviet Union's red flag every day.

"Sometimes I wondered why my family and I were celebrating the October Revolution Day, for example. They killed my grandfather and caused my father's early death," Tarlan said.

Regardless of their personal feelings, they did celebrate Revolution Day because they feared one of their neighbors might report them if they didn't.

One neighbor was believed to be a prostitute and a government informant. The locals feared her because of the number of police officers and strangers who went in and out of her apartment.

Toward the end of Soviet rule, rumors spread that the meat actually came from kangaroos and nutria, or swamp rats. Muslims, like Tarlan's family, declined to eat such meat.

"In theory, the government discouraged such behavior. The government claimed that capitalists were immoral," Tarlan said. "But the fact that she could live in the neighborhood and act that way convinced most she was connected to the police or the intelligence services," Tarlan said.

Tarlan Ahmadov's family of six lived in a two-bedroom apartment in a Soviet-style concrete building in a "micro-district" neighborhood. Each micro-district included a series of nine-story residential buildings, plus schools, parks, stores, a health clinic, and a stadium. Each self-sufficient neighborhood was controlled by a housing authority, or *upravdom*, staffed by residents loyal to the communist regime. The housing authority tried to ensure that neighborhood affairs went well—trash was removed, common areas clean, and buildings maintained. The staff also acted as the local eyes and the ears of Soviet rulers.

Tarlan lived in a district with a population of some 200,000 residents. Since citizens were prohibited from owning private property, the state owned all the buildings and every resident was a tenant, although no one paid rent. In this way, surgeons and blue-collar workers lived in similar dwellings as neighbors. All children attended the same schools and ended up working together, depending on what they studied, and lived as neighbors as their parents had done before them.

"Of course, if your father was a judge or a doctor, or connected to the government, you were treated better in school," Tarlan said. "Corruption was everywhere."

Tarlan didn't enjoy such connections and ghosts of the past still lingered. In the 1980s, when he was a high school student, Tarlan was denied recognition for his academic success because of his grandfather. "I remember the day when my mom was told, 'Your son, unfortunately, cannot get the honorable golden medal'—even though I had received the highest grades in my high school class."

Tarlan walked to school, which was located in a large building that housed the elementary, middle, and high school grades. Each level was on a different floor, with high school classrooms located on the top floor. The population of 1,200 students attended classes in two shifts and took turns eating their daily meals in a common dining hall. The students were fed three meals a day, at no cost to them.

"We had milk and cookies for breakfast, different soups along with vegetables, pastas, and some meat and juice for lunch. At 4:00 p.m., those coming to school for the later shift were given a light supper. It was usually yogurt with bread, and tea with a biscuit," Tarlan said.

A typical school day began at 7:45 a.m. when students lined up based on their grade level and entered the halls. Each morning, the school blasted broadcast speeches by political and party leaders through the speakers, followed by the national anthem and pledge of allegiance. All students wore uniforms, including a white shirt and silk cravat, knotted as a bowtie.

Tarlan recalled two uniforms, one for winter and another for the warmer months. "My mother had to iron the cravat, but few families owned electric irons," Tarlan said. "We heated the heavy cast-iron pan on the range in the kitchen and then used it for ironing."

He had family members working in the schools. His mother managed the cafeteria and his two aunts worked as teachers. They earned 160 Russian rubles a month, equal to $250 based on the 1990s rate of

exchange. Like most Soviet citizens, they lived in the rent-free, state-owned apartments, but they had to budget for utilities and food. Luxury goods cost more. Tarlan remembers everyone shopped for presents to exchange with family members in preparation for Novruz, the Azerbaijani/Persian New Year, the most important holiday in Azerbaijan.

The KGB, the Soviet's notorious security agents, kept a watchful eye on citizens who visited mosques and other houses of worship.

"My aunt would travel to Moscow to buy stuff there to sell for a small profit to her friends in Baku, for special occasions like weddings or other celebrations," Tarlan said.

Like most people, his aunt and mother looked for ways to supplement their income, including tutoring children academically in their homes.

Worship

Though most Azerbaijanis were secular, Tarlan remembers his grandmother as a devout Shia Muslim. "I used to sit and watch my grandmother perform her daily prayers. I loved to listen to her praying."

She would often tell him that her prayers would help him pass his exams. During Soviet rule only the elderly went to mosques. The KGB, the Soviet's notorious security agents, kept a watchful eye on citizens who visited mosques and other houses of worship. As a result, many people, including some who worked for the government, hesitated to attend worship services at those synagogues, churches, and mosques that were still open to the public.

That changed during the High Holidays.

"During the annual Shia ceremonies of Muharram and Ashura, it was different," Tarlan said. "Large crowds came out to participate in the processions that took place near the mosques."

During the month of Muharram, Shia Muslims hold rallies to recognize the battle of Karbala, when Imam Hussein, the grandson of the Prophet Muhammad, attained martyrdom in the seventh century. Devout Shia Muslims reenact the battle and its tragic outcome, weeping and beating their chests to mourn Imam Hussein and his family. Tarlan's mother made halva, wrapped in lavash bread, to bring as an offering to participants of the processions.

While life was hard, Tarlan also spent many happy, fun-filled summers with his family at their dacha (a seasonal or year-round second home), located outside of Baku on the Caspian Sea in Russia. They inherited the dacha from his maternal grandfather.

"I have fond memories of those getaways, especially the fun the boys and the men in the family had sleeping outside on platforms on summer nights," Tarlan said.

Marriage Traditions

Tarlan's family was also strained by societal pressure that required them to put together dowries for his two

sisters as they approached the traditional marriage age. In Azerbaijan, the bride is expected to provide all household goods, including furniture, while the groom's family helps with housing and some jewelry, given to the newly married couple as gifts.

"To organize the dowries, my mother would save money to buy goods on annual trips she and I took to Moscow," Tarlan said.

When he visited Moscow, Tarlan felt like an outsider. As a Muslim from the Azerbaijan Republic, with a slightly darker skin color than the Slavic Russians, he was treated like a second-class citizen.

"I remember the day well, when I was insulted while I was waiting in line somewhere in downtown Moscow. I was called a *chernozhopiy*, an offensive term in Russian, referring to my dark skin and dark hair," he said.

By the time Tarlan finished high school, the seemingly all-powerful Soviet Union was disintegrating. He remembers the day in 1989 when he and his classmates raced out of their school to join the crowd of protesters. On their way, they burned the red communist flag. The massive, noisy crowd marched to the central square in downtown Baku to protest communist rule. Tarlan was happy to see the end of a regime that had killed his grandfather and caused the early death of his father.

Change was sweeping across Europe, but problems remained.

"A few months later, we witnessed the collapse of the Berlin Wall and the start of anti-Soviet protests in Eastern European countries," Tarlan said.

He felt like he was watching a movie. Life around him was changing, and he was witnessing history being made. During those exhilarating moments, he, of course, didn't know that in just a few months, his beloved country would be attacked in a military crackdown trying to silence the national demand for independence. On January 19 and 20, 1990, military forces belonging to the Red Army attacked, in what became known as "Black January." Soviet tanks and troops rolled through the streets of Baku.

"That night we were watching TV when suddenly the screen went fuzzy," Tarlan said. "The program went off the air. From our balcony we could hear people using loudspeakers mounted on cars, asking the city's residents to come out to protest the Russians' attack on the city."

Tarlan remembers going with his mother to get his aunt, who lived alone, bringing her to stay with them, for safety. Military searchlights looked for residents who dared to step outside.

"We were scared as we made our way through residential alleys that we knew were safe to get to my aunt's place," Tarlan said. "I saw bullet tracers passing overhead."

His other aunt, who worked for a state-run television station, called to tell them she was okay, but that the radio and television stations were now controlled by KGB agents and the news anchors had been arrested. That same evening, television transmitters were destroyed as the Soviets quickly moved to seize control of communications.

Once the radio and television stations went down, Baku residents had no idea what was happening in their city, let alone across their country. Similarly, the outside world knew nothing about the attack. At the time, no foreign correspondents were stationed in Baku.

"The Russians were ordering everyone to stay indoors. I guess they did not want any eyewitnesses," Tarlan said. "They warned the residents via the helicopters' loudspeakers that a curfew was in effect. I remember we stayed up all night and felt frightened."

Tarlan was right to be worried.

British journalist Thomas de Waal wrote about the Russian attack in his 2003 book *Black Garden*, saying that "tanks rolled over barricades, crushing cars and even ambulances. Witnesses spoke of soldiers firing at people who fled and of soldiers stabbing and shooting the wounded. A volley of bullets hit a bus full of civilians and many of its passengers, including a fourteen-year-old girl, were killed. Some one hundred thirty citizens of Baku have been killed and several hundred were wounded on the night of 19–20 January."

The next day Baku residents woke up to a terrible sight. The city's streets and squares were bloodstained, marked with the remains of mutilated corpses. Cars were crushed and buildings had been sprayed with bullets. In keeping with Azeri tradition, a period of forty days of public mourning was declared throughout Azerbaijan.

"'Friendship of Nations'—a park once used as a cemetery—became a cemetery again, this time to honor the victims of Black January," Tarlan said. To this day the park, now called "Alley of Martyrs," is visited by Azerbaijanis who place red carnations on the graves of the martyrs, including those killed in the First Nagorno-Karabakh War, from 1988 to 1994.

"Everything changed again in Azerbaijan when the country regained its independence in 1991, after the collapse of the Soviet Union," Tarlan said.

"A volley of bullets hit a bus full of civilians and many of its passengers, including a fourteen-year-old girl, were killed.

For the next several years, military insurrection and coup attempts threw Azerbaijan into further turmoil. The political trouble brewing in the disputed enclave of Nagorno-Karabakh, populated by Azerbaijanis and Armenians, caused fighting that displaced one million ethnic Azerbaijanis who lived in the disputed region.

"Hundreds of thousands of refugees poured into Baku, overwhelming the city," Tarlan said.

By 1994, after fighting in Nagorno-Karabakh had escalated into war, a cease-fire was reached. Negotiations produced a stalemate that remains unresolved to this day.

With the chaos and food shortage in Baku, Tarlan, now an adult, once again found himself standing in a food line.

During this time, he worked toward his master's degree in history at the century-old Baku State University. The country faced a teachers' shortage and Tarlan was asked to teach while he was still a student. Many well-educated Azerbaijani citizens, now free to travel because of the nation's independence, were leaving the country to find better wages and opportunities.

Tarlan remembers feeling nervous on his first day as a teacher. But when he entered the classroom for the first time, something unexpected happened. "Through the classroom's open window, a pigeon flew in. The students started to jump up and down, shouting. The bird sat on my shoulder. There was silence. Suddenly it flew away. But it had pooped on my shoulder. The students yelled, saying it was good luck!" Tarlan recalled.

"The Bahá'i Faith has taught me to treat people with unconditional love regardless of who they are, and to work hard for the betterment of the world."

New Faith

While he was teaching, a student invited Tarlan to visit the Bahá'i Center in Baku. At the time he was experiencing a crisis of faith, studying different religions and visiting places of worship.

"In the midst of all the changes in my country, there was also change in my spiritual destiny," Tarlan said.

In 1995, he converted to the Bahá'i Faith, an independent global belief system that teaches the oneness of God, the unity of humanity, and the essential harmony of religion. Followers of Bahá'i believe in peace, justice, love, altruism, and unity. The Bahá'i teachings promote the agreement of science and religion, the equality of the sexes, and the elimination of all prejudice and racism.

"The Bahá'i Faith has taught me to treat people with unconditional love regardless of who they are, and to work hard for the betterment of the world," Tarlan said.

He and his wife, Zema, are now active members of the local Bahá'i community in Maine. The two met in Azerbaijan through mutual friends. He was thirty and still a bachelor. His aunt asked him if there was something "wrong" with him for remaining single. The families got together, introduced Tarlan and Zema, and sent them on a date. They were engaged for one month before getting married. For their wedding reception, Tarlan and Zema had 350 family members and friends as their guests.

The day before the wedding, Tarlan's male friends took him to the Turkish-style public bath, *hamam*, where they bathed and got massages, haircuts, and shaves.

Later at Tarlan's house, a group of traditional musicians played for Tarlan's relatives and friends, both men and women. They danced to the live music

while family elders came to bless the groom-to-be. Before leaving the house to go to Zema's, he walked under the Qur'an, or Islamic Holy Book, to seek blessing, while his relatives showered him with candies and sweets.

The entire procession of musicians, friends, and relatives drove over to Zema's house where Tarlan asked Zema's oldest uncle for permission to marry her. The uncle had them join hands and kissed them to bless the marriage.

"We call spouses *hayat yoldashi*, meaning 'friend for life,'" Tarlan said.

With permission to marry, the wedding festivities began. Tarlan dished out money to bribe relatives and friends, who, in keeping with the local tradition, pretended to block him from dancing with Zema. After the reception, Tarlan and Zema went to his house. Tradition called for Zema to step on a plate placed on the door's threshold and break it into pieces before entering her new husband's house.

For the next seven days the bride and groom stayed in the house. After that relatives from both sides showed up with more gifts.

"Azerbaijani weddings are very traditional, with lots of fun!" Tarlan said.

Helping Refugees in the United States

Tarlan Ahmadov said his decision to leave Azerbaijan, where he still has family, was beyond his control.

After arriving in Maine in 2003, Tarlan and his wife settled in the Portland area. Tarlan, who is fluent in Russian, Azeri, and Farsi, decided to volunteer at the Catholic Charities Maine Refugee and Immigration Services, the state's only refugee resettlement program. Soon he was hired as a caseworker with the same agency, helping new refugees find housing and employment, and enrolling them in English as a Second Language classes. Tarlan was promoted to supervisor and later selected as director of the program.

In 2017, Tarlan was named State of Maine Refugee Coordinator. In this position he coordinates the federal government's transfer of funding to help with the settlement of refugees in the state. According to Tarlan, since 1975, Maine has settled 25,000 refugees from over seventy countries. As the state's refugee coordinator, Tarlan oversees the direction, supervision, coordination, representation, and monitoring of all activities related to the settlement of refugees.

When he is not working to help newly arrived refugees, Tarlan is involved in the cultural and political affairs of the Azerbaijani diaspora in the United States. In 2006 he led efforts to establish the Azerbaijan Society of Maine, with a mission of building cultural and political relationships in the state. He hosts public events, including art shows, to help Mainers learn about his country of birth and facilitates visits by delegates from Azerbaijan.

"I am a bridge maker. I want Americans to get to know my country of birth, Azerbaijan, better," Tarlan said. "I want Azerbaijan and the United States to become friends because I love both countries."

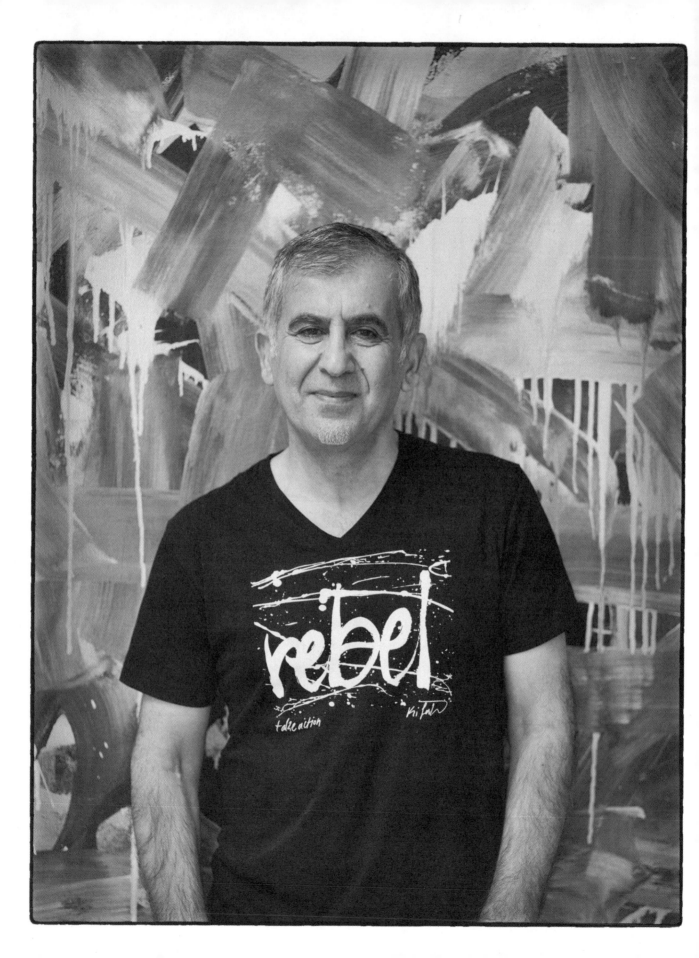

Kifah Abdulla

Iraq
Population:
40.22 million
Distance from Maine:
5,587 miles

Kifah Abdulla's life could be the coming-of-age story of any young man, anywhere in the world. Kifah remembers being a hippie, or looking like one, back in 1970s Baghdad, Iraq. He grew his hair long, wore the era's fashionable seventeen-inch bell-bottoms, and listened to Aerosmith. At the time, Iraq was experiencing economic growth due to an increase in international oil prices. Westerners, including some Americans, visited, lived, and worked in Iraq. Kifah recalls watching Jimi Hendrix play the guitar on Iraqi TV. There were two state-run television stations: one in Arabic and one in English, for the sake of the expatriates. Kifah was studying biology at the University of Baghdad, where he had a girlfriend who wore short skirts and lived with him. He refers to the time as Iraq's short-lived "Golden Age."

"Life was good, in general," Kifah says, in a reflective mood. The government was repressive, but so long as you stayed out of politics, you were able to do mostly as you pleased.

Soon the nation's destiny and that of twenty-four-year-old Kifah changed dramatically. In 1979, notorious Iraqi strongman Saddam Hussein became president, instituting increasingly oppressive laws, and in 1980, Hussein declared war on neighboring Iran.

"The war is now a disturbing memory, recurring like a nightmare," Kifah says. It changed his life forever.

"My true identity as one who was educated, creative, and peaceful was taken away from me," he said. "Imagine being surveilled, insulted, and without the right to speak out against the ideology of the ruling regime."

When Kifah was growing up, Iraqi society was secular and tolerant of Western lifestyle. Foreign visitors flocked to Baghdad, Iraq's capital city known worldwide for its rich history, museums, and mosques. English-speaking tourists gave Kifah ample opportunities to learn about the world outside of the Middle East. He had a young male Japanese friend, a diplomat named Sominto, known as Sammy. Despite speaking Arabic fluently, Sammy preferred to converse with Kifah in English. Since English was taught as a second language in public schools, most Iraqis could speak the language.

Kifah and his classmates read Shakespeare in middle school. Their English teacher was strict in not allowing the pupils to speak in Arabic, which was their first language. The students had to respond to every question in English. This was when Ahmed Hassan al-Bakr, Iraq's fourth president, was in power.

Ahmed Hassan al-Bakr became president in 1968, and he appointed Saddam Hussein, a younger cousin, as his vice president. Over the course of the next decade, Saddam Hussein gradually increased his power within the government and was soon in charge of Iraqi intelligence and security services. When Ahmed Hassan al-Bakr stepped down in July 1979, allegedly for health reasons, Hussein became president.

When Saddam Hussein took power, he and his authoritarian regime initiated oppressive policies and were known for their notorious and feared secret police, Mukhabarat, responsible for arbitrary arrests, torture of the regime's opponents, and executions.

As a university student in the 1970s, Kifah was not interested in politics. When he was invited to attend the university's student chapter of the ruling Ba'ath (Resurrection) Party and pressured to join, he refused. His refusal made the state suspicious—a misgiving that would follow him for years to come.

Years earlier, his father, a lawyer, had disappeared after being arrested by the secret police, interrogated, and tortured for helping an American client, who was employed by a Western oil company, marry an Iraqi woman.

Despite all of this, Kifah managed to enjoy a carefree life, continuing his higher education at the tuition-free, state-sponsored university, and going dancing with his young friends during his free time.

"You just had to stay out of politics and pretend there was no oppression," Kifah said.

This was easier said than done.

Kifah knew something was wrong in his country. According to international human rights observers, the Iraqi regime had a dark record when it came to human rights. Because of his will

to stay out of politics, Kifah's life had remained relatively untouched by the sorrow and hardship that many of his countrymen and -women experienced during the same period.

"My father was a lawyer, traveling for work a lot. My mother was well-educated, and a fan of Clark Gable and Hitchcock's horror films," Kifah says.

Kifah has a kind face, which, judging by his popularity in the city of Portland, must win him many friends. With a twinkle in his eye, he talks of learning to play the guitar. In Baghdad, he enjoyed listening to The Jackson 5 and going to popular nightclubs like Casino Club and Moulin Rouge. He visited cinemas with names like Atlas, Simiramis, and Nasr to watch Hollywood cowboy movies starring Clint Eastwood.

Kifah's plans beyond graduation from Baghdad University were typical: He planned to marry his sweetheart, a young Iraqi woman who attended university with him—even though his mother had other women, including a relative, in mind for him to marry. He wanted to have kids, settle down in his country of birth, and, thanks to his university degree, join Iraq's burgeoning middle class.

"I read many books. I was happy!" Kifah says.

War with Iran

Kifah says life in Iraq was transformed when Saddam Hussein declared war on Iran, the country's eastern neighbor, in September 1980.

A year earlier there had been a revolution in Iran, a non-Arab nation that belonged to the Shia sect of Islam. The 1979 Islamic Revolution in Iran resulted in the overthrow of the Shah of Iran, a close ally of the United States in the Middle East. His regime was replaced by the Islamic Republic of Iran, led by the Shia Ayatollahs and inspired by Ayatollah Khomeini, who had been exiled to Iraq for several years but forced out of that country shortly before the 1979 revolution.

Iraq's new president, Saddam Hussein, was suspicious of Iran's revolutionary regime. Saddam knew he was widely unpopular among Iraq's Shia communities, and he detested the firebrand

revolutionary coming to power next door. Saddam Hussein suspected Ayatollah Khomeini, who was popular among the Shia Iraqis, of wanting to export his brand of Islamic revolution to secular Iraq, where Sunnis controlled the power in an otherwise Shia-majority nation. For years, Saddam Hussein had oppressed the Shia minority, just as he had done to the Kurdish minority and other Iraqis. He feared Iran's new government would encourage Iraqis to revolt against him.

He went through basic military training. Looking back, Kifah calls it a brainwashing campaign to "empty his mind of everything he had known in favor of blind obedience."

Hussein's risky gamble to win a quick war against an Iran that seemed weakened by post-revolution infighting and internal factionalism proved a costly mistake for all sides. The Iran–Iraq War dragged on for eight years, leaving millions of Iraqis and Iranians dead and millions more wounded. Entire cities and villages were ruined on both sides of the border. It became a war of attrition, and it ended with neither country being declared the winner.

Kifah considered it a "war of media and propaganda," with each side spinning the facts and outcomes while dehumanizing the other side. While the regime in Tehran claimed Iraq was waging a war against Islam, thus labeling the Iranians' resistance a holy war against the infidels, the Iraqi state promised a repeat of the humiliating defeat of Iranians (Persians) in the historic Battle of al-Qadisiyyah in 636 CE between the early Muslim Arabs and Persians, which brought Islam to Persia (now called Iran).

Kifah saw through it all. Nonetheless, military service was mandatory in Iraq, and the government drafted every able-bodied young man into the army. Young Kifah, a university graduate, an artist, and an idealist at heart, was drafted in 1980.

The war would disrupt Kifah's life and his future.

Iran, due to its larger population and bigger army, pushed the Iraqi army out of the land they had occupied. The ensuing retreat eventually led to Kifah's displacement and his ultimate exile to the United States. As a pacifist, Kifah believes the "realm of humanity was bigger than the narrow space between borders."

Before joining the front lines, he went through basic military training. Looking back, Kifah calls it a brainwashing campaign to "empty his mind of everything he had known in favor of blind obedience." Dispatched to the artillery academy, he remembers looking at a large Russian-made cannon and worrying about how he would manage in the artillery unit. He had

never held a gun in his life. His artillery training turned out to be quick and basic.

By the time Kifah was sent to the front lines, the fighting was intense. Human casualties on both sides were rising. Kifah said he felt "like a robot fighting at the war front, not a human, defending that stupid border." He was not proud to fight for a regime that did not respect him as a citizen. The first time he heard a cannon fired, he felt like his body had torn apart. The pain in his ears was so intense that he opened his mouth involuntarily to lessen the pressure. He later realized he had cried from the pain.

Kifah did not want to fight in a war he did not believe in, but deserting was punishable by death. He knew Saddam Hussein and Ayatollah Khomeini's stubbornness and refusal to see the futility of war would prolong it. Each side accused the other of starting and perpetuating the conflict.

Kifah visited his family in Baghdad during a scheduled leave. His beloved city had changed. Sirens warned the population of incoming Iranian bomber and missile attacks. Funeral processions for dead soldiers were held in city neighborhoods. He reflected with sadness on how the war had turned Baghdad from a happy city to one of sorrow.

During this same leave, he remembers thinking how much he hated being in the war. "My place wasn't supposed to be there. I had studied. I thought I'd serve my country in an academic way, not as a soldier in a dirty war."

On the front, Kifah saw companions lose their limbs, and some, their lives. He said it felt as if he were swinging between a dream and a nightmare. "At times, I felt I was a feather tossed around by the wind, playing no role in the outcome."

After eighteen months of fighting, moving between locations inside the Iranian territory occupied by the Iraqi army, Kifah's unit was ambushed. The Iraqis had abandoned him and his unit during a rushed retreat. While some soldiers from his unit were captured, Kifah managed to escape. He tried to make his way home, or at least to find Iraqi positions. He was alone and lost in the "desert of fear."

The front lines of the war were always shifting and changing as armies advanced and retreated. For Kifah, home was on the other side of the shifting border to the west, where the sun dropped every day. As he walked through the desert, he fought thirst, hunger, heat, and various reptiles and insects. He talked to himself as he hallucinated. He remembered his happy childhood and wondered if he'd ever see his loved ones again. He trudged on day and night, at times only narrowly avoiding Iranian forces.

In a desert empty of trees that could provide shelter from the sun and feeling desperately thirsty, he saw mirages. At night he saw the sky light up with the flashing of shells, cannons, and passing missiles. He saw columns of black smoke rising up in the direction of both borders, a constant reminder of the "dirty" war going on nearby.

At one point, he found scraps of old bread and moldy fruit in an abandoned Iraqi barricade, and he ate. He drank stale water from a rusting metal drum left at a set of abandoned bunkers. After quenching his thirst, Kifah remembers submerging his tired, hot body inside the drum, among the mosquito larvae.

"My war is over," he thought, as he held his head under the sun-warmed water to muffle the loud noises of the ongoing war. After all, it was not a war he had chosen to be in.

Kifah was weary and confused. Mistaking the building for an Iraqi camp, he walked in and was captured by Iranians.

After five days of wandering in the desert that separates Iran from Iraq, Kifah came across a military barricade with a flag hoisted on top. Kifah was weary and confused. Mistaking the building for an Iraqi camp, he walked in and was captured by Iranians, who were surprised to see a lost Iraqi soldier in a torn uniform.

"The worst thing that I could imagine had happened: I became a captive," said Kifah, who believed they were all "just poor soldiers, fighting on a land that belonged to no one." He was now a prisoner of war. It was 1982. Kifah was twenty-six years old.

Kifah spent eight years and three months as a POW. He lived in a camp in Arak, near Iran's capital city Tehran, with thousands of other Iraqi POWs. His captors suspected he was a spy, so before he was sent to the camp, Kifah was interrogated, beaten, and humiliated. Later, they asked if he was an officer, belonging to Saddam Hussein's notorious Ba'ath Party, on account of his college education and knowledge of the English language.

While a prisoner, he almost died of a ruptured appendix. Fortunately he was transferred to a hospital outside the prison and saved by a stranger's kindness at the last minute.

When he was taken as a prisoner, Kifah pledged to prove that a dream was stronger than a nightmare. He knew if he stopped dreaming, he would grow old and die, fulfilling his captors' wishes.

The war ended in 1988. It took two more years for Kifah to be freed. The International Red Cross informed the Iraqi regime and Kifah's family of his capture.

The girl Kifah had planned to marry had heard that he'd died on the front lines and had moved on with her life. Once back in Baghdad, Kifah married a different woman and tried to start a new life in the postwar era. However, Iraq's intelligence services continued to view him as an enemy, since he was half-Kurdish and half-Arab and had refused to join the Ba'ath Party. As a result, he was required to report his activities to a neighborhood branch of the intelligence

services every month. Agents from the Mukhabarat showed up randomly at his house, inquiring about him. Fearing for his safety, Kifah fled to Jordan in 1996.

Kifah has now lived in America for more than a decade. He teaches Arabic and calligraphy, paints, and writes poetry in Portland.

Later, he sought asylum in Holland and lived there for five years before coming to America as a refugee in 2011, to join his family, who were already in Maine.

Kifah has now lived in America for more than a decade. He teaches Arabic and calligraphy, paints, and writes poetry in Portland. He is a community activist, working to advance peace and unity through art. In 2020 he self-published a memoir, *Mountains Without Peaks*, describing his life as a soldier and a POW.

When asked if he misses his hippie days, and what informs his identity today as he builds a new life in America, he smiles and says, "Now I am a world citizen!"

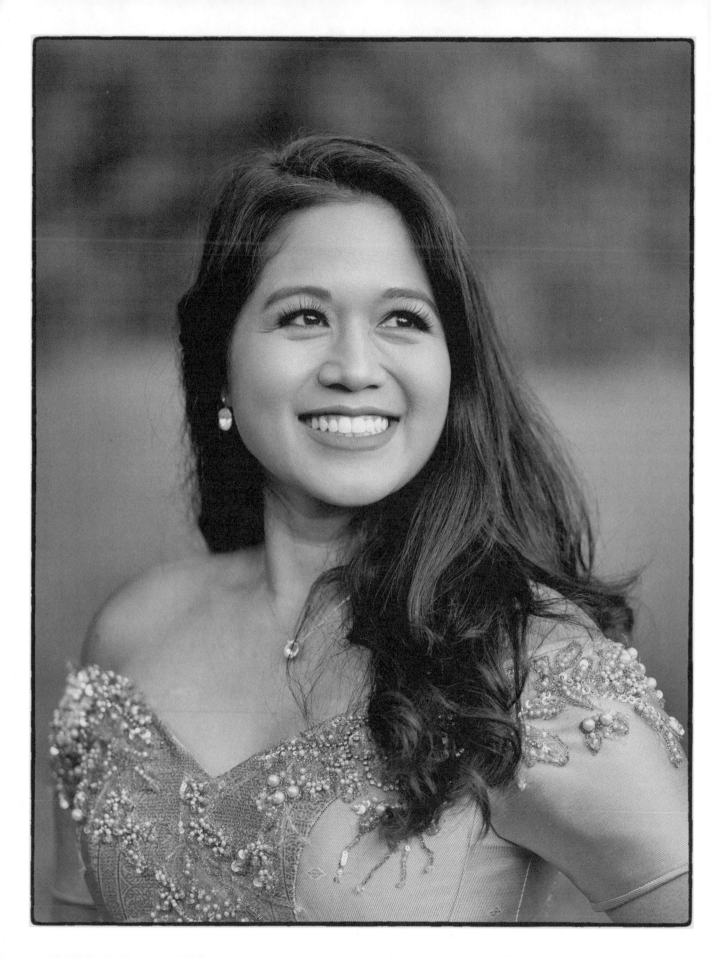

Chanbopha Himm

Cambodia
Population:
16.72 million
Distance from Maine:
8,421 miles

Chanbopha Himm, better known as Chan, had a tough time balancing her Chinese-Cambodian and American identities while growing up as a refugee in New England. Her father, a Khmer Rouge survivor, wanted his children to retain their Cambodian identity in America. He spoke only Cambodian around the house, kept chickens in their garage, and cooked traditional meals like pho.

Teenage Chan felt that this held her back from learning English and becoming, in her mind, more American. Now, as the former co-president and co-founder of the Cambodian Community Association of Maine and Unified Asian Communities, and currently serving as a program manager with the Maine Department of Health and Human Services COVID task force, she feels like she has found that balance. And she has found a way to honor the memory of her father, Song Kry, by helping Cambodian Mainers in need during the COVID-19 pandemic.

Song Kry grew up in Khet Kandal, a province close to the Vietnam border in eastern Cambodia. His family was of Chinese-Cambodian descent, and his father, Chan's grandfather, owned large tracts of land.

"He owned over a hundred acres," Chan said. They farmed rice and grew papaya, lychee, oranges, and guava. Lychee is a sweet and fleshy red berry fruit from Cambodia.

Her grandfather was a leader in the Chinese-Cambodian community in Khet Kandal. The wealth generated from the family farm allowed Song Kry and Chan's older brother, as well as other relatives, to receive an education. Chan's grandfather pushed her older brother hard in his studies, especially English.

Chan's mother, Yorn Un, grew up at the royal palace in Phnom Penh, Cambodia's capital. Chan's maternal grandparents were chefs for the king and queen of Cambodia. They would cut up the vegetables and fruits, and grate their fruit a certain way. Yorn Un was a dancer for the royal court, and she got a chance to dance for the king and queen during certain ceremonies.

While the family spent their time around royalty, they didn't have many actual interactions with them.

"They would normally stay within the kitchen," Chan said.

They lived in a complex right outside the palace for fifteen years. However, life at the royal palace came to an end for Yorn Un after her parents died.

"When both my grandma and grandpa died, Mom just quit. She had to leave the palace and survive on her own," Chan said. "So she came near Battambang, and that was apparently when she met my dad."

In Battambang, Chan's mother sold Cambodian *nom banh chok*, a rice noodle dish eaten for breakfast, in a market. It was there that she met Song Kry, who often traveled to Battambang on business trips from Khet Kandal.

"My mother was doing trading and she was selling cigarettes, and that was their first interaction when they fell in love," said Chan. They had both been married previously, and joined their families together in Battambang.

The Rise of the Khmer Rouge

Chan's parents and grandparents were not immune from the war in neighboring Vietnam. Spillover from that conflict led to America bombing parts of Cambodia and taking part in a secret war known as Operation Freedom Deal. As this was going on, Cambodia's Communist Party, the Khmer Rouge, grew in power and influence in the countryside, with deadly consequences for the Cambodian people.

The Khmer Rouge was an extreme militant group that combined communism with Khmer (another name for Cambodian) nationalism. They wanted to rid Cambodian society of intellectuals and anything that they perceived as outside influence.

"All of a sudden a group of people came and took over, so everyone in the family got separated," Chan said, describing the rapid rise of the Khmer Rouge. As they went from village to village, they looked for signs of intelligence—anyone wearing glasses, or anyone whose hands "didn't show that they were farmers," and might be part of the middle or upper class.

Chan's family spoke French and had Chinese ancestry. Because they were educated and owned

land, they were targets for the Khmer Rouge's genocide.

"They had to lie," she said. "A lot of people had to lie in order to survive."

Her family pretended not to understand questions or answered them incorrectly to hide who they were. Her grandparents lived through French colonial rule and Japanese occupation during World War II. The cruel occupations by both countries paled in comparison to the Khmer Rouge, according to Chan.

The Khmer Rouge separated her family. They put Song Kry in a camp and made him a chef because he knew how to cook.

"At the same time, my dad helped a lot of people by hiding food in the kitchen. So, certain times during the day he would have a little stick [used to designate if it was okay to get the food]," Chan said. "He would place it wherever he was hiding the food."

Such actions were necessary, because given the extreme rationing by the Khmer regime, food was scarce and portions small. In many cases, a family might share a single banana or a teaspoon of rice.

"You would have one big wok of water and, like, one teaspoon of rice in that wok. You needed to feed over a hundred people. You were basically just drinking plain water," she said. A lot of the rice that was grown was sold to the Chinese government, which was backing the Khmer Rouge in exchange for weapons.

Chan's older brother was forced to work, creating an artificial pond for the Khmer Rouge.

The Khmer Rouge killed her grandfather and confiscated their family farm.

Decades after they left Cambodia, Chan and some of her family returned to the farm.

"Their home doesn't look the way it used to, but we can still picture that that was where they lived," Chan said.

"The Thai military were dumping the Cambodian people off the mountains while driving them up."

On Christmas Day in 1978, Vietnam invaded Cambodia to oust the Khmer Rouge. The two countries had a long rivalry, and border conflicts had increased since the end of the Vietnam War. The invasion presented an opportunity for Chan's family to flee the Khmer Rouge and head to Thailand.

Refugee Life in Thailand

Chan's family fled to the Khao-I-Dang camp in eastern Thailand, near the Cambodian border. "Unfortunately, a lot of Cambodian lives were lost there as well," said Chan.

The camp conditions were awful, and Thai soldiers guarding the camp reportedly killed and tortured Cambodian refugees. "The Thai military were dumping the Cambodian people off the mountains while driving them up," said Chan. Many Cambodian women were raped. "Luckily,

my half-sister was small. She was safe," Chan said. "It's unfortunate what the Thai soldiers did to the Cambodian people during that time."

At the refugee camp, her family was assigned a small hut to live in.

"Each hut had a number, so 1, 2, 3. Everyone had their own hut," Chan said.

Sometimes groups of families had to share a hut together. Chan's mom was pregnant with her. Chan was born at the refugee camp and spent the first several years of her life there.

One small saving grace was that Song Kry became the camp chef, providing some financial security and food for the family.

"Dad told them he was a chef, so he helped cook for the village," she said. "During this time they had their struggles, but they also had their pros because of my dad's career."

He had his own farm where he raised pigs and chickens to feed the camp. Still, Chan explained, "there was never enough. So no matter how much food there was, we were short of supply." Despite these difficulties, Song Kry hosted weddings and potlucks for the community in the camp.

Yorn Un worked to keep her daughter safe and healthy and the family financially secure.

"My mom was smart enough to buy gold," Chan said. Her mom would barter with other Cambodians in the camp for gold jewelry and gems to use later, after they had left the camp. "So she tucked away a lot of gold," Chan said. She would trade extra rice and food for it. "Rice

back then was just as available as giving up gold." Her mother hid the jewelry from the Thai soldiers, who would have taken it for themselves.

Chan's father, who helped Cambodian families during the regime of the Khmer Rouge by hiding food, continued to help them at the camp in Thailand. He even hid a family who had crossed over illegally.

"There was this family my dad helped, and this family is actually still alive," Chan said. The Kry family didn't know this family before they came to the camp. "They must have crossed the border and saw our farm one night. My dad just felt bad because, of course, they were Cambodian." He knew their struggles. "My dad understood the consequences—that if they were caught, they would die or get kicked back into Cambodia," she said. "And they didn't want to get kicked back to Cambodia."

The Himms hid this family for a year in the storage corner of their small hut. The Thai military conducted random checks to make sure no Cambodian refugees had snuck into the camp without approval. When these checks occurred, Chan's parents quickly hid the family with rice bags, pots, and pans. "They knew not to move a muscle," Chan said. "They [the Thai military] wouldn't come with appointments; they would just show up during the day."

The Khao-I-Dang camp was also run by the United Nations, which was trying to resettle the Cambodian refugees through a visa lottery. Many refugees were to be resettled in the United States.

Many of the camp's Cambodians were uncertain about coming to the United States. Many sold or traded their visa lottery tickets with others in the camp. The family that the Himms were hiding traded for a ticket, allowing them to be resettled in the United States.

Chan's family had an advantage, because her older brother, Kimley Chea, was already living in America. He had been living in a different section of the camp before he was resettled in 1981 through World Relief's refugee resettlement program. He petitioned to have the rest of the family join him in the United States.

"They knew they were being given a new future, a new opportunity, and a new form of life for their family."

Coming to America

"My family was sponsored by my brother, Kimley Chea, who was already in America," Chan explained. He knew some English and attended graduate school in Massachusetts. They traveled from the camp to Bangkok, and then took a flight to Manila in the Philippines. They waited in Manila for a year for the correct paperwork to arrive, which would enable them to come to the United States.

In the winter of 1983, Chan and her family flew to Boston, where her older brother waited at Logan Airport.

"My parents did not know much about America," Chan said. They just wanted to reunite with their son and escape the camp.

"They knew they were being given a new future, a new opportunity, and a new form of life for their family," Chan said.

Her family was not prepared for the cold weather that awaited them, arriving in Boston during the winter wearing flip-flops. Anticipating this, her brother had brought jackets, sneakers, and boots to the airport.

The drastic change in climate was not the only difficulty the family faced. They had used almost all of their money to get to the United States.

"When my parents came to the United States, they only had fifty cents," Chan said. "They wanted to get a soda at the airport, and my dad took out some Cambodian or Filipino money that was only valued at fifty cents in the United States. He was trying to buy himself a soda, but the lady was like, 'No, we can't accept this money.'"

Her brother paid for the soda.

The Himms moved to Attleboro, Massachusetts, where Chan grew up and attended high school. They lived in a twenty-unit apartment complex with other members of their family who had resettled in the United States. All of them arrived before 1985.

"It was fun seeing my cousins," Chan recalled. "A lot of my cousins got married at that building. Those are great memories."

While they were glad to be in the United States, it was hard for both Chan and her parents to adjust to a completely different lifestyle.

Their family eventually bought a house in a more rural part of the town, where one of her sisters still lives today.

While they were glad to be in the United States, it was hard for both Chan and her parents to adjust to a completely different lifestyle. Her parents did not speak much English and struggled to find work with no college education.

Like many immigrants, Chan learned to balance her Cambodian and American identities. Because her parents only spoke Cambodian around the house, Chan struggled with English in grade school. "I got made fun of a lot when I was in school," she said. "I mean, I knew enough to pass my grades, but I didn't know enough, because when I came home, all I would speak at home was Cambodian."

Her English-speaking older brother had his own family by that point and did not have time to tutor her. Chan improved by practicing with friends at school. Her parents were strict and traditional, so she was not able to hang out with them after school. Some of the other Cambodian kids at her school thought she was a snob because she prioritized hanging out with American kids. Chan wanted to practice her English, not speak Cambodian.

"I couldn't talk on the phone with them because number one, they were boys," Chan explained. Her dad felt like he needed to protect his family after everything they had been through. "I don't blame him," she said. Because of the Khmer Rouge, their experiences at the Thai refugee camp, and the stark differences between life in Cambodia and life in Massachusetts, her parents were wary of non-family members.

Song Kry wanted to retain their Cambodian culture, so he cooked for his family and their relatives. "He would cook stir-fry. He would make pho. When he would make pho he would call the entire neighborhood, because he is so used to preparing food for large groups of people," Chan said, having done so for family gatherings or for the refugee camp. "He was used to feeding people in big portions," Chan said. "So he would call my brothers and sisters and uncles and aunts. There would be pho that entire weekend. We would always eat with the family."

Like he had done in Thailand and Cambodia, Song Kry raised his own food, including chickens in a coop inside their garage. "My dad was a farmer, so whatever house, wherever we go, there were always fresh vegetables from my dad," Chan said.

He grew Thai basil, Cambodian spinach, lemongrass, squash, lettuce, Thai red chili peppers, and other herbs and vegetables found in traditional Cambodian cuisine. Chan said Song Kry preferred to grow and prepare food at home instead of buying it in stores or restaurants.

It would take years for Chan to appreciate how he shared Cambodian food and culture with her. "My dad would always try to steer us toward the Cambodian and Chinese traditions because he wants us to pass it on," she said. "That's the best thing about my father: the way he conditions his kids."

Starting a New Family

After Chan graduated high school, she married a man through an arranged marriage. Her parents and in-laws, who were also refugees, knew each other from Cambodia. Her husband's family was from Khet Kandal, like Song Kry. Her husband was living in Portland, Maine, where he had attended Deering High School and worked at the Reiche Community School.

"When I came to Maine I didn't attend school," Chan said. "I didn't attend college right then. I jumped into a family life. From my family life, I worked. First, I worked at West Stevens Avenue in Biddeford at a blanket factory. I worked third shift. It was pretty difficult for me. I never had experienced working that hard before. Working third shift was not my forte, especially during the winter."

Chan left the factory job when she and her husband moved to Saco, where they have lived for the past twenty years. Chan has spent the past two decades working hard, in addition to raising her son and daughter. When she had her first child, her son, Nathan, she did accounting at the Thomas Agency. She then worked at Southern Maine Health Care.

> "My dad would always try to steer us toward the Cambodian and Chinese traditions because he wants us to pass it on."

"I enjoyed what I was doing, which was finance," she said. "I then worked at Stanford Management, as an accountant. I then got into corporate accounting from there," Chan said. She decided to work for Unum, in hopes of helping the Cambodian community with insurance. When that did not work out as she had hoped, she explored other ways to help the Cambodian community in Maine.

Helping Cambodians in Maine

Before Song Kry passed away, he was helping orphanages in Cambodia. He returned to the country a few times, starting in 2001.

"The day he passed," Chan recalled, "he was volunteering with the Hopes Alliance, which is an orphanage in Cambodia. It's in the rural area," she said. His team raised a lot of money. "They

were able to build an entire new complex from the bottom up," she said. The orphanage gave the kids vocational training to help them find a job or get into college later in life.

Chan was proud of her father's work in Cambodia, but wanted to help Cambodians in the United States, and in her own community.

"I know my dad wanted to take care of the people in Cambodia, but yet, I was thinking, what about the people here?"

"I know my dad wanted to take care of the people in Cambodia, but yet, I was thinking, what about the people here?" She looked for Cambodian cultural, business, and religious associations, but could not find any in Maine. Chan remembered that the caseworker who had helped her family when she was growing up in Massachusetts also helped a hundred other families. "I was thinking, where do these people go to look for help?"

The Maine Immigrants' Rights Coalition and her local state senator, Justin Chenette, introduced her to Marpheen Chann, another Mainer with Cambodian roots. Over coffee the two created the Cambodian Community Association of Maine, and they served as co-presidents. They worked day and night to secure funding for the organization.

"It was a struggle in the beginning to get it going, but once we got the right group of people, the dedication, the commitment, it's just riding its course," Chan said. "It's going really smoothly right now."

During the COVID-19 crisis, they raised money to create care packages for members of the Cambodian community. Chan is thrilled with how fast the organization is growing.

"We are grateful for the opportunity to serve so many in our community in such a short period of time," she said. "We didn't know there were this many Cambodian people living in Maine."

Creating the Cambodian Community Association of Maine has also given Chan the opportunity to preserve and pass along the culture and traditions her father passed on to her.

"In time, as we grew and got older, I learned to really appreciate what my dad did," Chan said. "If he didn't do what he did when I was little, I wouldn't be the person I am now. I wouldn't know any part of our traditions. A lot of the second generation who were born here, don't know the Cambodian traditions or the Chinese traditions. I was very fortunate that my dad made sure that he drilled and drilled me with this, so I can teach it and pass it on to my siblings and to my kids."

Chan works hard to help her family find a balance between their Cambodian and American identities. "I would bring my kids every year to the temple for Cambodian New Year," she said. She even taught her son the proper way to put

rice in the monks' bowl. "He would know not to eat until the monk's blessing. He would know to set up the table for the monks to give them the food properly," she explained. Chan taught her children about Cambodian ceremonies and how to give flowers and food to their ancestors.

"Everything symbolizes something, and you can't get it wrong because it's like a little bad karma coming in."

"Everything symbolizes something, and you can't get it wrong because it's like a little bad karma coming in," she said.

While it is important that her children understand their Cambodian heritage, she also wants to make sure her kids enjoy their childhood and hang out with friends.

"I would never want to keep those experiences from my children, because these are life lessons that they need to learn."

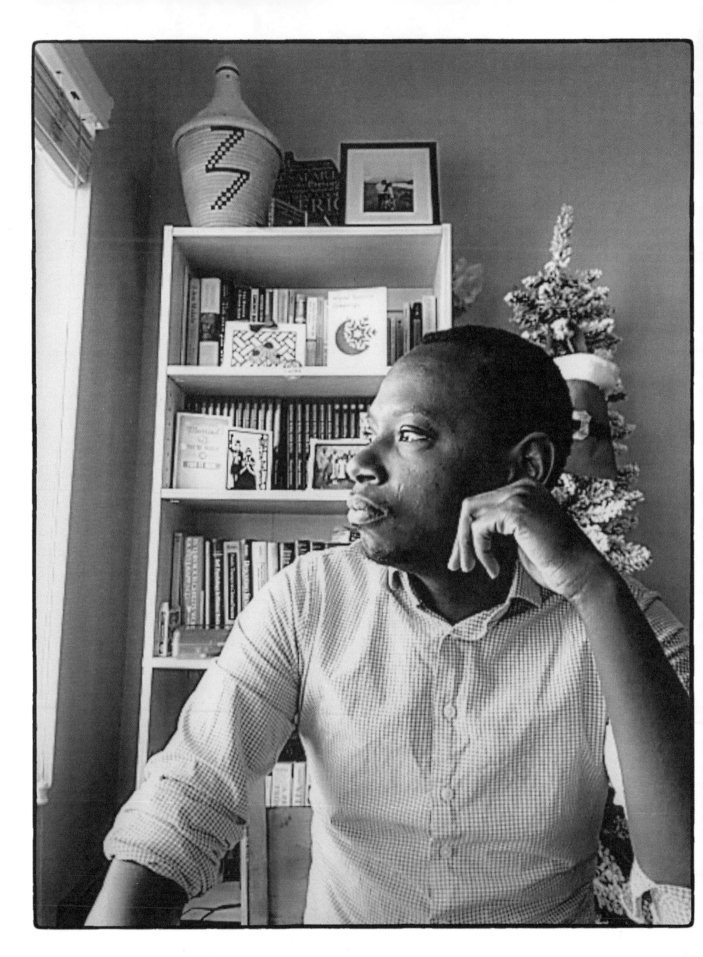

Prosper Ishimwe

Rwanda
Population:
12.95 million
Distance from Maine:
6,762 miles

Under the cover of darkness, young Prosper Ishimwe, his cousin Kennedy, and an older man slipped across Lake Mugesera in a wooden canoe to reach his grandfather's village.

And, they hoped, safety.

Prosper had been on the run since Rwandan Patriotic Front (RPF) soldiers attacked his village and massacred many of the villagers. Only days later, he was forced to flee another massacre. In Rwanda in 1994, such killings came in waves, as soldiers marched through the countryside, indiscriminately killing villagers and people who crossed their path.

In all the confusion of the second attack, Prosper became separated from his immediate family, but found his way to this village—his grandfather's—to rest. That rest didn't last long. Soon the relentless soldiers swarmed again. This time, they captured Prosper at his grandfather's house. They forced him, his grandfather, and a three-year-old cousin to the ground outside. As the soldiers watched his grandfather lying there helpless on his belly, they shot him.

Knowing he was next, Prosper jumped up and ran away, zigzagging to avoid the gunshots. As he ran, he could hear his little cousin crying. And then he couldn't.

They shot her too.

Prosper fled into the bushes and didn't venture out until the sun rose over the bombed-out village. He found the landscape "silent as a tomb" as he walked alone among the bodies. He was eight years old. He knew somewhere out there in the Rwandan countryside, either hiding or dead, were his mother, father, and the rest of his family.

The scope of the violence that devastated Prosper's homeland is stunning.

What he didn't know is that it would take years before he would learn all of their fates. He would spend even longer trying to reconcile what had happened in Rwanda and, he said, "to understand what happened to me, what I went through, why my mom died . . . why hundreds of thousands of people died."

The scope of the violence that devastated Prosper's homeland is stunning. By some estimates, nearly 70 percent—800,000 ethnic Tutsis—were killed in the 1994 genocide. The violence that erupted from both the Rwandan civil war and the Rwandan genocide, along with Prosper's personal experience with the RPF, prompted him to seek asylum in the United States in 2014. He wanted to find safety, a better education, and the freedom to tell the stories he felt must be told in order for his country, and himself, to heal.

Now in his early thirties, Prosper has begun telling those stories. His book, *Neither Tutsi, nor Hutu—A Rwandan Memoir*, explores his experiences with the genocide, its aftermath, and the toll it took on his family.

Childhood in Rwanda

Prosper Ishimwe was born on March 19, 1986, in Karembo, a tiny town in the parish of Zaza in Rwanda, a small African nation bordering the Democratic Republic of Congo, Burundi, and Tanzania. The parish of Zaza is in the southeastern part of Rwanda, near Tanzania. Like Maine, Rwanda is green and filled with farmland, rolling green hills, sparkling blue lakes, and forests. But instead of pine trees, the Rwandan countryside is dotted with mango, papaya, guava, and avocado trees.

Prosper's mother and father were born in southeastern Rwanda. Both were elementary school teachers in Karembo. Rwanda's school system is similar to the French model, with primary years from kindergarten to sixth grade, followed by another six years of secondary schooling. Like many Rwandan farmers, Prosper's family grew most of the food they needed to survive, including bananas, peanuts, beans, corn, soybeans, papaya, sorghum, and avocados. As a child, Prosper liked to sneak into the "banana room," where the family hung bananas to ripen.

"Every time we came home from school, we rushed to the banana room to see if there were any ripe bananas," said Prosper. "I remember that my mom

would always make sure that we didn't eat bananas before lunch because it would ruin the appetite."

His family also raised cows, goats, rabbits, and chickens for dairy and meat. They rarely purchased processed or packaged foods. "We didn't go shopping for food. Not really," Prosper said. "The only grocery shopping would be for beef once in a while, or fish, or salt and sugar."

When Prosper turned six, he started attending a local school several miles from his home. His walk took him over a long dirt road that became slippery during the rainy season. He and his friends often played soccer while walking to school or stopped to pick papayas and bananas off roadside trees to save as snacks to eat later.

His school was Catholic, and strict. Belgium controlled Rwanda from 1916 to 1962, and the remaining colonialism left a strong Francophone and Catholic mark on the country. Most Rwandans spoke French and practiced Catholicism. "You couldn't talk during class unless the teacher asked you to respond to a question," Prosper said.

Recess was a quick fifteen-minute break between classes. Every morning before class, the students lined up for inspection to see if they were practicing proper hygiene. Prosper's parents worked at his school; he even had his mom as a teacher in 1994.

"She was very strict, and being in her class . . . there were a lot of expectations," he said. "I had to behave. I had to be a role model. I had to work very hard to make sure I was living up to her expectations. Education is very important in my family."

Even when he was not actually in his mother's classroom, she kept an eye on him. The other teachers reported back to her on how he was doing in class.

As teachers, his parents earned enough money to hire people to work on the family farm. Still, Prosper and his brothers and sisters helped out during the harvest of the beans, peanuts, corn, and sorghum. The family hired a cowboy to take care of the livestock.

Prosper's paternal grandfather instructed that upon his death he wanted his land divided among his sons. This side of Prosper's family still lived in Karembo. His grandmother lived only a few feet away from Prosper in a house his father had built for her. His uncles also stayed close, including Prosper's youngest uncle, also his godfather, who lived just over the hill.

Prosper recalls his early childhood fondly, but soon the conflict brewing between the Hutus and Tutsis, two of the country's ethnic groups, exploded into one of the worst atrocities of the twentieth century. The resulting Rwandan genocide killed hundreds of thousands of Rwandans and forced Prosper and his family to flee their native country.

According to Prosper, the Belgian government, during its nearly fifty-year rule, fostered division and disagreements between Hutus and Tutsis to keep them from joining forces to oppose its control. Belgium backed the Tutsi monarchy, leading to widespread resentment toward the Tutsist government.

When Rwanda achieved independence in 1962, the Hutus and the Tutsis battled for control. The RPF, which opposed the Hutu-dominated Rwandan government, was made up of Tutsi refugees who had fled persecution to neighboring countries during previous conflicts.

> Prosper was eight years old. He heard gunshots in the distance, and the RPF bombs were so loud they seemed to be exploding all around him.

In the 1990s, the RPF invaded Rwanda, triggering a civil war that lasted about four years before ending in a cease-fire that left the northern part of the country under RPF control. In early April 1994, Hutu extremists—made up of soldiers, police, militias, and civilians—began to massacre Tutsis, along with some Hutu moderates, in an attempt to ethnically cleanse Rwanda of all Tutsis, and anyone else who stood in their way.

The RPF moved in from Uganda, a bordering country in the north, to end the genocide by fighting the government and the forces behind it. However, while the RPF managed to end the genocide and restore order, some of its soldiers also committed atrocities in the process. RPF soldiers did the same thing when they later invaded the Congo.

In 1994 alone, roughly 800,000 Tutsis, about 70 percent of their population, were killed. After the RPF took control, nearly two million Hutus were displaced, becoming refugees. Many, like Prosper's parents and relatives, left for neighboring countries.

The Violence Hits Home

When RPF soldiers marched on his home village in 1994, Prosper was eight years old. He heard gunshots in the distance, and the RPF bombs were so loud they seemed to be exploding all around him. When his family realized serious danger was on their doorstep, they fled their homes, escaping to a hillside called Kanzai, about twenty kilometers away.

"We just ran in the opposite direction from where gunfire could be heard," Prosper said. "We did not really have any reliable information."

They had little time to gather any of their belongings, just some clothing and a few bits of food. "It was putting on as many layers of clothes as we could," he said. "That's it."

After reaching Kanzai, they settled in a camp for internally displaced people (IDPs)—those who have not crossed a border to seek safety, but are doing so in their home country instead. Prosper's family built a makeshift shelter with eucalyptus trees and leaves to keep them warm and dry at night.

But the twenty kilometers they had traveled could not provide protection for long.

After sunrise, the RPF attacked the Kanzai camp. Soldiers walked through the camp, firing their weapons as they walked, killing people indiscriminately.

Prosper ran in one direction with his cousin. His parents ran in another with his younger brother. He would never see his mother again.

Although Prosper's family had sheltered together, they were scattered when the soldiers overran the camp. His parents were nearby, making porridge for breakfast. His older sister and younger brother were visiting a friend's shelter nearby. His younger sister was with his uncle. And Prosper was with Kennedy, a cousin his age.

When the shooting started, chaos and confusion reigned. Fearing for their lives, the family fled the massacre and became separated. Prosper ran in one direction with his cousin. His parents ran in another with his younger brother.

He would never see his mother again.

Prosper eventually found a neighbor who agreed to take him to his grandfather's place on the far side of Lake Mugesera, a body of water in southern Rwanda close to Burundi. He and Kennedy reached the near side of the lake during the day, but it was not safe to cross the lake with RPF forces roaming nearby. They hid with a man who lived on the edge of the lake, and he agreed to take them across once it was safe. Later, under the cover of darkness, the three paddled across Lake Mugesera in a wooden canoe.

For a few days Prosper found respite with his grandfather. When one of his aunts arrived in the village, she took Kennedy to find her children.

The RPF continued to march across the countryside, and soon closed in again. When they struck the village, the soldiers killed almost every villager, including Prosper's grandfather and a three-year-old cousin.

Although he was initially captured, Prosper escaped and spent days hiding in the papyrus marshes until his sister and aunt came for him. Kennedy's mother had left Rwanda's capital Kigali to look for her daughter, who had been killed in the chaos. She took Prosper, his sister, and one of his younger brothers home with her.

Prosper would not learn what had happened to the rest of his family until much later.

The Immediate Aftermath

The unrelenting violence had caught Prosper and his family off guard. They did not define themselves by their ethnicity and they were not involved in the growing conflict between the Hutus and Tutsis.

"I didn't understand what was going on. I didn't know my ethnic background," Prosper said. "My family used to be Tutsis during the monarchy,

and after that, when the monarchy was abolished and Tutsis started to be persecuted, some people changed their identities," he explained. "So every time they did a census, they changed their identity."

Prosper's older sister and one of his brothers stayed in Rwanda and were arrested. They lied to protect themselves.

"They lied that they were related to some well-known Tutsis in the area," Prosper said. "They were found by the RPF where they hid."

Since the RPF were carrying out reprisal killings against Hutus, his younger sister and uncle fled from an IDP camp to Tanzania, where they remained in a refugee camp until after the conflict.

Prosper's parents and then-youngest brother ended up in a refugee camp in the Democratic Republic of the Congo, known at the time as Zaire. While there, Prosper's parents found their daughter in Tanzania through refugee services, and she flew to reunite with them. His mother gave birth to another child, Prosper's youngest sister, at the camp.

Still, there was no safety in the Congo camp for Prosper's family.

In 1996, RPF leader Paul Kagame and his forces invaded Congo to oust the Hutu extremists controlling the camps. The RPF bombed and shot up the refugee camp where Prosper's parents and siblings were living. During the chaos, his mother and baby sister were separated from the rest of the family. That was the last time anyone reported seeing them. Both are still missing and presumed dead. His father, sister, and brother "ended up wandering in the Congolese natural rainforest, trying to survive" by digging taro, a starchy root vegetable. In 1997, the three finally made their way back to Rwanda.

Prosper finally reunited with his father four years after the genocide. Back in Rwanda, their old house had been looted and was occupied by strangers. Almost all of their personal possessions and photos from before the genocide were gone. And his mother's disappearance hung over them.

"The last time I saw my mom was on that hill where we camped and where our IDP camp was attacked—Kanzai Hill," Prosper said. "That was the last time I saw her."

An Education in Rwanda

As the remnants of his family began to rebuild and start anew, life for Prosper became somewhat normal, or at least more routine. After finishing primary school in 1999 and doing well in his final exams, Prosper attended Petit Séminaire St. Kizito de Zaza, an all-boys boarding school about three kilometers from where he lived. Secondary, or high school, education in Rwanda is not free as public schools are in America. It is also expensive and difficult to get into college. Luckily, Prosper received a government scholarship.

After secondary school, Prosper attended the Kigali Institute of Education (now the University of Rwanda College of Education) from 2007 to 2010, where he majored in education and English.

Prosper did not choose this school; his test scores placed him there. In Rwanda, test scores from a graduating student's final exams of secondary school determine whether, and where, they attend college. Prosper actually wanted to study translation and interpreting.

"College was tough," he said. "People went hungry. You couldn't afford a pair of shoes. So you really had to work."

In 2009, while Prosper was in college, the Rwandan government began to emphasize teaching English and made it one of the country's official languages. As a result, the language of Rwandan education changed from French to English almost overnight. This created an opportunity for Prosper, who was studying English, to become a teacher and a translator. Teachers were fired if they could not teach in English. "There was a market for people who were learning English in college," Prosper said.

He attended college during the day and taught English classes to teachers and business people in the evening. He also taught English to students from Francophone countries at one of the top private schools in the capital. While Prosper's scholarship helped him attend college, it did not give him enough money to eat or a good place to stay. He worked a lot to make ends meet.

"College was tough," he said. "People went hungry. You couldn't afford a pair of shoes. So you really had to work. I was fortunate to be able to get these part-time jobs, temporary jobs."

After graduating from college, Prosper worked as a translator and interpreter for different nongovernmental organizations in Kigali. He also worked on some US Agency for International Development (USAID) projects as a translator, interpreter, and researcher, and for the Peace Corps as a language and cross-cultural facilitator. Working with Americans and foreigners helped Prosper improve his English and exposed him to a wider world.

Prosper later worked for Never Again Rwanda, an organization dedicated to fostering peace in the country, and for the Thought Field Therapy Foundation, an organization treating Rwandans suffering from post-genocide trauma. He also translated a documentary called *From Trauma to Peace* that shares the stories of genocide survivors who healed from trauma. While working with Never Again Rwanda, Prosper became frustrated with the Rwandan government, which controlled all information about the genocide, even the organization he was working for.

"Everyone is being watched," he said. "It's a very small country. We could not speak the truth about what happened in the liberation war."

He added: "Everyone had to agree with the official narrative of the story . . . I was so disappointed and terrified. I didn't know what to do because I

had lived this history. I was eight years old when the genocide and war happened. I was there. I had witnessed the genocide and the war. I knew what happened. Somehow people were not distorting the history, but were telling just part of the story."

According to Prosper, the government was omitting the violent reprisals committed by the RPF and their leader, Paul Kagame, the current president of Rwanda.

"I was convinced this would not work," said Prosper.

But it was too dangerous for him to speak out. During this period, Paul Kagame was consolidating his power and exerting control over the Rwandan government. His government imprisoned critics, including genocide survivors and even a famous Rwandan musician, Kizito Mihigo. Prosper did not feel safe.

"Everyone who was trying to challenge the official narrative of the genocide was being arrested and accused of having a genocide ideology, even the genocide survivors," he said.

The repression made it even more difficult for Prosper to come to terms with his own losses, including witnessing the murder of his grandfather and young cousin.

"I was with them. I could not say this," he said. "I could not heal."

Asylum in America

In 2014, Prosper decided to seek asylum in America to try to heal and share his story. He had visited Hawaii once for trauma relief training and decided he wanted to live there. He did not stay long because the sister of a former Peace Corps colleague invited him to live with her in Maine. She agreed to host him while he waited for his work authorization and Social Security card.

> "I see being an American as the start of being a global citizen. Focusing on just Rwanda would be very narrow for me."

Later that year, Prosper applied to the University of Maine at Orono and received the Thurgood Marshall Scholarship to pursue a master's degree in global policy. To understand why his mother and hundreds of thousands of people died, he felt he needed to understand the events from a global perspective—why the international community did not stop the genocide or protect refugees.

"I'm very interested in how countries work together on international issues, because it's going to take everyone working together . . . We are, more than ever, interconnected."

He now considers himself a global citizen.

"I see being an American as the start of being a global citizen. Focusing on just Rwanda would be very narrow for me. I feel like the whole world is my motherland."

While attending the University of Maine, Prosper spoke to Maine high school and college students about his life. After graduating in 2017, he planned to write his story, but he needed to earn some money, so he worked in Boston mentoring children, and later, at a factory in Lewiston. Ultimately, he moved west where he lived with friends and was able to write, a process that helped his personal healing and growth. His memoir, *Neither Tutsi, nor Hutu—A Rwandan Memoir: My Search for Healing, Meaning, and Identity after Witnessing Genocide and Surviving Civil War*, was published in 2020.

"I had wanted to write this book since I was really little because my experiences in the genocide and the war were not talked about in the genocide narrative in Rwanda," he said. "I felt like most of the narrative was all black and white . . . too simplistic . . . and I realized my experiences were not reflected in that narrative."

Twenty-three years after the genocide, Prosper feels that he has healed enough to share his experiences in an objective and reconciliatory tone.

"I was at a point in regards to my Rwanda experiences," he said, "where I felt I had healed enough to do justice to the experiences I had lived in, because I didn't want to write a story that just blamed the other side, that demonized people. I felt like I was in a place where I could actually be objective and be nonjudgmental and tell a story that has the potential to unify people, instead of reminiscing about how bad a group of people has been and all those things."

Reconnecting with Family

Prosper has also reconnected with part of his family. His aunt, his mother's sole surviving sister, recently resettled in Denver with her husband after spending two decades in a refugee camp.

"She is the only aunt that I actually have left," Prosper said. "I haven't seen her since 1994. So that has been really interesting, because now I have a biological mother figure. In the African context, your sister's kids are your kids. Period."

Without his mother and sister, and the slim possibility that he will ever see his father and other siblings again, reconnecting with a blood relative has been restorative for Prosper.

"That was a part of my life that I was able to reconnect with," he said. "I don't really have any person here in the United States who knew me before 1994. So it was really nice to reunite with my aunt."

It has also helped connect his two worlds. In a larger sense, Prosper hopes he can help heal divisions to bring people, and countries, together.

"I still have a lot of affection for Africa, but at the same time, I feel indebted to America for hosting me and for giving me so much," he said. "So, I see myself as a bridge."

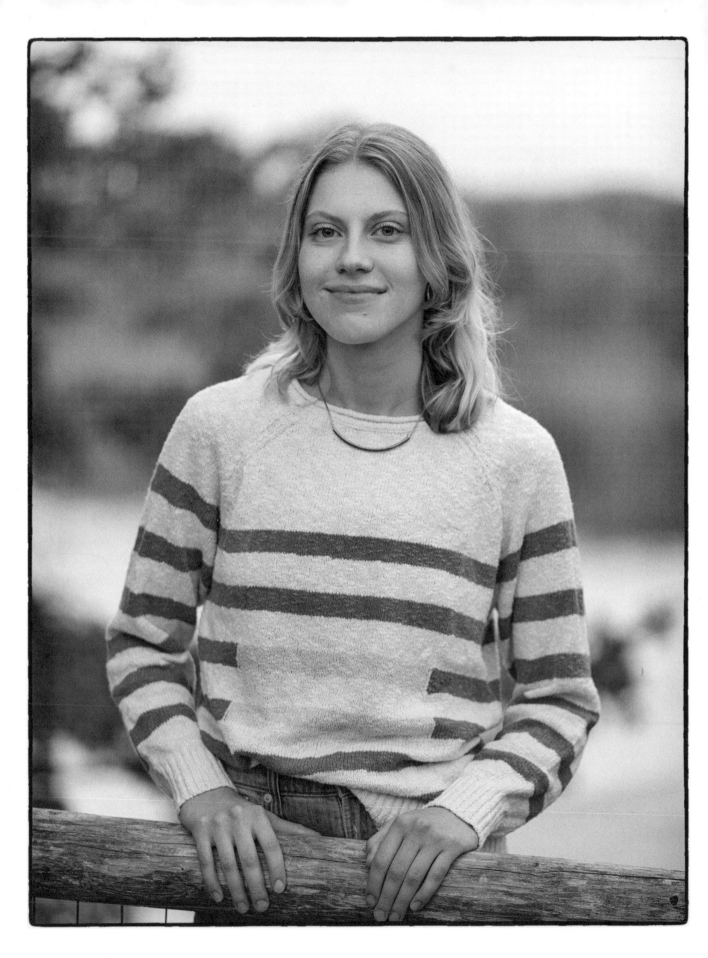

Masha Kolovskaya

Russia
Population:
144.1 million
Distance from Maine:
5,050 miles

Masha Kolovskaya came to America in 2007 as a nine-year-old girl. Her flight from Russia landed at New York's John F. Kennedy International Airport, and the young girl fell asleep while the car she was riding in worked its way through New England toward Maine. When she woke, darkness had settled. As the former city girl stared out the car window, she still remembers thinking how nice the Maine countryside seemed, that it "felt safer, more quiet, more peaceful" than the large city of St. Petersburg, where she had lived in Russia.

The countryside may have been pleasant, but during the days ahead, she would learn that life in America was not what she had expected. As with many young immigrants, everything she knew about her new country she had learned from Hollywood movies. The movies and shows that Masha watched were aimed at teens, and they painted a narrow picture.

"I watched a lot of movies that were made in America," she said, "so I thought it was going to be like Hilary Duff or something." She expected Americans to drive convertibles and speak like Valley girls. She watched Disney Channel movies like *High School Musical* and shows on the Nickelodeon network, so she thought "high schools are not strict at all, and you can do anything you want—everyone hangs out at the mall."

No one in Westbrook broke out into song and dance in the hallways. Convertibles were rare, and few people sported the latest fashion trends.

"I expected Americans to be really cool people—like really cool people—but then I came here, and two days later, I was in a gas station and I saw a woman with a tank top and some tattoos . . . that was not what I pictured," Masha said, laughing and shaking her head. In St. Petersburg, that would be too casual of an outfit to wear in public, Masha explained.

Non-movie real life was jarring as she tried to learn a new language, adapt to a new culture, and make new friends.

The Soviet Union

Masha's mother, Maya, was born in the southwestern Russian city of Samara in 1972, the same year her father was born one thousand miles away on the Baltic Sea in St. Petersburg. Once known as Leningrad, St. Petersburg is the second-largest city in Russia, with a population of nearly 5.5 million people. Masha's parents met while they were attending a music college in St. Petersburg. Her mother later became a saleswoman, while her father remained in music, playing tuba in the Russian rock band, Auction.

When her parents were born in communist Russia, it was the dominant political, cultural, and economic force in the former Soviet Union, which geographically spanned parts of Eastern Europe and Asia. The Soviet Union was also one of the most powerful military forces on the planet, one of the world's two superpowers. It stood in opposition to America and the West while essentially operating as a closed society behind what Winston Churchill had dubbed "the Iron Curtain."

The Soviet Union was formed in 1922 by Vladimir Lenin, and for more than twenty years was led by brutal dictator Joseph Stalin. During World War II, the Soviets sided with the Allied Forces against Hitler's Nazi Germany, suffering more than twenty-five million civilian and military deaths in the process.

After the war, the Soviet Union rose to superpower status, staying at that pinnacle for more than forty years until, for a myriad of reasons, it crumbled and collapsed in 1991. The former Soviet republics, including Russia, became independent states.

Non-movie real life was jarring as she tried to learn a new language, adapt to a new culture, and make new friends.

Samara

Masha Kolovskaya was born in Russia on May 26, 1998, about nine years after the fall of the Berlin Wall. She grew up in the center of St. Petersburg, where the River Neva meets the Baltic Sea, and lived there until moving to America, except for the one year that she and her mother spent in Samara with her grandmother. Once a closed city with strict travel restrictions, Samara sits at the confluence of the Volga and Samara rivers, and has a population of just over one million people. Masha and her mother sought respite there from the pollution in St. Petersburg, which was creating health issues for young Masha.

"I would get sick very easily as a kid due to some underdeveloped lungs, so the city air would just aggravate that," she said.

During her year in Samara, Masha would have attended first grade, but instead of going to the local school, her mother, who still wanted to make sure she received some education, took her to art and dance classes. Masha also took a martial arts class with a strict instructor who hit students with a stick and forced them to do pushups.

Art and culture were always important to her mother, who took Masha to Russian ballets, operas, museums, and art exhibits.

Once back in St. Petersburg, Masha attended a French school where instructors taught in French and Russian, but she said the teachers were mean and had high expectations for the young students.

Art and culture were always important to her mother, who took Masha to Russian ballets, operas, museums, and art exhibits. The Hermitage, St. Petersburg's famous art museum, was Masha's favorite place. "All of the furniture exhibits from the seventeenth century and Peter the Great's furniture . . . made me want to become a decor designer, but then I grew up," she joked.

Seeking New Opportunities

After her parents divorced, Masha's mother met an American man from Westbrook, Maine, when he visited Russia in the early 2000s.

"They then had a long-distance relationship," Masha said. "He visited multiple times over the next few years."

In 2007, Maya decided to take Masha and move to Westbrook, removing the term "long-distance" from her relationship. Masha was nine years old, and her mother felt America could give her daughter a better education.

"My mom thought the move was a good idea because I could get more opportunities that she didn't have growing up," Masha said.

Masha started at Congin Elementary School in Westbrook as a third-grader. While some subjects came easy—"Math was a breeze"—learning English was difficult. At Congin, Masha was part of the first group of students in the growing English Language Learner (ELL) program. It was hard to find a connection there, Masha remembers. "There were no Russian kids."

The language barrier made elementary school difficult; Masha was not able to communicate and make friends. However, she remembers a kind teacher named Ms. Anderson, who helped her out.

Outside of the classroom, Masha learned English by watching television shows like *The Simpsons* and *Everybody Loves Raymond*. They helped, but Homer Simpson and Ray Romano also added some unique words to her vocabulary.

"My first sentence, this is what my parents told me, is that on Christmas, in front of my grandparents and uncles, I stood up and said: 'I got to go hit the crapper.'"

Even as communication became easier, understanding the idiosyncrasies of American cultural habits and norms sometimes confused Masha.

By the time she entered Westbrook Middle School, Masha had become more fluent in English, which helped her social life dramatically. "I started making friends." Masha said. "People now would talk to me and say they knew me when I was in the third or fourth grade, but that they couldn't understand what I was saying at all."

Even as communication became easier, understanding the idiosyncrasies of American cultural habits and norms sometimes confused Masha.

"The first time I went on a walk with my father, someone went 'Oh, hello!' and my dad said 'Hello' and then they walked by and I was like, 'Do you know her?' and he said 'No,' and I was like, 'Then why did you talk to a strange woman?'" In Russia, she said, "Usually you don't even look at the other person. You might get a weird look in return."

Masha still finds small talk funny because it does not seem to be real or meaningful conversation.

"Russians don't do small talk. We just get straight to business."

While the transition from Russia to America was a struggle for Masha, she believes the culture shock was even more challenging for her mother.

"It was definitely a lot harder on her than it was on me, because I was young," Masha said. Her mother still has a very strong accent today and has trouble making jokes with people, according to Masha, because Russians have a different sense of humor than Americans.

Maya also missed Russian culture. She was used to talking about Russian plays, operas, and literature, and she missed that in Maine.

"She goes to the Merrill Auditorium for any show they have," Masha said, explaining how her mother buys season passes because she loves classical music and opera. "When I moved here, my mom always thought Americans were not as cultured," Masha said, "because no one talks about the latest opera or some book she read, like *War and Peace*."

Maya wanted to become a nurse and attended classes at Southern Maine Community College and the University of Southern Maine after coming to America.

"My mother enrolled in nursing school, which was very admirable, because although she knew English before, nursing school, even for fluent speakers, is challenging. She later worked in a hospital setting, but felt like her nursing skills were often overlooked due to her accent. She had some great co-workers, but there were instances where she felt alienated," Masha said. "She really missed her friends

and family, as she spent a lot of time with them previously, and even considered moving back someday. But now she has built a relationship with Maine where she enjoys a peaceful life and has created relationships with her patients. She is now a travel nurse."

> ## "I think I have done a lot better in America than I would have done in Russia," she said. "The path to success is a little less complicated."

Her stepfather, Bill Girard, was a science teacher and is now retired. He attended Colby College, earned a master's at the University of Washington, and taught at colleges in the Boston area before returning to teach in Westbrook, his hometown.

Westbrook High School

Masha was active at Westbrook High School, serving as vice president of her class twice, graduating with a 99.7 GPA, and participating in numerous extracurricular activities, which she believes helped her better integrate in her new hometown. She was on the swim team for four years, played tennis for four years, including as team captain her senior year, played saxophone in the marching band, and was a member of the Key Club. She was also a member of the Civil Rights Club, including serving as its leader during her senior year. As a member of that club, Masha relied on her own experiences to break down stereotypes and create a safe environment for the increasingly diverse student population in Westbrook.

"I want people to know that it is really, really hard to transition from one country to another," she said. She emphasizes the importance of giving people a second chance and being friendly to those who are new to this country, who may not speak the language and could be struggling to connect and make friends. Masha said the Civil Rights Club helped her unite classmates of all backgrounds and create a friendlier school environment.

Masha graduated from Westbrook High School in 2017 and from Simmons College in 2021 with cum laude honors and a bachelor's degree in biochemistry. She is exploring graduate school, hoping to either become a physician's assistant or enter the laboratory research field.

It's been nearly fifteen years since Masha first landed in America, not knowing how to speak English. She retains her Russian citizenship and misses her native country, but she also loves being an American and is proud of being a dual citizen.

"I think I have done a lot better in America than I would have done in Russia," she said. "The path to success is a little less complicated. America has a lot of opportunities compared to Russia, where there are limited choices on what you can do, so it can get competitive. I am not sure if I could take the same career path in Russia as I am now."

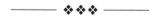

Kerem Durdag

Pakistan | Turkey
Pakistan Population:
220.9 million
Pakistan Distance
from Maine:
6,602 miles

Turkey Population:
84.34 million
Turkey Distance
from Maine:
4,977 miles

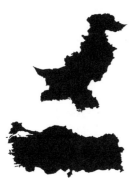

Growing up in the coastal Pakistan city of Karachi, Kerem Durdag says he lived a somewhat charmed young life filled with sports, beaches, and fun. As he grew older, he became more aware of the country's difficult history, the suppression of civil liberties, the violence, and the dictators. As a teenager, he began looking beyond the borders of his parents' adopted country. Filled with ambition and infectious energy, he felt staying would be self-limiting. He searched for a place where he could find a better education and enjoy more freedom. He looked to the West.

His father, who wanted him to attend a university in Turkey or Pakistan, both of which offer free tuition, was against the move, and refused to help his teenage son. Kerem scrambled on his own to apply for college, find the money and scholarships to pay for it, and obtain a student visa to make it all possible.

At just seventeen years old, against his father's wishes, he tucked a couple hundred bucks in his pocket, bought a one-way ticket out of Pakistan, and headed to America. He chased the same Hollywood-tinged dream that many other teenage boys living in small towns and big cities across America pursue: "Get educated, be with girls, listen to rock 'n' roll, and have lots of fun!"

Kerem recalled: "The United States was a universe that I knew from the news, TV shows, comic books, and what previous students had said.

It was gloriously warped. But, for me, it was a manifestation of distinct destiny and the culmination of getting away as an expression of personal freedom."

Of course, sometimes reality proves more difficult than a dream. Over the next few years, Kerem grew up quickly as he struggled with the emotions of losing his father, being wounded by the sting of racism, and battling a near penniless lifestyle as he adjusted to a new culture. He also obtained a great education, fell in love, began a flourishing career as an engineer and investor, and found peace among the pines and salt air of Maine. Through it all, he pushed onward with the same infectious energy, enthusiasm, and personal charisma that propelled him onto a plane out of Pakistan and into a new life.

Pakistan

Kerem's homeland of Pakistan is located in South Asia and is bordered by Iran, Afghanistan, China, and India along three sides. The Arabian Sea forms the country's southern border. With a population of more than 220 million people, it is the world's fifth-most-populous country and has the world's second-largest Muslim population.

The land that makes up Pakistan was part of many empires over the centuries, but most recently it operated under British colonial rule as part of British India. In 1947, Pakistan was carved out of India to create a new Muslim country. As a result of this partitioning, millions of Muslims migrated from India to Pakistan, while millions of Hindus and Sikhs migrated in the opposite direction, combining to create the largest mass migration in world history. The partitioning also sparked extreme violence that led to tens of thousands of deaths and ongoing tensions that would erupt into outright war four times. Following a civil war in the early 1970s, the region of East Pakistan, originally one of two Pakistani regions, was granted independence and became Bangladesh.

When Kerem was young, he lived under one of the country's most notorious leaders, General Muhammad Zia-ul-Haq.

For most of its relatively young life, Pakistan has struggled to find political stability and was frequently ruled by military generals. When Kerem was young, he lived under one of the country's most notorious leaders, General Muhammad Zia-ul-Haq. He seized power in a mid-1970s coup, instituted martial law, curbed civil liberties, enacted strict censorship on the press, and executed a popular former president. During his rule, Pakistan also saw a mass influx of refugees across its borders when people fled Afghanistan following an invasion by the former Soviet Union.

Double Roots

Kerem's father, a Turkish national who worked as an architect and civil engineer, was in Libya

when he responded to an advertisement from the government of Pakistan seeking engineers to help build the country's infrastructure. Still young and single, he headed to Pakistan.

"He was a free spirit. An adventurer," Kerem said. "Went to his own clock."

After a few months his father returned to his native Turkey to ask his girlfriend, an archaeologist, to join him in Karachi. The young couple had only known each other for a few months.

"My mother says, 'Well, I am not going anywhere with you until we get married, and for that to happen you must ask my father,'" Kerem said.

His father agreed. Once married, the newlyweds left for the coastal city of Karachi, located on the Arabian Sea. It is there, in Pakistan's largest city, that Kerem and his sister were born to Turkish parents living as expatriates in Karachi. Despite his Turkish lineage and deep ties to that country, Kerem said he always felt he "belonged" in Pakistan.

"I was born and raised in Pakistan. I was there. I was present," Kerem said. "There certainly was this constant thread that I physically looked different, but I wasn't an outsider necessarily because Turkey and Pakistan have some close cultural affections."

The Durdag family lived in an apartment complex in the city. Kerem either walked to school through the mass of people or jumped on crowded public transportation. In short, he lived as a true Karachiite.

"I am as much Pakistani as I am Turkish, and I adamantly refuse to make a distinction or choice," Kerem said.

Despite political oppression and the other issues that plagued Pakistan, Kerem recalls his childhood there in a way that seems almost magical. To start, he said he was lucky to win "the lottery of life" when he was accepted to and began attending the prestigious Karachi Grammar School. He made friends that remain like family today.

Kerem played cricket, field hockey, and soccer in the streets, on muddy fields, and at abandoned construction sites. He listened to music, went to the movies, and watched characters sing and dance to proclaim their love. He had crushes on many girls. He did the foolish things that young people do for no reason, like jumping from rooftops. He remembers drinking pure sweet sugarcane juice from street vendors and buying books from roadside booksellers.

And he keenly remembers long morning walks with his mother and sister.

"One summer, when I was eight or nine and my younger sister was still in a stroller, my mother took us for a long walk, from where we lived all the way to where you could see the ocean," Kerem said. "Along the way, there were jasmine trees. There were roadside vendors just starting to set up. The beggars were getting started. The city was waking up to another day. It was always sunny. Always."

Years later, Kerem realized that his mother wanted her children to feel the pulse of the overcrowded city just as it was being born anew. "We did this every

day," he said. "I will never forget it. To this day, I can still feel the warm sun on my shoulders."

Kerem spent his summer vacations in Turkey, either in his mother's ancestral town by the Turkey–Iraq border, or in his father's village near the coast of the Aegean Sea. Kerem also remembers those vacations as fairly idyllic.

"The kebabs are made on charcoals. The long dinners. Playing around the ruins from three thousand years ago," he said. "Being with my cousins and running around Ottoman mosques and bazaars. Arguing about politics and justice. Talking with our hands. Listening, singing, and crying to torch ballads by Zeki Müren that tend to bring the heavens down."

While Kerem certainly recalls growing up in lyrical terms, by 1988 he was looking for change. He was seventeen years old and ready to leave Pakistan, yearning for more freedom and better educational opportunities. His father urged him to go to Turkey, but Kerem wasn't interested. Instead, based on his good grades, he devised a more ambitious plan that focused on the United States or the United Kingdom.

He knew getting a student visa would be hard and that his current family situation made it even harder. His father didn't approve of Kerem's decision to study in the United States, and he would not readily fill out necessary forms for his young son. Additionally, his father made it clear he would not provide Kerem with financial support if he moved to America. As a result, Kerem needed a good scholarship and a college job to cover all the costs by himself.

Kerem was a driven young man and did it all in relatively short order. He was accepted to Saint John's University, a small liberal arts school of about 1,600 students located northwest of Minneapolis, Minnesota, where he would study science, philosophy, and theater. The school gave him a scholarship and expected him to work on campus as much as possible to cover additional expenses. When Kerem learned classes would begin that January, he headed to the US consulate in Karachi to apply for a student visa.

It was a frustrating experience. "You had to get to the consulate really early in the morning, wait for hours, and then go in and sit for hours," Kerem said. "Very Dante-like hell."

Kerem described the consulate building as a large facility with high electric steel barricades and fencing. Guards were everywhere. Long lines of visa applicants snaked through multiple checkpoints, and each person had to show application folders before they could advance to the next line. Before an applicant was allowed inside the actual building, documents were checked once again. When Kerem reached that point, he was told he needed his papers notarized before he could continue. Getting everything in order quickly was important—if you missed the daily cutoff time, you had to start at the beginning of the line again the next morning.

"So, I had to get out of line to find a notary," he said. "I ran and ran all around the consulate, asking everyone where to find a notary. Then this kind soul told me, 'My son, there is a man at the

end of the road over there and he is a notary.' I got the help and went back to stand in line," Kerem said. "It was insane. But I was not going to give up."

Once inside, he found himself in a brightly lit room where the interviewers sat behind a bulletproof window at least a foot above his eye level.

"The future is now. Your self is defined by what you see. The present is immense, and everything is possible."

"It is massively intimidating," Kerem said.

After his interview, he waited a few more hours until his number was finally called. He was given back his passport, stamped with a student visa.

"I was massively happy," Kerem said. "At seventeen and a half, the brain is not capable of being sad as you set out on this journey and leave your family behind. The future is now. Your self is defined by what you see. The present is immense, and everything is possible."

The North Star State

Kerem arrived at John F. Kennedy International Airport in New York on a snowy day wearing sneakers and a light jacket. Due to a mix-up, he had missed his flight to Minnesota, which actually departed from New Jersey. Thanks to an airline agent's kindness, he received a free night's stay at the Four Seasons, a five-star hotel in Manhattan. He spent the night watching *The Three Stooges* and eating the M&M's left in the hotel room for guests.

He then continued on his journey, eventually arriving at Saint John's University, a Catholic school run by Benedictine monks, which became a foundational element of Kerem's life. He was a young Muslim man of Turkish and Pakistani background who felt at home with the school's values of social justice, dignity of work, hospitality, and awareness of God. He also met a professor at the college, Rene McGraw, who became an influential mentor and a person Kerem continues to stay in touch with.

Kerem embraced campus life. He wrote for the university newspaper, edited an award-winning poetry journal, was elected to student government, and hosted a radio show. He also worked hard in the classroom and became the first international student to earn All College Honors.

Despite his success and his love for the university, college life was anything but idyllic. At times he was verbally and physically abused for being a Middle Eastern Muslim kid, he said. He saw xenophobia and suffered the sting of racism. Not to mention, he was trying to survive a near penniless existence.

"I used to eat ice-cream cones for lunch in the summer when I was working at the kids' camps

because I didn't have money to buy food," he said. "I had one pair of shoes, held together with duct tape. I wore those for three and a half years. At my graduation, I wore pants that were loaned to me by one of my friends."

Luckily the monks at the school were generous and supportive. They loaned him money to buy books and to cover room and board for three years. (Several years later, he paid back the loan, and then some.)

"I sobbed onto his shoulder inconsolably and he sobbed with me. So, I was surrounded by love and grace."

Meanwhile, even as a full-time student, he was working twenty to thirty hours a week at three to four jobs on campus, including cleaning toilets, housekeeping, tutoring, stacking books in libraries, and serving as a teaching assistant. Ultimately, with loans from the monks, academic scholarships, and pay from his grueling work schedule, Kerem successfully paid his way through college.

"I became an adult in Minnesota. I went through many rings of hell and found peace," he said. "I fell in unrequited love. Probably that's where I became a poet and playwright on my own terms and became a student of literature. There I found the articulation of my voice."

Near the end of his undergraduate life came one final, emotional blow—his father died. Kerem was heartbroken. He had not reconciled with his father nor spoken to him since leaving Pakistan when he was seventeen.

"The last time I spoke to him was at the Karachi airport when I was leaving for America and he said to me, 'May all your roads be open,'" Kerem recalled. "After I got the call about my father's death, I was afloat. I couldn't go home to bury him because I had no money, and I was in the middle of my senior year."

He was overcome by emotional currents and he sought the presence of love and grace. He went to the church on campus, famously designed by Marcel Breuer. It was the same church that he vacuumed and cleaned to earn money—a sacred spot to him in many ways. He sat in the church's back-row pew and cried.

A close friend, Luiz Moreira, came to sit with him. They both cried. The next day his mentor Rene McGraw saw him in a hallway and hugged him. "I sobbed onto his shoulder inconsolably and he sobbed with me. So, I was surrounded by love and grace."

After graduating in 1991, Kerem headed east for the University of New Hampshire. As a graduate student there he first heard the band Pearl Jam. The band was scheduled to play in Boston, so he and a few friends drove down to the concert. He lost his voice for days after screaming to the song "Alive." He still recalls the

emotional lyrics, with their reference to a father who was dying:

Son, she said
Have I got a little story for you
What you thought was your daddy
Was nothin' but a . . .
While you were sittin'
Home alone at age thirteen
Your real daddy was dyin',
Sorry you didn't see him,
But I'm glad we talked . . .
Oh, I, oh, I'm still alive
Hey, I, I, oh, I'm still alive
Hey, I, oh, I'm still alive
Hey . . . oh . . .

Finding Love

In 1992, Kerem met his wife, Mary, a native of South Portland and fellow graduate student. Their first meeting was not as promising as Kerem had hoped. A couple of his friends told him that a tall blonde who played volleyball had moved onto their dorm floor. He was sitting in the dorm's common area, watching *Star Trek*, when he saw the tall blonde, Mary, walking through the room.

"I saw her and fell in love right there," he said. "She had on a sweatshirt with a big blue 'W' written on it. I remember saying, 'I have a couple of friends who went to Wellesley College.' Fairly uninspiring. She smiled and walked right by."

Luckily, that was not his only chance to impress.

A few days later Kerem attended a group meeting to discuss xenophobia and the rights of international students. Ever the dynamic speaker, Kerem was especially vociferous during the discussion—impressive enough that Mary came over to talk to him after it ended.

"Later, we had tea together—a very Middle Eastern thing to do." Kerem said. "As we saw more of each other, we discovered we were each other's life partner."

They married four years later. But not everyone was happy.

"When my aunt heard that Mary was my fiancée, she was massively disappointed because she wanted to find a Turkish bride for me," Kerem said. "So, I kind of squashed that dream."

The couple's first apartment was in Rochester, New Hampshire. Kerem worked during the day and attended graduate school at night. Later he got a job as an engineer in an electronics manufacturing company, eventually becoming head of its engineering department. He was off and running.

In 2000, the couple moved to Maine to live closer to Mary's parents and Kerem took a job at STEAG Hamatech, a German-owned manufacturing company, where he rose to chief technical officer at the Saco division, until it shut down during the economic turmoil of the early 2000s.

Kerem then joined a friend's start-up company, BiODE, Inc., making electronic sensors, which the two of them built together before selling in

2007. As part of the deal, Kerem stayed with the purchasing company for three years. Later, he joined another start-up, which was also sold after six years.

Kerem spent a year as an entrepreneur in residence at the Maine Technology Institute and is now a member of the Maine Angels investment community. In 2017, he joined Great Works Internet (GWI), a Maine-based telecommunications company, where he still works as president and chief operating officer.

At Home in Maine

Although he considers Maine one of his homes, Kerem still sees nagging issues to address in the Pine Tree State. The "from away" mentality, for example.

"The entire concept of 'You are from away' is not only self-limiting, but a lazy excuse for not engaging in critical thinking," he said. "It leads to very xenophobic behavior. I have been called a 'wetback,' even though that was geographically misplaced, and 'camel-herder' and 'towel-head.'"

The issue became particularly acute in the aftermath of the 9/11 terrorist attacks on America, when Kerem became a target of racism. After some co-workers and neighbors called the FBI to report him as a terrorist, he was interviewed for six hours. It wasn't the first time. He had been targeted before, receiving hate mail in response to columns he wrote for the *Portland Press Herald*. While such incidents are difficult, and indicate there is still work to do in Maine, Kerem says that he has loved living in the state overall.

"It is one of my homes," he said. "There are physical roots. There are emotional tethers. There are spiritual and soul connections that are immensely personal. It is home because my wife and I made a choice to live here and determine the course of our family. Plain and simple. This is a place that is infused in my muscles."

He gets personal when listing his life events in Maine.

"I wouldn't have a life without my wife. With my son I've run some massively memorable races. With my oldest daughter, I have watched every single Marvel movie. With my youngest daughter we went to the FIFA Women's World Cup. We've hiked, swum in rivers, body-surfed in the ocean, had great ice cream for days on end . . . The list goes on and on," Kerem said.

Kerem, who said he gave up two countries to be with his wife, gets philosophical when discussing how Maine helped create him, and what he sees as his role in the greater world.

"I am surrounded by people who inordinately care for me, who love collaborating and partnering with me because we all share this vision of wanting to be part of the solution of progressing humanity forward. I am in a position of impacting and affecting change at this point of my life," Kerem said. "I want to leave a warm imprint on the Earth during my tour. I try to keep focused on meaning and grace and love. For me, the professional and personal being are one."

While Maine, his home for the past twenty years, has been good to him, Kerem has also

been good to the state, helping its economy for two decades.

In 2020, he established the Indus Fund, a micro-loan fund for Maine's immigrant-owned businesses. The fund is composed of investors with Port Credit Union as processor and underwriter, and it partners with institutions such as the Greater Portland Immigrant Welcome Center's Business Hub, among others. It operates a statewide mentor pool that is run by the State of Maine's Department of Economic and Community Development.

"I am driven by an innate desire to do good on a large scale—sometimes I humbly succeed, sometimes I fail . . . and that is okay."

"Our hope is that it will be a template for all. Even for the country," Kerem said. "We want to equalize the playing field and provide an entry doorway for immigrant businesses to participate in the financial structures we already have in this state."

Perhaps most importantly for him, the fund fits into his overall view of life and what drives him.

"I very much believe that it is our human and moral obligation to affect one life, which, in turn, impacts a universe," he said. "I am driven by an innate desire to do good on a large scale— sometimes I humbly succeed, sometimes I fail . . . and that is okay."

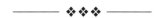

Natália Dyer

Brazil
Population:
212.6 million
Distance from Maine:
4,252 miles

Natália Dyer grew up in a culturally and culinarily diverse city. In Brazil, food and cooking were a central part of her young life, whether she was eating comfort food made by her grandmother and aunts, going to beach parties, eating snacks like *coxinha* (a small fried croquette of shredded chicken), or enjoying food at *lanchonetes*, places that sell breakfast, sandwiches, and lunch.

As she grew older, food became an even greater passion. As a student in São Paulo, she dropped out of law school in favor of culinary school with the dream of opening her own restaurant in Brazil, where she would be both chef and owner.

As often happens, life didn't go as planned. She took a detour to America to work as an au pair, learned to speak English, and fell in love before finally returning to her dream.

When she did, it was an American dream with her new husband, bringing authentic Brazilian food to eastern Maine and Greater Portland, first with Grillin' Brazilian, and now with Sampa Kitchen, a Brazilian steakhouse on wheels.

"In America, if you work hard and follow your dreams, slowly you get there," Natália said.

The Flavor of Brazil

Natália was born into a middle-class family in São Paulo, a city in the

southeastern region of Brazil with a population of more than twelve million people. The primary language spoken in the city, and Natália's native language, is Portuguese. Brazil became independent from Portugal in 1822.

Natália's mother was a social worker and her father worked in Brazil's civil service with the ministry of Justice and Public Security. Growing up as a Paulista, the nickname for people from São Paulo, Natália led the life of a middle-class Brazilian—attending private schools, seeing relatives in the countryside on holidays, and hitting the beach every weekend, where food trucks and shacks are popular. The trucks serve a variety of dishes including fried food, corn on the cob, Popsicles, and cheese on a stick called *queijo coalho*.

"You would sit in front of their trailer, and they would come and serve you. They would serve you beer or drinks or make fried fish or shrimp or french fries," Natália said. "Basically, we would go to the beach around nine in the morning and stay there until the sun went down."

On holidays, Natália would visit her father's family in the countryside where they enjoyed barbecue while lounging around the pool. Her grandmother and aunts cooked carb-heavy dishes like lasagna with a side of rice. She grew up eating a lot of rice and beans with a little bit of protein like a piece of chicken, beef, or sausage. This is a typical lunch for residents of São Paulo. In the afternoons, Natália would have a *cafezinho*, or "little coffee," with friends or relatives. In São Paulo culture, people like to take multiple daily coffee breaks consisting of a small cup of strong black coffee, a shot of sparkling water, and a cookie.

"It's a ritual. We love our coffee. It's so strong that basically you don't want to drink a full cup of that," Natália said. "In São Paulo we are pretty intense about it. We work all day. It's like New York life, just work, work, and work. So, every time you can take a break, you want to go get a little cup of *cafezinho*." She then jokingly added, "We don't have Keurig machines."

"We love our coffee. It's so strong that basically you don't want to drink a full cup of that."

While Natália enjoyed eating her grandmother and aunts' cooking and taking *cafezinho* breaks with her mother, she enjoyed going to buffets the most. In America, buffets are often seen as lower-quality food, but in Brazil, many Paulistanos frequent buffets near their work instead of bringing lunch from home.

"When I was nine years old, and I had summer vacation from school, I would beg my mom to take me to work with her because I knew she would go to lunch at a buffet," Natália said. "It was so fun. You would go there, grab your own plate, pick your own food, and then eat and pay at the end."

Still today, Brazilian buffet food guides Natàlia's cooking practices and catering business.

Brazil was hit hard by the Eurozone debt crisis of the 2010s, when several European countries suffered from the collapse of financial institutions and were unable to repay their own governmental debt. Although the crisis peaked between 2010 and 2012, the effects lingered in ways that damaged Brazil's economy, especially the tourism industry. When Natália left in 2013, the Brazilian economy was still in the midst of a recession.

Cooking Up a Future

When Natália entered high school she assumed she would pursue a practical career as a lawyer.

"I really wanted to be a vet growing up, but then I am more of a space cadet kind of person," Natália said. "I couldn't be a doctor, so I decided I wanted to be a lawyer—a prosecutor. I really wanted to do that, but first I needed to go to law school."

So she started out in law school, but soon realized that she did not enjoy the curriculum, or the stress. Just by chance, while on her way to her law classes, she usually walked by a culinary school. One day the school was hosting an open house, so she decided to attend. After watching the students cook during the event, Natália decided to switch schools.

Her decision was met with mixed reactions at home. Natália's mom encouraged her to pursue her own interests, while her dad opposed the idea of leaving law school.

"In his mind, you're either a lawyer or a doctor. Art in his mind is a hippie thing," she said. Her father equated cooking with art.

Brazilians typically attend whichever college is closest to their home and live with their parents instead of in an apartment or a dorm. It costs less to attend college in Brazil than in the United States. According to Natália, Brazilian students pay tuition monthly and do not have large amounts of student-loan debt.

"I would work in the morning, go to college at night, and then go home. That was my life for the whole time," she said. The culinary school was a two-year program, similar to an associate's degree. Natália learned a lot of techniques and cooking styles, including gastronomy basics, cutting techniques, and cooking French, Spanish, and other cuisines. She even learned how to cut up and serve an entire cow. Still a novice, she quickly adapted to the strenuous and fast-paced action of the kitchen.

While in college, Natália began working in the restaurant business, first running a restaurant's salad bar, followed by stints at a contemporary Japanese restaurant, a Brazilian buffet, and a Spanish restaurant.

Natália loved cooking, but she also wanted to own a restaurant. So she studied business administration at another local college and began taking English classes so she could work at a fancy hotel, catering to European tourists. That opportunity soon evaporated when the economic struggles of

the Eurozone impacted Brazil's tourism industry. Instead of the fancy hotel, she worked at a cupcake store while continuing to study English.

Love, American Style

Love works in strange ways, and a failed romance prompted Natália to look to the United States.

"I basically came to America because I had a bad boyfriend," she joked.

After breaking up with her boyfriend and not landing the fancy hotel job, Natália still wanted to work in the restaurant business but felt she needed a quicker way to improve her English. A friend suggested she move to America to work as an au pair.

> Love works in strange ways, and a failed romance prompted Natália to look to the United States.

It sounded like a good idea to Natália, although the vetting process was rigorous. She needed two hundred hours of child-care experience, which she worked to reach by caring for her niece and teaching children to make cupcakes at the bakery. The three-month application process took Natália an entire year, as she worked to meet her required child-care hours and prove her English skills were good enough to interact with a host family.

After completing the requirements, Natália created an au pair profile and quickly started to receive inquiries from parents in America. One woman from Cambridge, Massachusetts, wanted Natália to work as an au pair for her son, and Natália said "yes" without knowing where Cambridge was even located. In fact, she barely knew anything about America at all, much less where she wanted to live and work, so Cambridge seemed as good a place as any.

"All I knew about America was from watching movies," she said.

Her father was against it. He did not want her to leave her job and move so far away. Her mother was more supportive, but still worried about her daughter living so far away. Natália, who had never left Brazil before, was excited, but anxious.

Moving from Brazil to Boston in 2013 was quick, but challenging. Natália, now in her mid-twenties, flew to Cambridge just a week after talking to her host mother. She still didn't know much about the family she would join.

"Until I got to the T, the subway in Boston, I barely knew who the host mother was," Natália said.

It turns out her host mother lived in Central Square and was a consultant who frequently traveled for work. Her son was in elementary school and, much to Natália's chagrin, was a picky eater.

"We Brazilians have big hearts, but also a culture of being strict," she said. "That's why she chose me, but her kid was a pain in the butt."

Natália tried cooking him new foods, but he preferred mac and cheese or chicken parmesan. She

counted as one of her victories convincing him to eat broccoli.

Natália had a difficult time adjusting. Living with people she barely knew in a place that was entirely foreign was challenging, as was New England's famously stoic culture. In Brazil, people greet each other with hugs and kisses, but a New England greeting can be, at best, a handshake and a hello.

Language also remained a barrier. While she had studied English in school, Natália still struggled to find the right words, which sometimes prompted people to become impolite and impatient, demanding "Come on, what do you want?"

"Massachusetts people can sometimes be very rude," Natália said.

As a way to relieve some stress, Natália began working out at a nearby gym. She met her future husband, Brooks, on her very first day. He was the fitness and gym manager and gave her a free class as part of her new membership.

Brooks led boot-camp-style classes, and Natália was unprepared for the rigors of the workout that awaited her.

"The next day I came back and he almost killed me," Natália said. "I almost passed out."

But she welcomed the workout and the stress relief. She thanked him for the free class and told him she would return to the gym every day, but could not afford a personal trainer. Brooks offered to exercise with her when he was on break if she was at the gym.

"I was, like, 'Sweet—I just got a personal trainer!'" Natália said.

The two still joke about each other's motivations.

"He makes fun of me even today, and says, 'You took advantage of me. I was not training you.'"

Natália quickly noticed that Brooks was kind and professional.

"He would look directly in my eyes," Natália said. "Not checking me out. Just being really professional and very nice."

She drew stick figures on a piece of paper to explain the type of workouts she was doing in Brazil. She did not know the English words for her workout routines, but Brooks helped her figure it out. Having someone help her communicate was a relief.

"Your brain is constantly trying to assimilate to a foreign environment, a new language, a new culture. Day in and day out, hearing and having to speak English was exhausting. We were just trying to communicate with each other in a better way, and he was pretty patient," she said.

One day after their workout, Brooks mentioned he was heading to a whiskey bar with some friends. Natália asked if she could join him, but said she was not looking for a romantic relationship. Although "he was thinking, like, 'Whoa, she just asked me out on a date,'" Natália said. "I was just really excited to have a friend. He was just so kind and respectful."

Brooks helped Natália adapt to life in America by finding local connections to Brazil. They started eating at Brazilian restaurants in Boston and cooking together.

"I think it was just comforting for me to go to the Brazilian places, and he loved to go with me," she said. Natália even replicated São Paulo culture in Cambridge by meeting Brooks for a *cafezinho* in coffee shops along Massachusetts Avenue.

When Thanksgiving rolled around, Natália planned to spend the holiday alone because her host mother and son were celebrating with extended family. Instead, Brooks invited Natália to join him at his parents' home in Bangor. She had heard about Thanksgiving in American movies and decided to head north with him. It was a good decision.

"His family and I bonded, like, right away," she said.

As someone who loves food, Natália was excited to try "American" cuisine like sweet potatoes with marshmallows on top, turkey, stuffing, and pies.

"Since I was young, food has been part of my life, because I have those little memories, and everything is around food, so I have a lot of those memories, and I was watching all those things [at her first Thanksgiving]."

Natália also enjoyed spending time with Brooks' family.

"They are really sweet. They were very happy I was there. Kept saying my English was amazing. It was exactly what I wanted," she said.

After that Thanksgiving trip to Maine, Natália and Brooks started dating.

"In my mind, I was going to stay one year and then come back to Brazil. So I did not want to get too attached," Natália said. Brooks initially felt

the same way. But, like Natália, he found himself growing increasingly attached and dreaded her return to Brazil. Natália wanted to be with him, but did not like working as an au pair for her host family. Brooks tried to get her to explore different jobs or attend school in Boston.

"He's smart. He asked in a way that planted a little bug behind my ear. I would have freaked out if he had proposed to me."

"I just couldn't see myself living in America." Natália explained, "The cultural difference, being away from family and my style of life in São Paulo." Still, she became increasingly torn between returning to Brazil and staying in Boston with Brooks.

"A little before May, I could tell he was anxious and wanted to talk to me about something," she said. The relationship was getting serious, and they spent each day together. Brooks "suggested that we could stay together, and see what the future would hold for us," she said. "He's smart. He asked in a way that planted a little bug behind my ear. I would have freaked out if he had proposed to me."

She said yes.

"We love each other now, so why not? I got excited to live somewhere new, mostly with him by my side," she said. "If we get a divorce, and I don't have a kid, then I just go back to Brazil.

"Before Brooks proposed to me he did the old-school thing of wanting to call my dad and ask him," Natália said. They had a call, and she interpreted for Brooks. "For me, this was all hilarious." She added, "I can marry whoever I want. I don't need to ask my dad, but I thought it was very sweet.

"I didn't know what they were going to say. My mom had a crying face because she was happy for me." Her father only knew one word and one phrase in English—"beer" and "Have a great weekend"—but he was able to express his happiness. "He was saying 'Yeah, yeah, beer, beer. Have a great weekend!'" Natália said.

Brooks proposed to Natália in Portland. In May of 2014 they filed a marriage license with the city clerk, and in July they held a ceremony on Great Diamond Island, just off the Maine coast.

For the wedding, Natália and Brooks rented several cabins for both sets of parents and two of Natália's friends from Brazil. It was the first time their parents had met each other.

"My dad and Brook's dad's whole conversation was beer, beer, beer," which was still his only English word. "My parents and his parents got along right away, even though they could not understand each other."

Natália cooked at her own wedding, making a blend of Maine and Brazilian foods.

"I made lobster mac and cheese. His grandma brought the baked beans. Brooks' mom brought pulled pork. I made *bobó de camarão*, a shrimp stew from northern Brazil. I made coconut rice to go with that."

She also made "roasted potatoes with rosemary, *coxinha* croquettes, and a cheese platter. All the items we used to have together on the weekends. We wanted to have what actually made us grow together, cooking on the weekends. I made Romeo and Julieta cupcakes. Romeo and Julieta is a classic Brazilian dessert consisting of cheese and guava jam—I was a pro at making those, plus *brigadeiro* truffles, a classic Brazilian dessert, and some strawberries covered in chocolate. I was literally finishing cupcakes thirty minutes before getting married."

After the wedding, Natália quit working as an au pair and returned to Brazil to see family and friends. Before she left, Brooks and Natália filed for a green card.

"The interview was nerve-wracking just because we didn't know what to expect," Natália said, "but the love was real, so we passed right away!"

Brooks joined Natália in Brazil for Christmas, where he met her many relatives at family barbecues and spent a lot of time at the beach.

After the holiday, Natália and Brooks returned to Boston, where they lived for three years. Natália worked at Barcelona, a tapas restaurant in the South End, and Brooks opened a gym in the same area with a friend. While Natália liked this work, she also wanted experience in the hospitality industry, so she found a seasonal job working as an innkeeper at a boutique bed-and-breakfast in Boothbay Harbor. Soon, Brooks had a falling-out with his business partner and the couple decided to move north to Bangor, to be near his family.

Achieving Her Brazilian-American Dream

Not long after the move, Brooks, who is entrepreneurial and a great handyman, came to her with "crazy ideas" and suggested opening a Brazilian food truck in Bangor. "We have nothing like that here in Maine," Brooks told Natália. "Your food is amazing. You are a great cook."

Natália shook her head at the memory. "So he's nuts, and he just went and bought an Airstream." He remodeled it himself, building Natália a food truck called The Grillin' Brazilian. They prepared the food at Brooks' parents' house before loading it onto the Airstream, which they nicknamed "Bundona," slang for "lady big butt" in Portuguese.

The Grillin' Brazilian was an instant success. Brooks and Natália sold out within the first hour.

The Grillin' Brazilian was an instant success. Brooks and Natália sold out within the first hour.

Success was rewarding, but the food truck was a lot of work. They had to get propane, clean, cook, serve, decide how much food to order, set up licensing, and figure out where to park the Airstream and sell food.

It also took a while for Natália to develop a menu. "I did a little bit of everything that I knew, that was comforting food to me. It took me a few months to figure out what I really wanted to make and what really worked. A few things didn't work because of lack of equipment, and because clients were not willing to experience something so different," Natália said. "Bangor customers were great, but not very ambitious for the super different stuff like *feijoada*, a classic beef and pork stew."

Selling food in Bangor, a place that is not known for its Brazilian population, posed its own unique challenges. "I had so many people asking me if I had burgers or clam cakes or fried clams. I was like, 'No, it says right there, it's Brazilian food.'"

When possible, Brooks and Natália tried to use ingredients from local farms, like sausage from Maple Lane Farms in Charlestown. At the end of the first season, Natália reflected on her time with the food truck. "Wow, I am opening up a business in America, serving Brazilian food." She realized she had achieved her dream, in her own way, of owning her own restaurant and becoming a chef.

After a year in Bangor, Natália and Brooks decided to move the business to the bigger city of Portland. They set up shop at Thompson's Point and again sold out of food on their first day. The pace of work was quicker and days were longer and harder. It was more challenging to find locations, because with all the food trucks in Portland, sites filled up months in advance. Luckily, Brooks and Natália were able to sell their *feijoada* and *coxinha* at Austin Street Brewery and Cellar Door Winery, as well as cater private lunch events.

In the latter part of 2019, Natália started to spend more time catering, and by December she

had sold the food truck in order to cater weddings and larger events full-time. Her catering business, Sampa Kitchen, serves the same meals that Natália enjoyed growing up, centered around rice, beans, and meat. *Sampa* is a nickname for the city of São Paulo. She also sells Brazilian food that can be found at food trucks on the beach in São Paulo, like "beach cheese," which is a grilled slice of cheese with a high melting point on a stick.

Soon, Natália hired a team of women to help.

"It was the four of us," she said. It made her feel "really amazing" to be a part of a team with these women, making Brazilian food. "I am giving jobs, they want to follow my lead, they trust what I do." She had achieved another dream: becoming the head chef of her own business.

In 2020, she and Brooks moved into a new home in Kennebunk with their son. She loves Maine and her new hometown.

"I consider myself half-Mainer"—pronouncing it with the Down East accent, Maine-*ah*—"I love flannels," she joked.

Brooks also started a business doing carpentry, painting, and remodeling, called the Stone Coast Handyman.

"I miss my family in Brazil all the time," Natália said. "Every day. But, you know, I am building my own family now."

Occasionally, Natália will meet Brazilians who tell her how lucky she is to be an American and to have her own business. Natália usually responds: "No, I am not lucky. I worked really hard, and I was in the right spot at the right time, and I just kept on going forward. Brooks tells her that "luck is a product of effort and opportunity."

Since coming to America, Natália has accomplished her dreams. She has gone from enjoying food trucks on the beach in São Paulo to operating her own in Portland. She has shared her love of Brazilian cuisine with her new home.

"Look at where I am right now. It's been almost seven years since I moved here. I absolutely love Maine with all my heart."

Amarildo Hodo

Albania
Population:
2.838 million
Distance from Maine:
4,274 miles

Amarildo Hodo was born in Albania, one of the last communist holdout countries, to a family of entrepreneurs. They came to America seeking opportunity and Amarildo flourished, taking the entrepreneurial torch from his parents and becoming a store manager as a teenager.

Amarildo was born on March 26, 1995, in Tirana, the capital of the newly post-communist Albania. The small European country in the Balkans lies north of Greece, on the Adriatic Sea. Growing up in Tirana with his older brother Mateo, Amarildo fondly remembers playing soccer "from morning to night—that's all my friends and I did," he said.

The local children played in the streets and parks until the sun set, then he and his brother would head home. Amarildo also enjoyed Albania's beautiful southern coastline, where his family vacationed every year on the beaches of Vlorë, Himarë, and Sarandë.

"They are each beautiful in their own specific ways. The waters are clear, warm, and relaxing. We would rent a beach house for the summer and spend our time down south." he said. "A typical day at the beach would consist of hanging out with my family, playing cards, soccer, volleyball, and swimming with my cousins."

Amarildo's parents, Natasha and Zamir, owned a small grocery

store in their neighborhood. They both graduated from the University of Tirana, where Zamir received a degree in engineering and Natasha studied business management.

Because of its location on the Adriatic and Ionian seas, Albania has long served as a bridgehead for various nations and empires seeking conquest abroad. In 1939, Italian dictator Benito Mussolini invaded Albania, and occupied the country for much of World War II.

"Everybody got along well. There were no outbreaks between Muslims and Christians," he said. "People were very respectful toward each other's religion."

In the decades that followed, Albania was controlled by different dictators who effectively made Albania one of the most repressive, underdeveloped, and isolated communist countries behind the Iron Curtain. Albania's communist regime outlasted the other countries in Eastern Europe, where communism collapsed in the late 1980s and early 1990s. In Albania, communism ended in 1992, three years after the fall of the Berlin Wall and one year after the downfall of the Soviet Union. During the 1990s, Albania went through a rocky transition to democracy. A country-wide Ponzi scheme led to an economic crisis and a civil war in 1997. Largely agricultural, Albania is still one of the poorest countries in Europe.

Amarildo was born shortly after the fall of communist rule and just before the civil war, meaning that world was his parents' reality. He is proud of how his parents survived during that era. "Times were a little hard and the economy wasn't that great, but they made it by," he said.

Albania is predominantly a Muslim country, with some Catholics and Eastern Orthodox Christians. Although the former communist government brutally repressed all religions, Amarildo recalls people worshipping and coexisting peacefully despite their different beliefs. "Everybody got along well. There were no outbreaks between Muslims and Christians," he said. "People were very respectful toward each other's religion."

There was harmony between different religious groups in Albania, unlike in other parts of the Balkans, such as Kosovo and Bosnia, but other issues made life difficult.

"My parents wanted to move here to America because of all of the bad things happening there," Amarildo said. "There's a lot of drugs . . . They thought it would be better to go to school here and better ourselves."

In addition to the political upheaval, the country was vulnerable to the international drug trade and human trafficking in the late 1990s and early 2000s due to the instability from the collapse

of communism. Amarildo's family decided to move to the United States, seeking a safer life and better opportunities.

They had never seen America. Like many immigrants, Amarildo's introduction to the United States came through watching films. "I pictured America like in the movies," he said. "It's the American dream. You come here, you build a business and start a family and enjoy life."

They chose Maine because Natasha had several cousins living there. They saw it as a quiet state with few problems.

His family applied for the diversity visa lottery, a program that aims to diversify the immigrant population in the United States by selecting applicants from countries with low immigration numbers in the previous five years. The Hodos were hopeful they would be selected to come from Albania to the United States in the drawing.

Their selection changed their lives.

Winning the Lottery

Amarildo's family landed in Chicago on July 4, 2002, and took the train to Troy, Michigan, where some relatives lived. Neither Amarildo nor his father spoke any English, but his mother and older brother had studied the language in school. Amarildo had finished second grade before arriving in America, but his new school placed him in second grade again. To help him learn the language, the school placed him in an English Language Learner (ELL) class with students from Africa, Europe, and even others from Albania.

Amarildo learned English quickly because he was young, but he continued ELL classes until the eighth grade. "Some people say I don't have an accent, but I think I do a little bit," he said. "I would probably say going into high school is when I felt comfortable with the language and could speak fluently, but I am still learning."

Playing soccer and basketball along with watching movies and television helped him improve his English. After living in Troy for about a year, his family moved to Standish, Maine, in August 2004, where they lived for five months before moving to Westbrook. They chose Maine because Natasha had several cousins living there. They saw it as a quiet state with few problems.

In Westbrook, Zamir got a job delivering medicine to nursing homes across Maine and New Hampshire. He previously worked at a nanochip factory in Standish, but the "company got sold to China." Natasha worked at the Dunkin' Donuts shop in Standish and then at TD Bank. His brother, Mateo, started a coffee shop on Cumberland Avenue in Portland called CoffeeMeUp.

In 2007, Amarildo and his family became United States citizens. Their ceremony took

place in South Portland. "Because I was under eighteen I wasn't questioned," Amarildo said. "It was my parents and my brother."

Becoming a citizen was extremely important to Amarildo. "It was a great moment," he said. "I felt really proud."

He learned lessons of hard work and business ownership from his parents' grocery store in Albania, and he was ready to continue on with high hopes and ambitions.

Becoming an Entrepreneur

Amarildo started working at Wendy's when he was sixteen and was quickly promoted to manager. Then he went to work at Dunkin' Donuts with his sister-in-law, who was the store manager. He became a shift leader there while he was still in high school.

But he dreamed of starting his own business, as his parents had done in Albania. "They were private business owners and I wanted to become something like them," he explained. "I wanted to start my own business."

After graduating from high school in 2013, he got a degree in criminal justice from Southern Maine Community College. During that time he earned money by fixing iPhones at the Maine Mall in South Portland. Amarildo realized what he wanted to do instead of pursuing a career in criminal justice.

He loved repairing iPhones.

"I enjoyed what I did," he said. "I would go to work happy . . . so that's when I knew what I wanted to do and something that I did with a passion."

While attending classes, Amarildo formed a limited liability company and operated a business called Repair Me at the Bangor Mall. In June 2015, an outside company came in and pushed him out.

Becoming a citizen was extremely important to Amarildo. "It was a great moment," he said. "I felt really proud."

"After closing my kiosk I moved back down to Portland. I was offered an assistant manager position at my old company, iFixHere. I am now the store manager at our Maine Mall locations. I'm a firm believer in things happening for a reason. Bangor was a great experience; I grew a lot as a person, learned a lot. Had my highs, had my lows, but at the end of the day it's those difficult situations that we have to overcome that define us."

Amarildo's experience as a business owner has been paused, but he is still open to the idea of starting a new business.

"At some point, I think I would like to run my own business again, but I'm not sure it would be related to phones," said Amarildo. He added, "If I were to start my own business again

it would have to be something that is meaningful and with a purpose of helping people out."

"You can achieve great things here, whether going to school or working. It is all about having the will and determination to do it."

Amarildo has thought a lot about what might have happened if his family had stayed in Albania. After going to a cousin's wedding back in Albania, Amarildo reflected on his life here in America.

"My perception of America is that it gives you endless opportunities," he said. "You can achieve great things here, whether going to school or working. It is all about having the will and determination to do it."

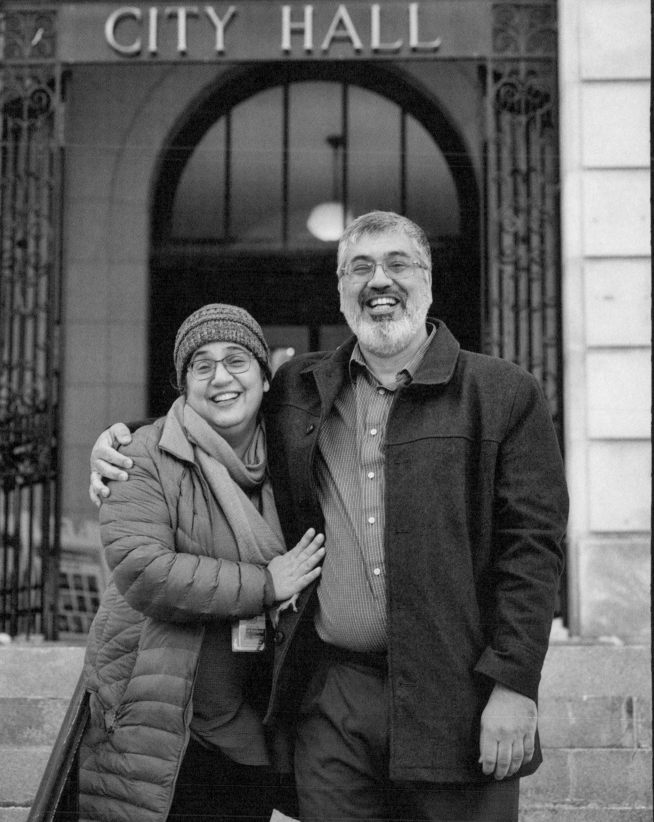

Mohammed Nasir Shir and Shukria Wiar

Afghanistan
Population:
38.93 million
Distance from Maine:
6,340 miles

One of Shukria Wiar's first memories of America is visiting a 7-Eleven store with her father, a man the seven-year-old girl had not seen in more than three years while the family's refugee journey played out across three continents.

Her father, Now Shir, originally left Pakistan, where he and his family lived as refugees from war-torn Afghanistan, for Germany in 1980. He stayed in Germany for more than two years, preparing to move across the Atlantic to America. Now Shir, in his thirties at the time, had once seen a postcard of New York City, with its skyscrapers and promise of opportunity and advancement in exchange for hard work. He finally reached America in 1983. He rented a one-bedroom apartment in Portland, Maine, to begin building the foundation of his family's new life. During the course of the following decade, Now Shir would sometimes work three minimum-wage jobs at a time to support his family.

Reunited in the spring of 1984, Shukria, who spoke no English, and her father walked to the nearby convenience store. It seemed exotic. "I felt like the kid-inside-the-candy-store cliché!" she said. "There were all these colorful candies everywhere I looked."

It was a fun moment. She has other early memories as well, like her mother constantly complaining about how bad the food looked

and tasted in this new country. She remembers her father bought a big used Ford station wagon that the entire family—she, her father, her mother, Sadri Shir, and her two older brothers, Mohammed Nasir, fourteen, and Ajmad, seventeen, would pile into and drive around the city before meandering out through surrounding towns, getting to know the city and region that would become their home for decades to come.

Eventually Mohammed Nasir, who goes by his middle name, Nasir, and Shukria, would thrive. They both attended Clark University, earned master's degrees, started successful careers, and now lead comfortable lives in a prosperous suburb outside of Portland. In keeping with tradition, they are committed to the principles of volunteering—to give thanks to the country that took them in, help the people, and honor their faith.

Back in 1984, riding around in that station wagon, it felt good to be together again after years of separation and living in a state of limbo in Pakistan. Still, they spoke no English in a strange city surrounded by strangers, whose language and customs were vastly different from what they knew. Success would come, but it would take a few long years as each family member struggled to adjust to their new home, honor their Afghan heritage, stay true to their Muslim faith, and fit into America.

"We love America," Shukria told a newspaper reporter in 2021. "It's our country. We're thankful we're here and we're free to practice our faith and celebrate with our families."

Afghanistan

The Shirs' journey to America begins in their ancestral home of Afghanistan, where their parents and the two boys were born. The mountainous landlocked country is at the crossroads of Central and South Asia with a current population of more than thirty-eight million people. It lies along the legendary Silk Road trade route, which connected East and West for more than a thousand years.

In keeping with tradition, they are committed to the principles of volunteering—to give thanks to the country that took them in, help the people, and honor their faith.

The family members are Pashtuns, an ethnic group native to Central and South Asia. Pashtuns belong to the Sunni branch of Islam and speak Pashtu and Dari. Also called Pathans, Pashtuns are known as warriors in the Indian subcontinent and are renowned for their bravery throughout history. The name *Shir* means "lion" in Pashtu, as well as in other languages spoken in Afghanistan, including Farsi, Dari, and Urdu.

Nasir seems nostalgic when he discusses Afghanistan as it existed before the current era of conflict that started in 1978. He shares stories of his

maternal and paternal grandfathers that he heard as a child. Their paternal grandfather was known for his physical strength. He was an authoritative and well-respected leader in his village. His maternal grandfather, on the other hand, was a businessman who traded in fabrics and scissors and traveled to Lahore, capital of the Pakistani province of Punjab, for business. While on a business trip, he once met Bacha Khan, the Pashtu leader of a nonviolence movement seeking independence from the British. Bacha Khan was an ally of Mahatma Gandhi and founded the "Servants of God" army, with 100,000 Pashtuns as members, in 1929.

"Bacha Khan's nonviolence movement was inspired by the Prophet of Islam's teachings," Nasir said. "Those wanting to join had to take an oath to serve humanity, forgive their oppressors, and pledge to two hours of community service every day."

As a country, Afghanistan has a long and winding history. Although there are many subplots during the twentieth century, the country achieved independence from Britain in 1919, stayed neutral in World War I and World War II (although it had close ties to Axis powers), and remained neutral during the Cold War, maintaining a relationship with both the United States and the former Soviet Union.

The dynamics of the country changed forever in the late 1970s. A coup in 1978 brought the People's Democratic Party of Afghanistan to power and was followed by widespread rebellion.

The Soviet Union invaded the country in 1979 on the pretext of aiding the new communist government against the rebels, who were supported by the United States and other Western countries. It was a moment that produced a dramatic change. According to the Shirs, the nation was mostly at peace in the years prior to 1979. There were no armed conflicts against its neighbors, which include Iran to the west, Pakistan to the south, China to the northeast, and the former Soviet Union to the north.

The dynamics of the country changed forever in the late 1970s.

Since the invasion, there has been no peace in the country.

The Soviets stayed for the better part of a decade until the Soviet Union itself started to collapse in 1989. It was a brutal nine-year conflict in which, according to *The Atlantic*, "an estimated one million civilians were killed, as well as 90,000 Mujahideen fighters, 18,000 Afghan troops, and 14,500 Soviet soldiers."

The Shir family lost uncles and cousins during the conflict and subsequent civil wars. The ancestral houses of their maternal and paternal grandparents were destroyed. The violence and civil wars split families who chose different political ideologies.

During the Soviet occupation Afghan resistance fighters, known as "Mujahideen" or freedom fighters, battled Russian troops and were supported by the United States and its allies. The withdrawal by Soviet forces in 1989 was followed by years of civil war between different Afghan groups and caused the displacement of even more Afghan civilians. Most, including the Shirs, were forced to flee to Pakistan and Iran. Some sought asylum in Europe and the United States. While the players have changed, the violence continues to this day.

From learning English to navigating school to balancing new customs with their heritage, many challenges remained.

Refugees in Pakistan

Fortunately, the Shir family left Afghanistan before Soviet troops marched in. In the 1970s Now Shir, Nasir's father, was a police commander, while another relative served in the military. Call it good luck or premonition, but the family fled Kabul to seek safety ahead of the invasion. The family moved to Pakistan to stay with family friends who shared the same ethnicity and language. They thought their stay in Pakistan would be temporary. Instead, they lived in limbo as refugees for about a decade.

"Our elders watched from a distance, with apprehension, how Afghanistan was ruined during the Russian occupation and the civil war that followed," Shukria said.

The Shir family's experience of waiting was not unique. According to London-based Amnesty International, by the end of 1980, more than four million Afghan refugees were in Pakistan. Over the next four years, that number would grow to more than five million refugees in Pakistan and Iran.

A year after the Soviet invasion, the elder Shir left Pakistan to seek asylum in the West. In Germany in 1980, he pursued refugee status and a chance for admission to the United States. His plan was to reach America, and then sponsor his family so they could join him.

In 1983, he took the penultimate step toward family relocation, leaving Germany and arriving in a resettlement community for Afghan refugees in Portland, Maine. It took another year to get his wife and three children, who had remained in Pakistan, admitted as refugees.

America

When the family reunited in Maine, they were together, safe, and finally settled. From learning English to navigating school to balancing new customs with their heritage, many challenges remained.

While the outside issues were a challenge, in the beginning the children faced a more family-based challenge—getting to know their father. Not only

had he been away for three years, but little familiarity had ever existed between the children and their father. When Nasir was growing up, his father, in keeping with Afghan tradition, spent more time working in places far from home than being around the family. The children said they knew their father loved them, even though it was rarely conveyed, which is common in traditional Afghan households.

"In Afghanistan, at least back then, the men would leave the wives and the children in their parents' houses to go to the larger cities to earn a living," Nasir said.

Shukria added: "In Afghanistan, we did not have the nuclear family model the way it exists here in the United States. There, for better or worse, extended families lived together."

Nasir and Shukria said displaying acts of love was not practiced in their family, again in keeping with the Afghan tradition and culture, and this applied to both men and women.

"My mother, as a woman, has a soft side to her. Still, no hugs, no loving words, but she wants us to show our love to her," Shukria said. "I tell my kids I love them. I am touchy-feely with them." Meanwhile, Nasir is a little more traditional. He shows his love to his children, two of them in their twenties, through his actions more than through his words.

Shukria also described their mother as a hard-working female role model who "survived the male-dominated and hierarchical society of Afghanistan."

Their mother and father's marriage was an arranged one. They were both fifteen. A year later their first son was born. "My father had not seen my mother till the wedding ceremony," Nasir said. "That is how the Afghan customs used to be."

Nasir and Shukria both praise their parents for their sacrifices and hard work that ensured their children would succeed in America.

> "In Afghanistan, we did not have the nuclear family model the way it exists here in the United States. There, for better or worse, extended families lived together."

"We owe everything we have achieved to our parents. Their sacrifices were not only material things, but emotional. I know I will do the same for my children," Nasir said.

"They were demanding and were hard on us," Shukria added. "But they wanted us to become successful in America."

Old Ways

Even though they moved to America and lived on the coast of Maine, their parents tried to live a similar life to the one they were forced to leave behind. Their effort has not changed over the years, and the siblings joke that, at times, their parents act as if they still lived in Afghanistan.

"Honestly, they are mentally living in 1980s Afghanistan," Shukria said. "For them, the life back home has frozen in that period when they left the country."

Nasir concurred. "My parents are here physically, but their hearts and minds are left in Afghanistan."

However, both brother and sister agree that the old Afghanistan life to which their parents cling has disappeared. They wonder if their parents' efforts to romanticize the country are part of the coping skills they developed to adjust to a new country.

Nasir's personal experiences as an adult in Afghanistan, to which he returned and lived for nine years, are indicative that significant changes occurred in the country. In the months after the 9/11 terrorist attacks on America, during a period when the Taliban regime had been overthrown by the US-led International Coalition Forces, Nasir was recruited by the US State Department to help create geological survey maps in Afghanistan. Although his parents were against the idea, he decided to go. But when he arrived, Nasir discovered he was seen by the Afghans as an outsider.

"I was expecting to be loved by my own people. They thought I was not a pure Afghan," Nasir said. Once, when talking in a private gathering with Afghan colleagues and friends, the conversation stopped the moment Nasir, sensing a sharp pain, touched his own chest. "They thought I was a spy for America and was turning on a hidden microphone or something!"

It was then that he discovered many outdated traditional practices had disappeared, and that the country once known for its peaceful countryside had grown unsafe.

"I thought I would be welcomed with open arms, but maybe because of tribal tensions, I was suspected to be a Pakistani and not an Afghan," Nasir said. "I was even seen as a potential American spy."

American Education

Adjusting to America was difficult for the children as well as their parents. When they arrived in Portland during the spring of 1984, Nasir, Shukria, and Ajmad started school even though the academic year was near its end. They signed up mostly as a way to learn English. Nasir attended King Middle School and Shukria started at the Reiche School. Their older brother attended Portland High School.

Because she was younger, learning English came easier for Shukria. As teenagers, her two brothers faced an uphill battle in learning the new language and adjusting to the American educational system. They had also fallen behind because of the gaps in their formal education caused by their displacement.

"I did not know a word of English," Nasir said. "I lost a year and was forced to stay back."

At the time, few schools in Maine offered English Language Learner classes. Shukria and other non-English-speaking students were taxied

from one school to another during the regular school day. There were times when young Shukria was the only passenger sitting in the backseat of an old taxicab, being picked up from home and dropped off at an out-of-district school.

"In Reiche School, there were twenty to twenty-five of us, all newly arrived refugees. Some were from Vietnam, Cambodia, and Poland. We were sitting in one large hall, all learning English. I wanted to be in a regular classroom, one with walls and privacy," Shukria said. Most of her classmates were boys, Shukria added. "I was shy and was bullied. I didn't mention this to others."

She was mainstreamed in the middle of the fifth grade.

Once he became acclimated, Nasir also started to catch up. Eventually, encouraged by a teacher impressed by his academic progress, Nasir applied for admission to Waynflete, a private school in Portland. He was accepted. "Waynflete brought out the best in me," Nasir said. "I felt valued."

He began to thrive academically. After high school graduation, he attended Clark University in Worcester, Massachusetts. At Clark, he had two close friends—a young woman of Egyptian origin, who wore a veil in accordance with Islam's encouragement of modesty in dress for practicing Muslims, and an atheist gay man from Haiti. The three students enjoyed late-night conversations discussing life, politics, and religion. He called his Egyptian friend an "angel."

Nasir originally planned to study archaeology, thinking he would work back in Afghanistan. Instead, he double-majored in geography and international development. After graduation from Clark in 1994, Nasir worked for the State of Maine and then spent seven years at the Geographic Information Systems Lab at the University of Southern Maine, where he did his graduate studies at the Muskie School of Public Service.

"In Reiche School, there were twenty to twenty-five of us, all newly arrived refugees. Some were from Vietnam, Cambodia, and Poland."

Sibling Bond

Shukria followed in her brother's footsteps, starting at Waynflete in the ninth grade on a scholarship. She also attended Clark as an undergraduate, earning a dual bachelor's degree in biology and environmental science and policy. She stayed at Clark to earn her master's degree in public administration.

Shukria recalls not having friends at Waynflete high school, in part because many fellow students had been attending the same school together for years, including some who met as early as kindergarten. As a teenage girl, Shukria had a difficult time fitting

in. At one time, the only other student of color at the school was a girl born in China.

Shukria also struggled at home against some Afghan traditions. She felt her parents treated her differently from Nasir because she was a girl. Nasir's extracurricular activities at Waynflete, which included overnight field trips and spending time with classmates away from home, created more conflict.

"I was feeling bitter that my parents did not allow me to do sleepovers with my female friends, where Nasir, being a boy, could come and go as he pleased with no restrictions," Shukria said.

Nasir agreed that a different standard existed for his sister.

"What could I have done differently? I felt it was the culture's fault," he added.

It was part of a larger battle for Shukria.

"When younger, I used to argue with my mother," Shukria said. "She would not believe that even in Afghanistan itself things had changed; that the young people had more freedom and made important decisions on their own, and so on."

Such conflicts aside, the two siblings, who both learned English and adapted to American culture more quickly than their older family members, grew close in America. Since their parents and older brother worked a lot, the two leaned on each other for support and together they assumed adult responsibilities at a young age.

"Nasir would clean the house and do the laundry while I did some cooking for the family,"

Shukria said. "I remember I was in sixth grade and I was sorting out the mail, reading and paying the bills, and balancing the family's checkbook. That was maturity by necessity."

Nasir agreed. "Because of our English proficiency, we soon became the cultural brokers and translators for our parents."

Even as adults, the siblings, who are seven years apart in age, remain close, interrupting one another when speaking and teasing each other as only siblings do.

Shukria also struggled at home against some Afghan traditions. She felt her parents treated her differently from Nasir because she was a girl.

There also might be a playful sibling rivalry between them. They both attended Clark University. Years later, they both live in Cape Elizabeth and both worked for a time at Portland City Hall— Shukria has been a city planner for more than fifteen years working in the old building's attic, and Nasir's former office was located in the City Hall basement.

"Our lives have run parallel to each other," Shukria said.

However, in some ways Shukria and Nasir are also quite different. Shukria said she is more

at ease interacting with Americans, and that her brother is less "American."

Nasir agrees. He admires his younger sister's consciousness about the inequality and inequity in the treatment of girls and women in some Afghan and Muslim families. Nasir believes her passion and aggressive spirit complement his own style, which is more diplomatic.

"In working with the local Muslim community to resolve issues and overcome barriers, we make a good team," Nasir said. "I am laid-back while she is intense. People are surprised by how different we are." He added, "We have the same goals, but our means to reach the goals are different. Sometimes, she is too fast and aggressive for me. I like it slow and easy!"

Shukria admits she is passionate.

"I tell my daughter she should be tough and fight for her rights," she declared, while adjusting her head covering. She believes she represents the true traits of a Muslim woman, as prescribed by Islam.

Nasir and Shukria practice another Islamic value: volunteering. In addition to their long-term work with two of Portland's four mosques—which ranges from organizing Eid celebrations to mosque visits by non-Muslims as part of the community's interfaith efforts—the siblings support the local Muslim youth team that competes in the Muslim Interscholastic Tournament (MIST), where the young participants compete in science and other subjects.

"This is a way for us to engage our young persons in educating their minds and having goals," Shukria said. In 2012, the Portland team—featuring boys and girls from local high schools and colleges, including Nasir's two daughters and a nephew—won the regional championship in Boston to qualify for the national tournament in Washington, D.C.

In 2017, Nasir was elected to the Cape Elizabeth School Board. Nasir said he wanted to make a difference in the system, as a parent of school-age children.

> He admires his younger sister's consciousness about the inequality and inequity in the treatment of girls and women in some Afghan and Muslim families.

Muslim Traditions and Repaying Debts

When Shukria and Nasir were younger, cultural and generational tensions existed between the siblings and their parents. The parents worried that their kids were too young and impressionable—that they might not learn or want to follow Afghan cultural practices and traditions.

Although they meant well, Now and Sadri demanded that their children behave exactly as

their counterparts in strict, traditional, and predominantly Muslim Afghanistan did, despite living in a mostly white and Christian Maine. They worried America would change their children for the worse.

Looking back, Nasir and Shukria agreed that their parents' apprehension was understandable, but unfounded. "We have grown up to be good Muslims and we take pride in that," Shukria said.

They are also Americans and have much to say on how they, as new Americans, see American democracy.

In spite of their modern Western outlook and contemporary worldview shared by many of their American counterparts, they agreed that they are the devout Muslim Afghans their parents wanted.

More than thirty-seven years after they first arrived, Nasir and Shukria are now parents with large families themselves. Nasir has five children and Shukria has four. Somewhat miraculously, given that it is almost impossible to find properties large enough to accommodate families with many children in the Portland area, they have managed to practice the extended-family tradition in Maine. In some ways, they have managed to create a mini Afghanistan. The families have purchased properties close to each other, rehabbing and adding floors to create more living spaces. In a way, this might count as living together in one large compound, as most extended families do in Afghanistan.

In the spring of 2021, about twenty-five family members across three generations gathered at the Shirs' home in Cape Elizabeth to celebrate Eid al-Fitr, the Muslim holiday celebrating the end of Ramadan. The family members kneeled together on large carpets spread on the grass and faced southeast toward Mecca, in Saudi Arabia, birthplace of the Islamic faith. All wore traditional Afghan pants and tunics called *shalwar kameez*, the men mostly in plain white, the women's outfits brightly colored with coordinating hijabs, or head scarves.

They are also Americans and have much to say on how they, as new Americans, see American democracy.

"I may not look 'American,' but I am more American than my siblings," Shukria said. "Democracy is the ground rule in the room when we sit together at the national table."

"It is the etiquette of sitting at the table," Nasir agreed.

"What works so well is that American society is secular," Shukria said. "The government cannot tell me which religion to follow. I am a Muslim and can practice my faith freely and yet be a good American."

The two kids who were born in Afghanistan and arrived in Portland, wide-eyed, knowing no English, are now community leaders paying their

debt, as they see it, to the community that has helped them become who they are.

Shukria mentioned an Afghan saying: "You need to have a full belly to seek justice." Now, according to the siblings, each generation feels a little more at home in America. Nasir feels at home in Maine, and his children tend to correct his English. On the other hand, Shukria finds herself nagging at her children the way her mother did when she was younger.

"That is the Afghan mother in me," she said with a chuckle. "My nagging is exactly the English version of the Afghan things my mother used to say to me!"

"Maybe we're in limbo. We're not fully American and not fully Afghans," Nasir said.

"We're between two worlds," Shukria said, adding, "but then, who is the authority on defining what's American and what's Afghan?"

Nasir agreed. "I love this country, but who gets to tell me what's American culture?"

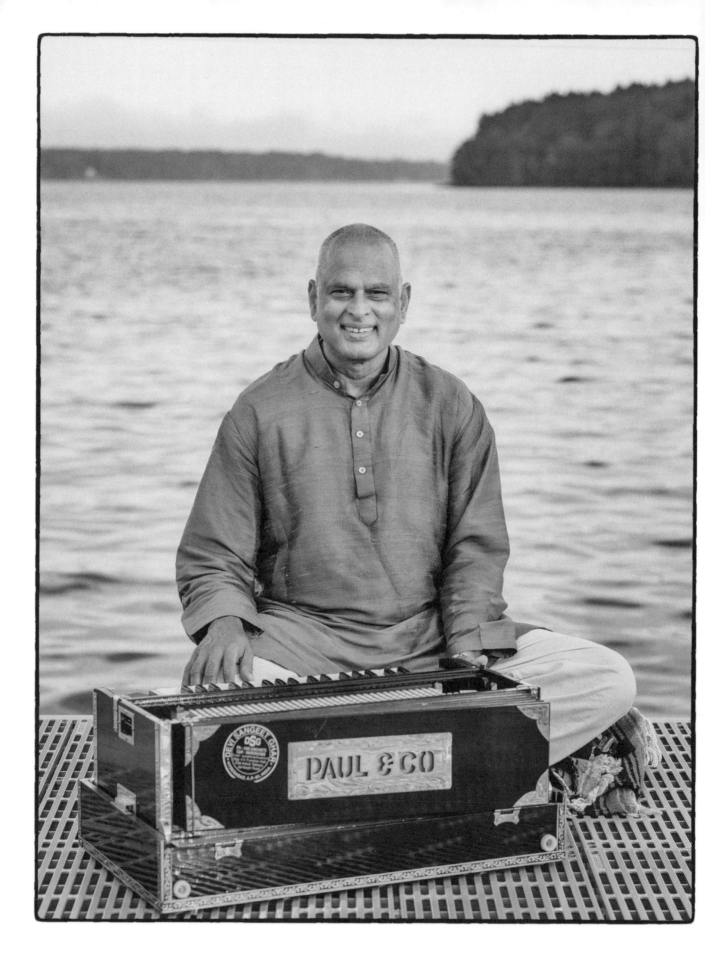

Ashok Nalamalapu

India

Population:
1.38 billion
Distance from Maine:
7,468 miles

Ashok Nalamalapu, who grew up with no television and no telephone, came to America with a hundred bucks in his pocket and a dream. By any standard, the immigrant from India has fulfilled his dreams and then some. His strong personal drive, relentlessly positive personality, and personal devotion to spirituality helped him build not only a successful IT business and overcome the unexpected loss of his voice on a personal level, but also support others through a thriving spiritual center that seeks to bring people of different backgrounds together to lead more peaceful and fulfilling lives.

Ashok's personal motto in life is straightforward—live, love, laugh, learn, lead, and leave a legacy. But at the core of his daily life, and all he has accomplished, is undoubtedly his spirituality. People who meet Ashok for the first time notice his positive aura, which he attributes to his spirituality and healthy life habits. Ashok calls it *Shakti-pata*, in Sanskrit, or "transmission of spiritual energy."

On a typical morning Ashok, who is a vegetarian, wakes before dawn, reads Hindu scripture and inspirational messages, then meditates for forty-five minutes and listens to spiritual teachings. He practices yoga for an hour or more, six days a week.

In the evenings he sings devotional chants, that, according to him, are a form of meditation. Ashok calls himself a "universalist," and the

chants often originate from faith traditions other than his own.

"I believe in what my master Sri Ramakrishna taught: 'Names are many. God is one,'" Ashok said. "Just like water has different names in different languages, God is called different names by different people."

Ashok is a devotee of Sri Ramakrishna, a prominent nineteenth-century religious figure, a mystic, and a yogi in India. Sri Ramakrishna preached universal tolerance, or the belief that most religions are different paths that ultimately lead to a single idea: that of a God who has form and who is formless.

"I have been spiritual most of my life. My mother was religious; my father never went to the temple or prayed at home," Ashok said.

Growing up in South India, he recalls watching his devout mother spending time doing *puja*, the Hindu act of devotion and a daily ritual essential to the religion, performed at a home altar. Now Ashok does the daily ritual and more.

Hinduism is said to be the world's oldest religion, dating back more than four thousand years. Rather than a single religion, it is a compilation of many traditions and philosophies. With about 1.15 billion followers, Hinduism ranks as the world's third-largest religion after Christianity and Islam. Most Hindus live in India and Nepal.

According to Ashok, Hindus believe in the dogmas of the endless cycle of life—death and

reincarnation, called *samsara*, and the law of cause and effect, or karma in Sanskrit.

India

Ashok Nalamalapu was born to humble origins in a small town in the Prakasam District of Andhra Pradesh, a state in South India. Prakasam has a population of more than three million and is home to the eighth-century Bhairava Kona cave temples. These were built in honor of the Hindu God, Shiva.

India, with more than 1.3 billion people, is the world's second most populous country and the most populous democracy. Bounded by the Indian Ocean on the south, the Arabian Sea on the southwest, and the Bay of Bengal on the southeast, it shares land borders with Pakistan to the west, China, Nepal, and Bhutan to the north; and Bangladesh and Myanmar to the east.

Modern India was created in August 1947, when the British Indian Empire was partitioned into India and Pakistan. The partition led to violence that

left some 500,000 people dead and saw the largest mass migration anywhere in modern history, as a total of twelve million Hindus, Sikhs, and Muslims moved between the newly created nations of India and Pakistan. Muslims moved to Pakistan. Sikhs and Hindus moved to India. Tensions between the countries have existed ever since. India is a diverse country with many languages spoken, although it is dominated by the Hindu religion, which makes up about 80 percent of the religious population.

Ashok's parents were modest—his father was formally educated while his mother was not. When he was young, Ashok changed his first name from the one given by his parents to Ashok, which means "no sorrow" in Hindi. He grew up with four brothers in a house without a television, telephone, or refrigerator.

Ashok was a happy child.

"From childhood, I was good at bringing the neighborhood's kids together. I networked. I created opportunities: You have a bat, so and so has a ball, there are enough of us to play, so let us find a flat field to have a game of cricket!" Ashok said.

Ashok also enjoyed going to the cinema, but his father was strict.

"I would get the money from my mother behind my father's back to buy a ticket to go to watch movies," Ashok said. "My father did not know about it."

In school, Ashok was a good math and chemistry student. He received top grades in his classes. Up until high school he attended small schools with few students. In elementary school, he recalled, he had six to eight classmates. In high school, there were more students. He did not do as well academically and was not listed as a top student.

When he was young, Ashok changed his first name from the one given by his parents to Ashok, which means "no sorrow" in Hindi.

Unlike at the elementary and middle school, where all subjects were taught in Ashok's first language of Telugu, instructions in high school were in English. Additional classes taught in Telugu discussed Telugu grammar and literature, the language that was spoken by most in Andhra Pradesh where Ashok was born. Some classes were conducted in Hindi, which is India's official language. India has twenty-two "scheduled" languages, with each state having its own language. Most Indians are fluent in Hindi and English, Ashok said.

Ashok was an athlete while in school. He played cricket, India's national and most popular sport, as well as table tennis. After high school, he hoped to study engineering.

"In India, similar to the rest of Asia, most young people want to become engineers and doctors," Ashok said.

After finishing high school, he applied to attend an engineering college, but was not accepted because

of the large number of applications. Instead he earned a bachelor's degree in science. After completing college and passing a certificate, Ashok was accepted into an engineering college where he earned a degree in chemical engineering. After graduation Ashok found a job and then felt it was his turn to help his brothers, by financing their college educations.

"I came to the United States with one hundred dollars in my pocket and a heart filled with hope for a better future."

"It was hard for my father to pay for the five of us to study in universities," Ashok said.

While studying at university, Ashok Nalamalapu started to think about going to America to work.

"I overheard my classmates talking about going to America to study further and to work there," Ashok said. "I liked the idea. It helped that my brother was already in America, working."

Ashok worked as an engineer for three years in India, while he dreamt about moving to the United States and saved money to pay for his journey. When he took the first step and went to the US consulate office in Bombay (now called Mumbai) to apply for a visa, he was surprised to see the long lines of visa applicants waiting outside of the consulate building. They were all there to be interviewed by the American diplomats charged with issuing visas.

Ashok left, returning to the consulate's office at midnight to stand in line: "I always like to be ahead of the crowd," Ashok said with a smile.

After waiting overnight with his passport in hand, he was let inside and interviewed. He thought the interview went well. He was asked to return to collect his passport later. By the afternoon of the same day, his passport was stamped with a visa.

"I screamed with joy running around on the streets of Bombay when I got the visa. That was thirty-four years ago," Ashok said. Single and in his late twenties, he was overjoyed to come to the land of opportunities.

In the years before he obtained his visa, Ashok's father had died. He went to see his mother, to give her the news of his departure and to receive her blessing.

"Out of the two hundred dollars I had saved, I gave her one hundred," Ashok said. "I came to the United States with one hundred dollars in my pocket and a heart filled with hope for a better future."

According to immigration experts, the technology boom of the 1990s in the United States caused a surge in the number of highly educated Indian immigrants, particularly those with a background in information technology, arriving with H-1B visas.

Ashok's decision to move happened before the trend started. According to the 2010 US Census, the number of Indians in the United States grew from almost 1.7 million in 2000 to 2.8 million in 2010 as Indian Americans became one of the fastest-growing ethnic groups in the United States.

In America, Ashok worked hard while going to graduate school. He attended the New Jersey Institute of Technology and received his master's in computer information systems. His first job was at IBM, consulting for a NYNEX company in East Fishkill, New York. As time went by, he inched closer to his personal and professional goals.

"I had come to America to succeed," Ashok recalled.

Ashok Nalamalapu spent the next few years working as an information technology contractor for IBM and other companies in the insurance industry.

Ashok met his wife while visiting India in 1990. They got married. He sponsored his wife to join him in America. A few years later, they were blessed with their first child, a daughter named Denali, which means "the highest one."

"It is the Athabaskan name for the mountain in Alaska," he said. "Her mother and I visited Denali National Park, and we both loved the park, and the name."

When Denali was less than a year old, the family was living in the suburbs of Philadelphia when a potential job in Maine altered the family's plan. Ashok's wife, a physician trained in India, was offered a job at Portland's largest hospital, Maine Medical Center. The family faced a dilemma: If Ashok continued in his field, he would have to either live outside of Maine or spend long hours commuting to work. Ashok did not want to be away from his wife and their young daughter. He decided to give up his consulting work and settle in Maine—a state with few professional opportunities in his field, and fewer available IT positions.

In 1996 he left corporate America in exchange for a family life in peaceful, but remote, Maine. Always an entrepreneur, Ashok decided to start his own IT consulting company in the Pine Tree State. Working from a room in his attic, he started iCST to provide companies with IT staffing and software testing. He chose the United States and India as business sites. In the beginning the company employed engineers and IT personnel working in India.

Ashok was not alone in starting a technology company, as a new immigrant from India. According to a joint study by Duke University and University of California at Berkeley, immigrants from India started more engineering and technology companies in the years from 1995 to 2005 than immigrants from the United Kingdom, China, Taiwan, and Japan combined.

Among his many projects, Ashok remembers writing a lot of programs to combat the over-hyped and much-feared Y2K bug, a potential problem in the coding of computerized systems that most believed would wreak havoc in computers and networks around the world when the year 1999 turned to 2000. All computers and application programs had to be upgraded to make them Y2K-compliant.

"I was kept busy! There were programs to be updated and tested," Ashok said, recalling a time when the entire world seemed to hold its collective breath in the months prior to the new millennium.

All the hard work started to pay off.

Within a decade or so, Ashok had transformed his business from a start-up into a successful company. At its peak, Ashok said, iCST had a team of fifty employees, with annual revenues of $5 million.

Professional recognition followed. In 1998, the same year his second daughter, Vishva (meaning "the universe," in Sanskrit), was born, Ashok was selected as Maine's Minority Small Businessperson of the Year. And in 2001, iCST won the Maine Governor's Award for Business Excellence.

He now leads group chanting at meditation festivals and sings in national and international events, large and small, that are dedicated to spirituality.

Spiritual Practices

Ashok believes his spiritual practices have helped him overcome challenges that life has presented. In 2000, he lost his voice due to health issues. Specialists told him he would never speak again. Ashok was heartbroken.

"I thought I could never say 'I love you' to my younger daughter, Vishva, who would never know how I sounded," Ashok said. He also worried about his business and role in the community. By this time he was a well-known public speaker, having been invited to speak on diverse subjects ranging from business, spirituality, and interfaith dialogue at schools, churches, business gatherings, and leadership training sessions.

Overwhelmed, he privately mourned the loss of opportunities to speak to large groups. He started to write, hoping to express his thoughts through a different channel, and his essays appeared in local newspapers and industry publications.

"One night, my older daughter, who was being tucked into bed, asked if I could read to her," Ashok recalled. "With my voice gone, I shook my head and sighed. She insisted, pleading for me to read 'just one page' to her. But I could not."

Ashok's wife, a medical doctor, helped work through possible solutions. After countless phone calls and conversations, Ashok got referrals to specialists and began traveling out of state for surgeries. Finally, after a few surgeries and rehabilitation over the course of a year, Ashok regained his voice.

In addition to the successful surgeries, Ashok credits the recovery of his voice to meditation and yoga. Now, years later, he can sing devotional songs again.

In 2008, Ashok attended a meditation gathering in Chicago and came back excited to practice. That was the start of a spiritual journey that continues to this day, one that defines who Ashok is. He now leads group chanting at meditation festivals and sings in national and international events, large and small, that are dedicated to spirituality.

In 2010 he founded Sadhana, a nonprofit spiritual center, in South Portland. The mission of Sadhana (pronounced SOD-a-na) is to cultivate

compassion through spiritual practice. Sadhana has had an active membership of a few hundred people, as well as some 4,500 individuals in its database, since its start. Luckily, months before the COVID-19 virus emerged as a threat, Sadhana went online, giving Ashok a global audience these days.

Ashok's spiritual quest took him to retreats and meditation gatherings all over the world, among them, the Netherlands-based Center for Nonviolent Communication. According to Ashok, the organization draws followers from fourteen countries engaging in international peace efforts. In Spain he participated in "One Mantra," an international festival, being held for the first time. It was the largest yoga festival convened outside of India.

Since founding Sadhana, Ashok has donated over $100,000, in addition to countless hours of volunteering, to the Maine-based spiritual center. The center's yoga classes and meditation sessions are open to the public. *Sadhana*, which means "spiritual practice" in Sanskrit, has become a safe and loving space where spirituality is practiced. By intention, Sadhana was not established as a Hindu temple. In pre-pandemic times, it hosted devotional chanting sessions. Additionally, Ashok said, Sadhana has served as a center for the followers of Maine's different religious groups who gather to discuss their respective traditions and to seek common ground with each other. In one case the local Jewish, Muslim, and Christian leaders participated in a ceremony, sharing stories and breaking bread together, to highlight religious unity.

Ashok taught himself to play the Indian harmonium, a traditional musical instrument that is used to accompany devotional singing, to help him in his chanting sessions. In many images on social media Ashok is pictured sitting on the floor, chanting, while playing the instrument's hand-operated keyboard. He is often joined by other chanters, including native-born Americans who play Western musical instruments. The groups sing devotional songs common to Hinduism, as well as those from other faiths.

The happy child without a TV or a phone in India has grown into a serene adult. He helps people from all backgrounds—different races and religions, rich and poor, native-born as well those new to Maine—find answers in their quest for spirituality.

"People of different colors and cultures are like the flowers of different colors that together make a beautiful bouquet," said Ashok, at a time when religious intolerance and sectarian violence across the world are seen as a threat to humanity.

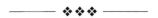

Itza Bonilla

El Salvador
Population:
6.486 million
Distance from Maine:
2,418 miles

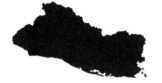

Born into a politically active family in El Salvador, Itza Bonilla knows what it's like to have people focus on her—not always in a good way. She hails from a long line of people fighting to make El Salvador a safer, more democratic country. Despite the uncomfortable attention that comes from those efforts and from immigrating to America without speaking English, Itza has achieved great success. She graduated from Bowdoin College and is now studying to become a lawyer. But even today she often finds herself struggling to understand where she is from—America or El Salvador?

Despite the political turmoil that her parents' generation faced and violence stemming from the illegal drug trade, Itza recalls a relatively peaceful childhood. So when her mother made the difficult choice to leave El Salvador, and her large family, to provide her daughter with a safer environment, more educational opportunities, and a better life, Itza resented her. Her mother's dream has come true, and Itza herself became a naturalized citizen in May of 2021, but she still does not yet feel fully accepted as an American.

Looking back, Itza has come to agree with her mother's decision, and, using her personal experiences, she now continues her family's fight for acceptance and respect for people from all backgrounds.

Fighting for Justice

Itza's parents were born in El Salvador and came of age during the civil war in Nicaragua. The war pitted the Contras, a far-right US-backed rebel group, against the Sandinistas, the leftist and Marxist government that held power in the 1980s. That conflict spilled over into and destabilized nearby El Salvador, which experienced its own civil war from 1980 until 1992. During this era, many young Salvadorans left their homes to fight in Nicaragua. Itza's father and uncle were part of a group of Salvadorans who fought for the leftist Sandinistas. The two survived the conflict, although her uncle was captured and tortured by the Salvadoran military.

Itza's family was in the political spotlight frequently as she grew up.

During the civil war era of the 1980s, Itza's father saw the injustices in Central America and decided to study to become a journalist, hoping to help expose the corruption in El Salvador. While attending the University of El Salvador, he met Itza's mother.

After graduation, Itza's father became heavily involved in politics as a reporter for a left-wing newspaper. He currently works as a journalism professor at the University of El Salvador. Itza's mother also worked at the university in its human rights program, and for UNICEF in El Salvador.

Itza's family was in the political spotlight frequently as she grew up. Itza's uncle, who was captured by the Salvadoran military, later worked for the United Nations and traveled to Timor Leste, a small island nation next to Indonesia, to help the newly independent country with conflict resolution and nation building.

Her great-aunt was a member of the Farabundo Martí National Liberation Front (FMLN), a revolutionary Marxist-turned-democratic-socialist party, and served as the mayor of a village in rural El Salvador. Her dad's cousin is still involved in Salvadoran politics today.

With the family in the spotlight, even small things could become an issue. When Itza was young, she received a vaccine at a local hospital—recently funded by the opposition party—and her photo appeared on the front page of the opposition newspaper. "My dad got a lot of crap for it," Itza said.

She quickly realized that her dad and family were important figures in Salvadoran politics. As she grew older, her family became disillusioned with the party government that they had been supporting.

"What the party stands for now is not what they were about before," Itza claimed. Her father felt the party was falling under the control of criminals in the drug-trade. Her parents originally

got involved with the FMLN—one of two major political parties—after it was created from five leftist guerrilla groups, because they wanted to make a difference in El Salvador and fight for a more equitable society.

While the civil war in El Salvador ended in 1992, there is still a lot of violence fueled by drugs. Itza never saw much violence firsthand, but she spoke about "children being abducted because they were children of wealthy people, and having to deal with ransom."

If the family didn't have enough money to pay the ransom, the loved one was killed.

Despite this brutality, Itza enjoyed a fairly normal childhood, growing up a little outside of the country's capital, San Salvador. The city is "pretty urban," she said. "Where I grew up it was more rural. I had a pretty normal life." She attended Catholic schools and enjoyed karate, ballet, and painting.

Itza acknowledges that she lived a sheltered, middle-class life in El Salvador. She visited her grandparents and relatives in the countryside, where they enjoyed Sunday-night dinners. "I have a lot of family memories that I don't have here in the United States, because many are still in El Salvador," she said.

Her great-grandmother lives in Tonacatepeque, an area in the countryside outside San Salvador that Itza describes as dangerous. The area is controlled by criminals tied to the drug trade who have waged a campaign of terror and violence

against its inhabitants. Luckily, Itza's great-grandmother has avoided being hurt.

"They don't mess with her because my family has had that land for as long as I can remember. It has been passed down for generations," she said. "Also, my great-grandmother has seen most of those people grow up and she gets treated as a grandmother of the town."

"I have a lot of family memories that I don't have here in the United States, because many are still in El Salvador."

Itza's mother worried about her daughter's future, growing up surrounded by so much violence. She wanted a better education and safer environment for her daughter, so she decided to move in with her parents in the San Francisco Bay area. By this point Itza's mother and father had separated and her father wanted to continue teaching in El Salvador.

Her mother also wanted Itza to be challenged. "I think she wanted me to have to work hard like she did growing up. She did not want things to fall easily like they had been to me," she said.

Seeking Opportunity

Itza and her mother came to the United States on February 9, 2009. "I think she just realized the

opportunities I would have both in education and my childhood would be better here," Itza said.

Itza was both excited and nervous about coming to the United States.

"I have some old journal entries where I recall being anxious, but super excited because I remember watching movies about the United States, and it seemed like such a glamorous place where everyone was constantly shopping and having fun," she said. "So, at nine years old, I was really pumped."

Her maternal grandparents, who owned a restaurant in Sausalito, California, were excited to have their daughter and granddaughter live closer to them, but her father's side of the family was not so pleased. Her grandparents moved to California to be with her grandfather's brother in the late 1980s. "They would not get to see me as often," Itza said. "But I think they ultimately understood that this was the best decision for my mom and me."

It was rough for nine-year-old Itza to leave her cousins, grandparents, and especially her father back in El Salvador. "Growing up I was very much a daddy's girl. Everything I did growing up was with my dad's family," Itza said.

She missed hiking, watching soccer games, and attending fairs and festivals with him. "I miss being able to be surrounded by so much family all of the time. My dad's family is big compared to my mom's, so I miss going over to their house during Christmas and seeing over fifty people

interact together," she said. "It's something I have not gotten since I was twelve."

Itza's first memory in the United States is of her grandparents picking her up at the airport and taking her out for pizza at their restaurant. Afterwards, they drove over the Golden Gate Bridge, and Itza was amazed by the size and beauty of the bridge and the Bay area.

It was rough for nine-year-old Itza to leave her cousins, grandparents, and especially her father back in El Salvador.

Itza started school in the third grade and attended a public elementary school where she went through ELL classes. Math was easy, but she had taken only basic English classes in El Salvador and struggled with the language. The language barrier made it more difficult for Itza to adjust to her new surroundings and to make new friends.

"I remember having to have people translate what I was trying to say to other kids in my friend group," she said. "There was this girl who I befriended who helped me a lot and would be my 'translator' when I was trying to communicate to other kids who did not speak an ounce of Spanish." By the sixth grade, Itza was attending mainstream English classes.

Her mother also found adjusting to the United States difficult. During her first three years in the

country, she continued to work remotely for the University of El Salvador as a coordinator for their Humanities Department, where she edited theses and honors projects.

"It definitely was hard for her," Itza recalled. "She was a single parent. She is a woman of color." Her mother now works at a bank in the financial district in San Francisco.

Itza attended Holy Names High School, a small, private all-girls Catholic school for middle and high school in Oakland. She graduated in 2016 in a class of thirty girls. In high school, Itza studied for hours and took SAT and ACT prep courses at the nearby university.

She planned to attend a top college in the United States that would set her up for law or medical school. "I think I always knew that I loved school, and I always knew that I wanted to make my mom proud," she said. Itza was considering Dartmouth College when her guidance counselor recommended Bowdoin College in Brunswick.

At Bowdoin, she found the strong political science department, pre-med program, and financial aid package that she sought.

Where Are You From?

Itza's move from California to Maine was exciting, but difficult for her mother. While Bowdoin represented the educational opportunity that she had dreamed about when she brought Itza to America, it was not easy to watch her daughter relocate three thousand miles away. The move also came at a time of tension between the two women.

Itza's mother worked hard to provide Itza with this opportunity, but that meant she was often absent. "She worked a lot when I was growing up," Itza said. "I would not see her. I only saw her on the weekends."

At Bowdoin, she found the strong political science department, pre-med program, and financial aid package that she sought.

It was during this time that Itza resented her mother for moving them to America.

"When I was younger, I was excited and naive," Itza said. "As I started to get older I came to resent my mom for not letting me choose if I wanted to come to the United States or not."

Now that Itza is older, she agrees with her mother's decision. Itza knows that she would not have received as good an education and would not have pushed herself as hard in life if she had not come to the United States.

"As I've matured, I have begun to realize why she did what she did, and I am grateful for her," she said. "I think my life, and my future, has been made much better by the decision to come to the United States."

At Bowdoin, Itza was a coxswain for the Bowdoin crew team. She also tutored children in Harpswell as part of America Reads and Counts, a program where she taught first-grade students at a local public school. She loves engaging with locals about New England life and finds it interesting how different people in the United States are from region to region.

Itza double-majored in government and biology and plans to continue her education in graduate school, studying bioethics and law. She hopes to eventually work with developing nations on health care.

While she loved Bowdoin, it also had its challenges. Moving to one of the nation's least diverse states was one of them.

"It's not like I am American or white," she said. "I am clearly not like that, so it is really different from going somewhere where you feel like you belong to somewhere where you feel like an outsider. It's a completely different mindset.

"I am so far from home that it is hard sometimes to relate to a lot of the people that I interact with, but I think that pushes me to think about the ways in which other people grew up."

Relating to people who come from very different backgrounds has transformed Itza into an extrovert. "It has taught me to pursue any sort of passions that I have and it has taught me to get out of my comfort zone," she said.

While these differences created opportunities for personal growth, Itza often feels like an outsider in America and disconnected from El Salvador.

"It is kind of weird for me, because I don't really think I am from El Salvador, because most of my life and learning has been in the United States," she said.

When people ask her where she is from, Itza often struggles to answer.

"I think it is tough, when someone asks me, 'Where are you from?'" she said. "In my mind, I am from California. And then they are, like, 'No. Where are you *from?*' And I am like 'Oh. I am from California. What do you mean?' And they are, like, 'Where are your parents from? And I am, like, 'Oh, I am from El Salvador.'"

Itza even experienced this form of hostility and xenophobia in college when, after telling one student she was from California, the student said, "No. You are brown. Where are you actually from?"

She also felt vulnerable and hurt during the Trump administration when the president made negative remarks about immigrants from Mexico and Central America, and directed unflattering rhetoric toward Salvadorans.

"The things he said . . . calling Salvadoran people and Mexican people lazy and not hardworking, that they use drugs, and are rapists, which is wild, because the majority of people coming from those countries in Latin America are none of those things," she said.

Itza said many Salvadorans, like her mother,

might not have a degree from Harvard, but they are still good, honest people just trying to get by.

"Just because you see someone who doesn't look like you doesn't mean you should underestimate them."

Wherever Itza goes in life, she continues to give those with different backgrounds a chance.

"Everyone should be given a chance," she said. "I think there are a lot of people who underestimate other people. Just because you see someone who doesn't look like you doesn't mean you should underestimate them."

Itza and her mother became naturalized citizens in May of 2021.

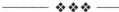

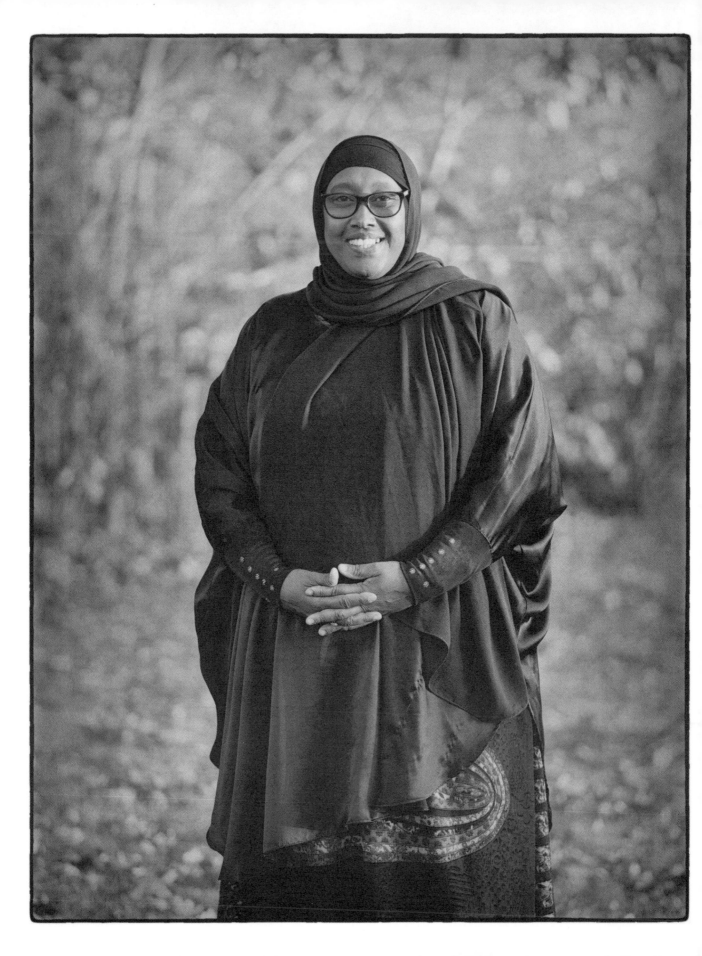

Deqa Dhalac

Somalia
Population:
15.89 million
Distance from Maine:
7,172 miles

Deqa Dhalac is the intercultural program manager at the Center for Grieving Children and the board president for the Maine Immigrants' Rights Coalition. She's a leader of the Somali Community Center of Maine and successfully ran for South Portland's City Council in 2018. She says she ran for office not only to challenge Donald Trump's attacks on the Maine Somali community, but to honor the legacy of her father, who rebelled against British and Italian colonial rule in Somalia.

Deqa's father, Abdi Dhalac, passed away in 1988. He never saw his daughter run for office, but his advice about the importance of educating herself and others propelled her campaign. He often told her: "If you die, people will inherit your wealth, your belongings, but the only thing that they cannot take away from you is your education. That will go to the grave with you."

"I always remembered that," Deqa said. "That's why I always want to make sure that I get a good education for myself and for my children and my family."

Abdi encouraged intellectual curiosity in Deqa and her brothers as they grew up in Mogadishu, capital of Somalia. He wanted them to know what was happening in the world and he wanted them to be inquisitive.

"There was always an education agenda of issues raised with my dad," she said.

He frequently discussed current events with his children, from issues between East and West Germany to the ousting of the Shah by the Ayatollah in Iran. Abdi even showed Deqa and her brother the television miniseries *Roots*.

"I remember watching *Roots* and we discussed that," Deqa recalled, adding, "That was eye-opening for me. I was like, 'Oh my goodness, why would this happen?'" The groundbreaking show aired in 1977 and was based on Alex Haley's book by the same name. It was Deqa's introduction to racial injustice in America.

Her father made sure they had tutors and could attend private language schools to learn English, Italian, and Arabic on top of their public education.

"He always gave us choices," Deqa said, recalling his talks about how difficult life was under colonial rule, especially in the countryside, how fortunate his children were to receive an education under those circumstances, and how those opportunities also imposed a duty to themselves and others.

"Do something to be proud of," he often told Deqa and her brothers.

In 1989, when Deqa was twenty-three, Somalia plunged into a civil war that pitted rebel groups against Siad Barre, a dictator who had ruled the country for twenty years. Siad Barre's regime started to crumble after a failed invasion of Ethiopia in the 1970s. His methods of controlling Somalia and quelling dissent grew increasingly repressive. Soon rebel groups started to pop up and challenge the regime. Siad Barre was ousted in 1991, but his ousting turned into a decades-long conflict that has left Somalia splintered into several states.

Deqa's family worried she would be hurt, or worse, killed, as the situation started to deteriorate in Somalia. One of her cousins who worked for a Somali airline bought her a plane ticket and sent her out of the country. She and a few other Somalis who were also fleeing the conflict went to Rome, where there is a Somali community, and where Deqa had some relatives.

Deqa stayed with her cousins in Rome for only a couple of months.

"That's when I felt very alone. I was staying with my first cousin who I grew up with. But she had to go to work. She was a domestic worker. So she had to go to a house and stay there for three or four days. The first night she took the day off because she had to bring me to the apartment she was sharing with two other ladies, who were not there, as well. So she left and she told me to go to this church for breakfast, lunch, and dinner."

Her cousin gave her a key to the apartment and then left.

Deqa already spoke English and Italian, so she felt like this would be easy.

"I am coming from Somalia where the sun sets at six o'clock in the evening. And I am here in Rome in summertime and I am expecting the sun to go down at six, but it did not. I'm looking at my watch. Seven, it is still up. Eight, I'm like, oh my god, that's it—I'm done. I am going to die here alone. The sun never sets down. It's doomsday. It's the end of the world. She did not explain to me that the sun does not go down until ten."

When her cousin came back to find Deqa upset, she apologized for not explaining. It was the first time Deqa had been outside of Somalia.

Deqa left Rome to stay with other cousins in London for a couple of months, then headed to Toronto, before arriving in the United States, where she lived in Atlanta.

After about thirteen years of living in Atlanta, first working as a cashier at a Marriott Hotel parking garage, and later, as an accountant for the same hotel, Deqa wanted to move somewhere quieter, with a better work-life balance. "It's a very busy town," she said. "You work, sit in traffic, and then go home."

She had an uncle in Lewiston, Maine, and knew of other Somalis in the Atlanta community who were moving there. She decided to visit Maine in 2004, and loved it.

In the winter of 2005, Deqa and her children, all of whom were born in Atlanta, moved to Lewiston. After spending most of her life along the equator and then in the warmth of Atlanta, Deqa had to prepare for a Maine winter. "It was a culture shock for the kids," she said.

She is still adjusting to the cold weather.

"Every year, I say, why am I here in Maine?" she joked.

After the move she began working as an interpreter for Catholic Charities in Portland. In Atlanta, Deqa had worked with many Somali immigrants, helping them learn to navigate their new lives in America. She showed them how to apply for benefits, how to register to vote if they had been naturalized, and where to receive health care.

Deqa wanted to give back to the Somali community.

"I received that help when I was in Italy, when I was in London," she explained. "I received that when I was in Toronto, so I have to give back as much as I can to make sure that at least they don't feel alone or isolated."

At each stop along the way to the United States, relatives, friends, and strangers from the Somali diaspora housed, fed, and comforted her. Deqa also wanted to honor her father's request that she "do something to be proud of" by helping the Somali communities in Lewiston-Auburn and Portland.

After several winters driving from Lewiston to Portland for work, Deqa moved to South Portland in 2008 to be closer to work and to avoid the icy commutes. She also started working for the City of Portland as a minority health/community health outreach worker, teaching life skills to new Mainers. She was involved with a grant-funded program to educate recent immigrants on "what is endangering their children. What kind of chemicals they use in their houses. How to throw those away. How to manage water," Deqa said. She also worked with new Mainers to raise awareness on public health issues like diabetes, hypertension, and STDs.

While working in public health, Deqa was finally able to pursue her education. She was accepted into a master's program in development policy at the University of New Hampshire. Deqa also graduated from the University of New England with a master's in social work. She balanced studying, taking care of

her family, and working, knowing that both of these master's degrees would help her serve those in need.

With her degrees in development and social work, Deqa worked again with the City of Portland as a human services counselor for new Mainers who were survivors of torture, particularly women who had experienced torture from repressive regimes. As Deqa's work increasingly shifted toward working with mental health issues and social work, she realized that she wanted to work with children who were grieving. She was eventually hired as the intercultural program manager at The Center for Grieving Children in Portland, where she currently works.

In 2016, while Deqa was studying for her master's degree, working, and raising her family, then-presidential candidate Donald Trump came to Maine. He attacked the Somali and new Mainer community in a speech.

"We are in this community, and this is a community we love and contribute to, and we are not going to take any negative things like that," Deqa said. She wanted to push back against the xenophobia and do something positive in her community. "I wanted to make sure I was really giving back," she said. "What am I doing? What changes am I making in my communities?"

Deqa saw her opportunity when a friend mentioned Emerge Maine, an organization that trains women who are Democrats to run for office. Deqa had lunch with her and representatives from Emerge Maine. "I thought 'This really sounds good.'"

Deqa ran the idea by her children to find out what they were thinking. Her oldest child was nervous.

"My oldest said, 'Mom, you are a woman, you are an immigrant, you are Black, you are Muslim. You got a big hijab on, and I don't want these people to do anything to you.'" He did not want her to become the focus of xenophobic, racist, and Islamophobic attacks that could turn physically violent.

Her two younger children saw this as an opportunity regardless of the risk, saying, "You have to do it, Mom, because you will be opening doors for people who look like you, women who look like you. You can open doors first for them. So if you don't do it, then who will do it?"

"It's a democratic house and majority rules," Deqa said. "We are going to do this thing." She trained with Emerge and prepared to run for local office. When the city councilman for Ward 5 in South Portland stepped down, Deqa took the leap. "My phone went wild with people saying you need to do this." She knocked on doors, met voters, and raised funds.

"What really helped me was building relationships," Deqa said. She met with local officials, organizations, and activists who helped her. She had a staff of volunteers who helped with the campaign and her social media presence. "I was really very lucky," she said. "A lot of people contributed to the campaign. A lot of people stepped up to volunteer to knock on doors.

"It was all positive. But you can tell if someone doesn't want to support you, they will say 'I am not a voter, or I just moved here,'" she laughed. She received very few negative responses during the campaign. She has received a few hate emails since taking office, but says she doesn't think they were Maine people.

On the South Portland City Council, Deqa has introduced new policies to promote racial equity and has followed in her father's footsteps by challenging power structures.

"For example, if we have affordable housing, the first thing they think of is to build those houses in Ward 5, which is my district, which has a lot of poor people and people of color," she said. "Not Ward 1 or 2, where it is close to the Willard Beach area. Why can't we spread affordable housing throughout the city?"

Now she works with other city officials and staff to help those who are eligible for United States citizenship to get the resources they need.

Deqa said that the South Portland City Council has now made it a goal to spread affordable housing throughout the city.

Deqa is also pursuing more diversity in hiring positions in South Portland, drawing upon her own experience with racial discrimination in Atlanta. While working as a cashier at a Marriott Hotel garage, she got to know the assistant controller of the hotel's finance department. "I told him I had a two-year degree in accounting. And he said, 'We are hiring. You should apply.'"

Deqa applied, but weeks went by without a response. When she saw the assistant controller again, she asked about the application, but he said he had never received it from their human resources department.

"So he called human resources and said I am looking for this person's application," Deqa said. "So he got my application, gave me an interview, and then he hired me."

Deqa said the department had tossed her application to the side.

"I talk about this a lot when it comes to the equity and the inclusion piece. The human resources person did not show my application."

Now she works with other city officials and staff to help those who are eligible for United States citizenship to get the resources they need. Deqa also helped create a permanent human rights commission in South Portland to examine the role of race and immigration status in interactions with police, economic development, and human resources.

Deqa has one piece of advice for dealing with the social changes that have come about since 2020: "Volunteer, do something in your community, give back. Respect other human beings and do not assume that if someone is from another country or another religion, you do not share any values with that person, without talking to them. You would be surprised. You have more in common than differences."

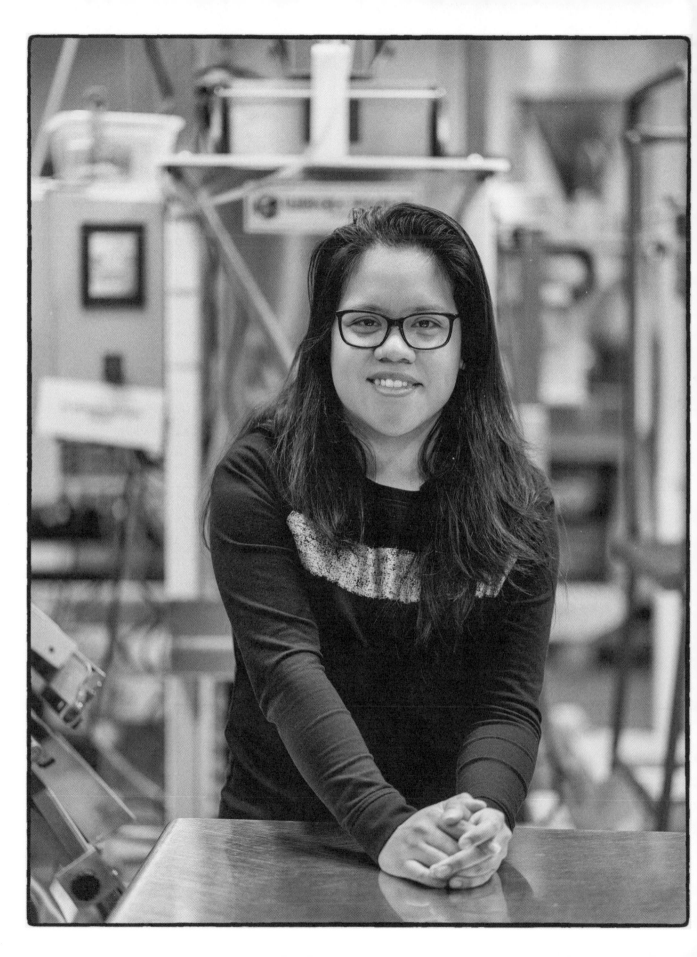

Quesias Parra

Ecuador
Population:
17.64 million
Distance from Maine:
3,245 miles

When she was pregnant, Quesias' mother spent time studying the Bible. As if she knew her daughter would become religious as an adult, she searched for inspiration in scripture. Her mother was unsatisfied with the more common names like Mary and Maria. She found her answer in the Book of Job, as one of Job's daughters is named Quesias, or Keziah in English. According to Job 42:14: "The first daughter he named Jemimah, the second Keziah, and the third Keren-happuch . . . Nowhere in all the land were there found women as beautiful as Job's daughters, and their father granted them an inheritance along with their brothers."

"I love my name. But some people have a difficult time pronouncing it," Quesias admitted.

In Ecuador, at least when Quesias was born, parents were not allowed to give their offspring Western or American-sounding names. When her mother was told Quesias did sound foreign, her grandmother intervened, using her contacts to get a compromise. In order to get a birth certificate issued for her newborn daughter, Quesias' mother took a copy of the Bible to the government office charged with birth registration.

"It became a big deal!" Quesias said.

Quesias Parra was born in Guayaquil, formally known as Santiago de Guayaquil, which is Ecuador's largest city and main commercial port. The city's population in 1994, when Quesias was born, was more than 1.5 million. In

117

1987, the city was named the sister city to Houston, Texas. Ecuador gained fame for exporting Panama hats—straw hats that were shipped to Panama and worn by crews that worked on the Panama Canal in the early nineteenth century.

"I was a surprise baby! I was not expected. I was so spoiled by my parents that I did not learn to speak till I was six years old!"

Ecuador is a country in northwestern South America, bordered by Colombia on the north, Peru on the east and south, and the Pacific Ocean on the west. Its diverse landscape encompasses Amazon jungle, Andean highlands, and the wildlife-rich Galápagos Islands in the Pacific. The country has experienced major political and economic upheavals, including long periods of military rule. The nation of some seventeen million people suffers from disparity in wealth distribution.

The family of five—her two older brothers and their parents—arrived in the United States on visitors' visas in the late 1990s. Quesias was four years old and has no memories of coming to America, but she knows that they lived in Brooklyn with her aunt for five years. Quesias' parents disliked living in New York because they preferred a rural setting.

They left Ecuador because of the country's financial crisis in the late 1990s. The small South American country was bankrupted by the combination of a collapse in oil prices and unusual weather conditions that affected agricultural production. Oil and bananas were Ecuador's main exports. With revenue from oil declining and the banana crop damaged by the storms, food prices increased rapidly, causing hardship for ordinary Ecuadorians.

To stop the hyperinflation and help the national economy recover, the government abandoned its currency, the sucre, and replaced it with the US dollar. Quesias said the exchange rate was 25,000 local currency to one dollar, which caused great losses for most Ecuadorians. National banks were unable to honor their customers' requests for withdrawals.

Quesias remembers hearing about massive migrations, primarily to the United States and Spain, which were triggered by the financial crisis. From 1999 to 2000 approximately 400,000 Ecuadorians migrated to the United States. By doing so, they joined roughly 500,000 other Ecuadorians living in this country, making the United States home to half of the country's diaspora.

In the 1990s, when the family left Ecuador, Quesias said, there was hardly any work there. "People were suffering," she said. "Some died because they had lost all their savings."

Faced with poverty, the Parra family considered Spain, but left Ecuador in search of better economic opportunities and more secure lives in the United States.

Before Quesias was born, her parents had been blessed with the birth of two boys.

"I was a surprise baby! I was not expected," Quesias said. "I was so spoiled by my parents that I did not learn to speak till I was six years old! I never

had to ask for anything by its name. All I did was to point at something, and it would be handed over to me."

Her family worried that she was mute. By the time she began to speak, they were living in New York and were surprised to hear her speak fluently in both Spanish and English. Quesias credits her mother for this trait. She spoke to the family in both Spanish and English, to ensure they would be bilingual.

Despite being a spoiled child, Quesias is now a hard-working young woman. She worked while attending school, just as her parents and her siblings did. In Portland, she started as a barista at Coffee by Design, a family-owned business known for its socially responsible practices.

"We are coffee drinkers in Ecuador. But even though we grow our own coffee, we'd rather drink the better-quality and imported Colombian coffee," she said.

After they arrived in New York the family made huge sacrifices to rebuild their lives. The parents worked long hours to provide for the family.

When she was in Brooklyn, Quesias' classmates asked her about Ecuador and where it was located on the globe. She was surprised to hear that they did not know much about Ecuador, or about the continent of South America. In Maine, she is often mistaken for Mexican, even though she does not look like someone from Mexico.

After five years in New York, the family moved to New Hampshire. Quesias said they waited for the right time to leave Brooklyn and move closer to relatives in Nashua, New Hampshire. They spent the next fourteen years in Nashua, before moving up to Maine. In New Hampshire, Quesias missed the ocean. She remembers the family being ready for a change when they came to Maine four years ago.

It took the family more than two decades to adjust their immigration status to become permanent residents eligible for citizenship. Thanks to Section 245(i) of the Immigration and Nationality Act, certain immigrants otherwise ineligible for changing their status in the United States are permitted to pay a penalty and then become eligible for permanent residency without having to leave the country. The family's dream to become legal residents has become a reality.

The Parra family's immigration case took longer than usual due to the 9/11 terrorist attacks in New York and elsewhere in America. In post-9/11 America, immigration, a formerly cherished American principle, received negative attention. In New York immigrants were targeted with suspicion. Nationally, there were widespread acts of discrimination against immigrants and their family members. Quesias said her father was challenged by Americans who disliked immigrants because they believed Hispanic immigrants were responsible for stealing jobs from Americans.

"My father told them why we moved here, mentioning the economic hardship we faced," Quesias said. "Frankly, if there were jobs in Ecuador, we would be working and living there."

In the post-9/11 era, applications for immigration status changes and the related paperwork faced major delays, in part because of new time-consuming background checks.

As if she wants to live up to her name, religion is central to Quesias' life. In New Hampshire, the entire Parra family converted to become Jehovah's Witnesses, a distinct Christian denomination.

According to a 2010 story in the *Seattle Times*, Jehovah's Witnesses' membership has increased from nearly 1 million to 1.2 million over the last four years. That surge is in part due to the growth of non-English congregations. Spanish-speaking converts make up a major part of this increase. (In Ecuador, more than 90 percent of the population consider themselves Roman Catholic.) The Pew Research Center says that Jehovah's Witnesses—less than 1 percent of US adults—are known for their door-to-door proselytism, and are "among the most racially and ethnically diverse religious groups in America." In 2020, the group reported a worldwide membership of 8.7 million.

Unlike other Christians, the Witnesses, as the members are known, do not believe in the Trinity. They reject the immortality of the soul and the eternal fire of hell awaiting sinners. They do not observe Christmas, Easter, birthdays, and other national holidays.

"We don't celebrate the usual holidays, but we do celebrate weddings, baby showers, anniversaries, graduations," Quesias said. She added, "Sometimes we just like to get together with friends. We don't wait for holidays to give gifts to friends or family."

While modesty in dress is emphasized, the religion forbids excessive use of alcohol, as well as illegal drugs, tobacco, and gambling. New members must be baptized.

Quesias was baptized when she was thirteen.

"I was in high school, and some kids were talking about religion," she said. "They mentioned the Jehovah's Witnesses and said they knocked on people's doors at three a.m. I smiled and said I was a Witness, and we did not do that. They stayed quiet and did not say anything more. After the class, one of them came up to me and said she was sorry."

Witnesses meet to worship and study at Kingdom Halls, functional buildings that lack religious symbols. Quesias worships twice a week, on Wednesdays and on Sundays.

"We believe in the Bible. God has made a promise: If you follow the rules, you will have a happy life," Quesias said.

Quesias misses the family she has left behind in Ecuador, the love they reserve for one another, and the sense of togetherness. She yearns to be with her maternal grandmother, who is ninety-four and suffers from dementia.

After gaining legal status and getting documents in place so they would be able to come back to the United States, Quesias and her family returned to Ecuador for a visit. At the time, they had been away for fourteen years. During a conversation with her grandmother, she mentioned a daughter who was "skinny and with long hair, who had a daughter of her own."

Quesias realized the skinny daughter that her grandmother remembered was her own mother. And the daughter was no one other than Quesias herself. She tried to persuade her grandmother that she was the same granddaughter. The elderly woman did not budge. Even when Quesias's mother explained that she

was the skinny daughter, her grandmother dismissed their argument, saying, "You do resemble my daughter, but you cannot be her. She was skinny, while you are somewhat chubby."

"My mother was heartbroken. After coming all the way to see her mother, she did not even recognize her. It was hard for her to accept," Quesias said.

Her mother had been sending money back to Ecuador to help with the grandmother's living expenses—a common practice among immigrant families. Migrants often provide financial support for the family members left behind.

"Despite sending money, my mother feels she is not doing enough," Quesias said. "Sometimes she feels she has abandoned her elderly parent by coming to America."

While visiting Ecuador, Quesias was teased for acting "white" by cousins around her age, but it hardly bothered her that they thought she was more American than Ecuadorian. She said she decided to ignore the jokes.

Her mother, however, teases her about being single at twenty-six.

"My mother tells me, 'When I was twenty-three, I was already married, and I had a child by the time I was twenty-five years old,'" Quesias said.

Quesias associates missing home with her longing for Ecuadorian food. In Maine, no stores or restaurants offer Ecuadorian food, so she makes simple dishes that do not require hard-to-get ingredients. Ecuador is famous for its bananas, and green plantains are plentiful and cheap. A typical Ecuadorian breakfast is *bolon*, a fried plantain mashed with cheese and then shaped into a ball.

"For snacks, we cut a plantain in half, put cheese on it and then grill it," Quesias said.

Quesias hopes to marry and own a house one day. She became a naturalized citizen, a personal goal, in 2018. Other members of the family had already become citizens, but the COVID-19 pandemic delayed her father's case. It has slowed down immigration processes across the United States.

Quesias dislikes the current anti-immigrant sentiment in America and the name-calling that targets Spanish-speaking migrant workers. She is uninterested in national politics, but defends hard-working, law-abiding immigrants.

"Immigrants come here to work," she said. "Trust me—nobody would leave their countries to come here if their countries were doing better."

She believes there are good and bad people everywhere, including in the immigrant communities. She added, "Our first country is the one we left. This is our second home. We should be respectful toward America."

According to the Book of Job, Keziah, Quesias's namesake, was a symbol for female equality in ancient times, as she and her sisters received an inheritance from their father—an unusual practice at a time when men and women were not seen as equals.

Quesias, however, strives for a life of spirituality and purity. She does not ask for much in her new life in the United States.

"I do not want to be rich, or famous," she said. "Just a simple life will be enough."

Mohammed Al-Kinani

Iraq
Population:
40.22 million
Distance from Maine:
5,587 miles

Mohammed Al-Kinani—or Mo, as his friends call him—received death threats as a teenager in Iraq. Al-Qaeda, Jaysh al-Mahdi, and other insurgents were facing off against Iraqi security forces and American and allied troops. Mo's neighborhood was a battleground. His father served as an interpreter for the American military.

One day Mo's father, Khalid Al-Kinani, received a bullet in an envelope. An insurgent had slid it under their front door. It was a warning, saying they knew he was working for the American military. Later, he received a note saying Mo would be killed if he went to the local boxing gym. Khalid realized that they needed to leave Iraq and start a new life in America.

Mohammed Al-Kinani knows the value of hard work and determination. The former boxer and current mixed martial arts fighter had to stop fighting in Iraq because of a death threat from a Shia death squad. He gives his parents, whom he watched start over in America in 2012, all the credit for his positive mind-set.

Life in Iraq Before the War

Mo was born on March 5, 1996, in Al-Hurriya, a neighborhood in Baghdad. His father owned a restaurant in nearby Al-Kadhimiya. Before the Iraq War, the neighborhood was religiously diverse, with

123

both Sunnis and Shias living alongside each other. It is now predominantly Shia.

Al-Kadhimiya is home to the Al-Kadhimiya Mosque, a holy site for Shia Muslims. The mosque holds a shrine for the seventh Imam of Shia Islam, a holy figure called al-Kadhim. The neighborhood borders the Tigris River on its west bank and attracts many religious tourists from Iran, Turkey, and Syria, as well as Muslims from around the world.

"It was pretty crowded, overpopulated; a lot of people spoke different languages," Mo said. "A lot of people from Iran. A lot of people from Turkey and Syria . . . basically just Shias."

Mo's father, Khalid Al-Kinani, a Shia Muslim, and his mother, Nahla Ghanwan, a Sunni Muslim, met in college at Al-Mustansiriya University in Baghdad, where they both studied to become librarians. "My mom comes from a really rich family so she never actually needed a job," Mo said.

When he was younger, Khalid worked in construction and ended up starting his own profitable cement-transportation company. The self-starter also opened a clothing store while he was in college. After graduating he started and ran a kebab shop called Al-Jawdin (a nickname for the two historical Imams of Al-Kadhimiya). Khalid's business partner now runs the restaurant, which still serves kebabs.

Prior to the start of the Iraq War in 2003, life was relatively calm for Khalid, Mo, and the rest of the family. Mo played with his cousins after school

and his father worked at the kebab shop. According to Mo, life was peaceful as long as one did not question the authority of Saddam Hussein.

"In schoolbooks on the very first page after the cover, I open up the cover and see a picture of Saddam and the Iraqi flag right next to it," Mo said. This was done to indoctrinate young students and ensure loyalty to Saddam Hussein.

War Comes to Iraq

Mo remembers when he learned that America had invaded Iraq. In March 2003, his parents didn't let him leave the house for several days.

"My cousin came up to me. He is two years older than I am," Mo said. "We were not allowed to go out for a few days. So we just stayed at home. We had no school. But he came up to me and was, like, 'Hey, do you have your books? Bring your books.' So I brought a couple of my books upstairs to his room. He opened them up and immediately was, like, 'Let's do something,' and he grabs a pencil and he starts drawing on Saddam's face. Like, he drew a mustache. He drew some glasses . . . and I am just in shock, you know? I know we don't like that guy, but I know we could get in trouble for that.

"I was just, like, 'What are you doing?! Your teacher is going to see this! You're going to get in trouble!' I am just freaking out. And he is, like, 'No. Relax. Saddam is no longer there. He ran away . . . The American army is here.' And I am, like, 'Is that good or bad?' I was clueless."

Soon after they had toppled Saddam Hussein's regime, Mo encountered American soldiers for the first time.

"The memory I have of them was them giving away candy," he said. "They would need to go through neighborhoods every once in a while. They would look for weapons . . . if you had a gun you would give it away to the American government."

The American invasion of Iraq created widespread looting, chaos, and instability, which culminated in a bloody civil war between Sunni and Shia Arabs.

He remembers the soldiers as being nice.

"They were just giving candies. They would start to have conversations. They would try to learn Arabic and would know some basic words."

Watching American soldiers, tanks, and convoys come down the street should have been intimidating, but Mo, who was seven years old at the time of Iraq's invasion, was not afraid.

"The image I have is literally just soldiers standing with a bunch of little kids around them. They can't be the bad guys," Mo said. "That was my thought process at the time."

While his family was happy that Saddam Hussein was no longer in power, they were skeptical that the transition would be peaceful. Hussein had ruled Iraq by pitting various ethnic and religious groups against each other. When he was gone many of the groups, like extreme factions of the Shia majority targeted by Saddam Hussein, sought revenge against Sunnis, regardless of whether or not they had supported Saddam Hussein. In turn, disillusioned Iraqi Sunnis who were afraid of losing their former status took up arms to fight Iraqi Shias. This would turn formerly peaceful mixed Sunni and Shia neighborhoods into battlegrounds.

Mo's family, a mix of Sunnis and Shias, was caught in the middle.

The American invasion of Iraq created widespread looting, chaos, and instability, which culminated in a bloody civil war between Sunni and Shia Arabs. The civil war killed hundreds of thousands of civilians and created a refugee crisis that displaced millions.

Mo's mother is Sunni and his father is Shia, so Mo's entire extended family is a mix of the two. According to Mo, Sunnis and Shias previously coexisted peacefully. The violence and hatred were manufactured and exploited by groups seeking power by dividing Iraqis and pitting them against each other.

"We never had a problem with Sunnis or Shias," he said. "That was created by the public, Jaysh al-Mahdi, and Al-Qaeda. They would respond in between them. They started hurting their own people. You know, I remember Jaysh al-Mahdi actually made some explosions . . . and they blamed it on Al-Qaeda."

Jaysh al-Mahdi was a radical Shia militia that would attack Sunni Iraqis, Iraqi security forces, and American soldiers. Al-Qaeda is an international terrorist organization that follows an extreme form of Sunni Islam. Terrorist groups like these used violence to create divisions between Sunnis and Shias and push the groups to extremist positions.

The boys would pause to determine if the gunfire, mortar rounds, and car bombs were close enough to hurt them.

Mo's childhood continued, despite the increasing violence between sectarian groups and insurgent forces facing off against American soldiers and Iraqi security forces. Sometimes, when he would play soccer with his cousins and friends on the streets and nearby fields, the boys would pause to determine if the gunfire, mortar rounds, and car bombs were close enough to hurt them. If they seemed far enough away, the boys would resume playing. According to Mo, this was their new normal.

In addition to soccer, Mo looked for other activities to help him find normalcy amid the rising violence. Strangely, he turned to boxing. Growing up, Mo had a cousin who liked to pick fights with other kids in the neighborhood. Mo often intervened to save his cousin from getting beat up. One day, Khalid caught his son and his cousin fighting with a group of kids. He made Mo promise to never fight anyone again. If Mo wanted to fight, Khalid said, he would have to take up boxing.

"I simply got into boxing because I was the worst soccer player out of my cousins, friends, and kids I grew up around," Mo joked. "I knew I had to try something different."

During this time Khalid enlisted as an interpreter to help the Americans, hoping to bring stability to his country and to fight Al-Qaeda and Jaysh al-Mahdi. He joined the American Army in 2006, at the height of violence in Iraq and during the early stages of the occupation. This was just before the American surge that led to heavy urban fighting throughout the country. He worked with the United States military for three years, keeping this a secret from Mo.

"Honestly, for the first three years he worked for the United States, I had no idea," Mo recalled. To this day only Mo, his mother, and a few of his uncles know that Khalid served as an interpreter for the US military.

"From what I understood, he was just leaving to run a business he has in Karbala [a holy city south of Baghdad] or something like that. He would leave for two weeks and would come back for a week."

Mo eventually started to realize that his father was working with the Americans.

"I noticed my dad would have toothpaste that would not have an Arabic word on it," he said.

"We would have snacks that would just be like the snacks you would have here [in America]. I had no idea what these snacks were and I started questioning myself. However, I was afraid, because that was when Sunnis and Shias were at war."

Death Threats

The risks Khalid took in helping the Americans were real.

"He kept it low-key . . . secret. We lived in an area where there was no government," Mo said. "It was run by Jaysh al-Mahdi."

The neighboring town was Sunni and heavily controlled by Al-Qaeda, the precursor to Daesh, which is also known as ISIS. "It would be big, big trouble if these people found out my dad worked for the Americans," Mo said. "My family would be kidnapped and killed. Especially me."

In spite of the danger, Khalid worked hard to improve his knowledge of English and his skills as an interpreter by playing English words over and over on an MP3 player. He carried a dictionary with him and a little green notebook in which he would write down new words as he learned them. With these three tools he was able to teach himself English.

But the danger of working as an interpreter got to him.

"My dad was never the same," Mo said. "He had a different car, had a different taxi pick him up every day." Khalid would even alter his appearance to avoid being noticed or caught.

"He was trying to be not him," Mo said. "He was trying to hide from something."

If Al-Qaeda or Jaysh al-Mahdi had found out that Khalid was helping the Americans, they would have killed him.

Mo remembers when his father received his first death threat.

"He got a letter from under the door and he just picked that up and went inside the house and I went inside the house," he said. "Inside there was a bullet."

No note or letter was necessary. Everyone knew what the bullet meant—it was a typical warning. They knew he was collaborating and would kill him if he did not stop.

Mo's family was respected, which protected them for a time.

"We were kind of well known," Mo said, "so they couldn't just say, 'Hey, this guy works for the American army; let's put him in the trunk and no one is ever going to look for him.' They are going to get in trouble too with my family."

Instead, the militant groups began to cause disturbances at the restaurant his family owned.

"It developed into a big fistfight with the restaurant workers. My dad got involved, and the cops got involved," he said. "After that, the problem was solved, but those people never stopped bullying my dad."

The death threats continued. One was even aimed at Mo. It said that he could no longer go to Al-Kadhimiya Boxing Club. "I was not allowed to walk anywhere in Kadhimiya anymore," Mo said.

This went on for a year and a half. Despite the danger, Mo did not stop boxing. He would take a taxi to the ring where he would train and then come home, accompanied by an older cousin.

The threats and stress finally got to Mo's father. Khalid did not want his family to suffer or be killed because of his involvement with the American army. The US military told him that he could be resettled in America after his contract with them ended. Although he had already declined the offer, Khalid rethought his decision.

After several discussions, Mo's parents chose to leave Iraq. The decision was hard on Mo, who was entering his sophomore year of high school, but he respected his parents' courage.

Escape to America

"The US Army gives interpreters the right to leave if they want to. That option was always open to him. However, my dad said no at the beginning. 'I have little kids. I want them to grow up here. Everything is all right.' After all that crap happened, he changed his mind and contacted people he worked with about the death threats. He told them his life was not in danger back then, but now it was."

The family discussed resettlement with the International Organization for Migration.

"We had to be really secretive about it," Mo said. "We couldn't even tell other family members about it. Didn't tell anyone until two weeks before we left."

Only Mo, his mom, and a few of his uncles knew. Mo's parents kept the conversation as light as possible for their daughters: "'Hey, you guys want to go on a trip . . . Hey, we are going to go to America. You are going to have better schools, they are going to have parks, they are going to have this and that.'"

Mo's conversation was different.

"I was sixteen years old. I was just in high school. I had plenty of friends," Mo said. "I had just started to go out on my own and explore. Because when I lived during the war my parents would not let me go out on my own, even to go shopping, like in the city center or something like that."

All of this made leaving Iraq difficult for him.

"I took it really hard, because I took it as my dad telling me to leave all my friends, all my life, all that stuff, and start all over," Mo said.

Despite not wanting to leave, Mo knew his father just wanted to do what was best for the family. "It must be good for me," Mo said. "I trust that man. I always trust his decisions."

Apart from the soldiers that patrolled the streets, Mo had had little interaction with Americans, or even basic knowledge of America. "Honestly,

movies were the only exposure I had," he said. "*Spy Kids* was one of the first movies I was interested in. A lot of Disney movies, you know. *Twilight* was the first exposure to the high school type of deal."

Mo and his family moved to Westin, Virginia, where he had an uncle, but they quickly realized Westin was not the best fit for them. It was too spread out and too expensive.

Mo's father heard from an Iraqi friend who had also served as an interpreter. He lived in Westbrook, Maine, and recommended the city to Khalid.

"The guy gave a pretty good image of Maine and how nice Mainers are. He was getting the help he needed to start up," Mo said. "So we got everything in a U-Haul and drove up."

Starting from Zero

As Mo entered his first American high school in Maine, he worried about being bullied and learning to communicate.

"School was different, you know," he said. "It's not like they make bullies in the movies just . . . bullying kids and stuff like that. But it's different. If there is any bullying in high school, kids are secretive about it."

Besides bullies, the most important thing to Mo was learning English as quickly as possible. "How am I going to survive high school?" Mo thought at the time. "I need to talk to girls in order to go out."

A fellow student, Mo's neighbor, invited him to his lunch table on his first day of school. Mo didn't have problems with bullies, but he did struggle with the language barrier.

"I spoke no English—nothing. Just listening. I was just in learning mode," Mo said. He desperately wanted to communicate with his new classmates. "I was just observing everything. Everything was new to me, still."

He learned sayings and slang from his teammates as they drove him to practice and games. Sometimes he was confused, like when some teammates said a table was "sick."

He was exhausted every day. "I would just go home and fall asleep after school."

Joining Westbrook High School's soccer team was a great way to learn English, integrate into his new environment, and even pick up American idioms. He learned sayings and slang from his teammates as they drove him to practice and games. Sometimes he was confused, like when some teammates said a table was "sick."

"In my head I was, like, 'It's a table. How can it be *sick*?'" Mo recalled. "I learned the lingo as they spoke between themselves and as they spoke to me."

Mo's teammates were supportive, helping him learn and adjust. "They never made fun of me

when I got something wrong or made a mistake or something like that. In fact, they corrected me and told me how to say it and I never was offended in any way," Mo said.

By his senior year, after only two years in America, Mo had moved into mainstream college preparatory English classes.

Mo applied to several colleges in Maine and was accepted to Husson University, the University of Maine, Thomas College, and the University of New England, but his family had other plans. His dad wanted to move to North Carolina to find cheaper living costs and warmer weather.

"I just wanted to get out of there," he said. "The South was really brutal to me."

They moved to High Point, North Carolina, where Mo attended Guilford Technical Community College, but was unhappy. "I just wanted to get out of there," he said. "The South was really brutal to me."

Mo said it was there that he encountered widespread racism and discrimination for the first time. "You can feel the tension," he said. "It was terrible. I couldn't find a job for the longest time for the simple fact that the name on the résumé was Mohammed. After I realized that, I made my way out and came back to Maine."

His family also realized they wanted to return to the Northeast.

"A month in, they decided this was not a place to live," Mo said. His family had moved south for cheaper living, but "I tried to explain . . . the life is going to be cheaper as well," he said. Mo tried to tell his father that "here in Maine, he is paying for the quality of life. He is paying for the safety, he is paying for everything that North Carolina would lack."

The move was an opportunity for Mo to show his maturity to his family.

"Now, my father did not believe me until he went down there and saw it for himself. Since then he has actually been asking me about any life decision he has to make," Mo said.

Since returning to Maine, Mo's mother has worked for a textile factory in Westbrook called American Roots. The company has given her the opportunity to succeed. She is now the production floor leader. Khalid worked at a gas station in Portland on Forest Avenue before being robbed at gunpoint. At Mo's urging, he quit and began working for American Roots as well. Mo's three younger sisters are in school. One is studying at Saint Joseph's College, while the other two attend Westbrook Middle School.

After returning from North Carolina, Mo briefly attended Southern Maine Community College before dropping out to return to his real passion—boxing. "I met some good people who actually saw the talent in me," he said. In particu-

lar, he met his coach, Nate Libby. "He's a brother to me, I would say."

At first Mo hung around Nate's gym, working out. Then he attended Nate's boxing classes. "Now I was a boxer who was extremely out of shape," Mo said. "I was just starting again after a two-year gap. I just started training on my own and beating his members up on a regular basis without legit training. So he just took me in and started teaching me wrestling and jiujitsu."

Mo says Nate made him "a better well-rounded fighter" and ultimately credits his coach for connecting him with one of the biggest mixed martial arts promoters in New England. Mo has enjoyed great success in the early stages of his career. He is ranked first in New England and second in the Northeast in the lightweight division.

In pursuing boxing, Mo relies on a lesson his father taught him. "If he taught me anything it was a mind-set," Mo said. "You gotta start from zero."

If he had stayed in Iraq, Mo explained, he probably would have taken over his father's business. Instead, Khalid took Mo to a place where he could actually prove himself with his own hands, starting from zero.

"That is awesome," he said. "That is the biggest lesson he taught me. I'm definitely forever grateful for him, and I'll give back to him. It's a debt."

Mo believes he owes his parents for giving him this life in America. He can only repay them by developing his mixed martial arts and boxing talent. It is this debt that leads him to wake up early in the morning, run fifteen miles, and train for hours every day.

"So, the whole story is, I am the friend of two amazing people—my mom and my dad," Mo said. "Now these people gave me everything. They never asked me for anything. I need to pay these people back. I need to do something for them and I need to do it fast. I'm a talented fighter, so I am going to take that to the next level. And I think I am going the right way. I want to give them a key for a new house. That's the motivation. I'm in debt. I'm in debt with people who will never ask anything in return. But I want to do it on my own."

Mo also feels indebted to his new hometown.

"Westbrook gave me everything," he said. "I forever will represent Westbrook. I already have in every single fight. So that's another debt that I need to return. The friendships. The stuff I have learned. The life."

Zoe Sahloul

Syria | Lebanon
Syria Population:
17.5 million
Syria Distance
from Maine:
5,327 miles

Lebanon Population:
6.825 million
Lebanon Distance
from Maine:
5,250 miles

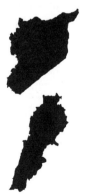

When you hear Zoe Sahloul talk about her life, you might think it sounds like a love story—a Lebanese love story, with a happy ending. She met her spouse, Walid Moumneh, in the seventh grade. They quickly became best friends, stayed in touch throughout their schooling, and attended the same college. They got married when they were both twenty-seven. The only time they were separated was when Walid went to study in Paris after receiving a scholarship. He could not bear the split and returned to Lebanon after just nine months.

"He's my rock! Our love has sustained us during the 1980s and '90s civil wars in Lebanon," Zoe said.

Zoe was born in Beirut, Lebanon. Her parents were Syrian. Her maternal grandmother had moved to Lebanon after her husband died in Syria. She was young and feared her husband's family might ask for the custody of her four children, including Zoe's mother, who was nine at the time. She took her children and left Syria, seeking a new life in the neighboring country. Zoe's father was from Damascus, Syria, but also grew up in Lebanon. Zoe's parents met in Lebanon, got married, and had seven children.

Although she identifies as Lebanese, Zoe has maintained a connection to Syria. When she was younger, she visited Syria frequently to spend time with her relatives. Now that Syria is embroiled in a bitter civil war

and many cities, including her mother's hometown of Aleppo, are in ruins, Zoe wonders what has happened to the people she knew there.

"Some of my relatives, after fleeing the war, are living in Jordan and Turkey now. Some have become displaced internally in Syria itself," Zoe said. "They are in limbo. COVID-19 has made their lives miserable. One of my uncles and a cousin have died of the virus."

Zoe's childhood memories of vacations in Syria are in stark contrast to the current situation in the country. Today, Syria is known for a brutal civil war that has lasted over a decade and caused the displacement of five to six million refugees, as well as a few million more displaced internally. The civil war began when antigovernment protests were met with violent backlash from the regime of Bashar al-Assad, the country's nineteenth president. Zoe described pre–civil war Syria as a beautiful country, known for its ancient cities and splendid Byzantine and Islamic architecture. She said the capital, Damascus, is one of the oldest cities in the world and home to ancient and magnificent mosques and shrines. She added that in her experience Syrians were kind, hospitable, and generous.

"When in Syria, a family might invite you inside. Even if they were poor, they'd put together a feast for you," Zoe said. "That was different than in Lebanon, where you had to be a relative or a friend to be treated that well."

There were other differences between Lebanon and Syria.

"In Syria, things were more affordable," she said. "There was less wealth disparity compared to Lebanon, where some people were extremely wealthy while many others were poor. Because the Syrian state subsidized what people needed, most things were cheaper compared to Lebanon."

Zoe remembers shopping at Syrian bazaars with her grandmother.

"My grandmother used to bargain to lower the asking price. It was fascinating to watch how most of the time she ended up paying half of the asking price!"

Zoe described pre–civil war Syria as a beautiful country, known for its ancient cities and splendid Byzantine and Islamic architecture.

Her other childhood memories of the country include accompanying her mother to visit Zainab Mosque, located outside of Damascus. Inside the shrine, her mother left cash she had pledged to give to charity in return for wishes. "The money the pilgrims left there was used to help the orphans, or the widows with no income, and the elderly," Zoe said.

She said the modest Syrian residences were beautiful, with gardens, fruit trees, small ponds, and fountains.

Similarly, her memories of Lebanon, where she was born and grew up, are also of a peaceful

and conflict-free land. She said she still feels the sea breeze coming from the Mediterranean Sea that hugs Beirut. Before the wars came, when she was young, Zoe's mother took her for long walks on the beach.

"The beauty of Lebanon is being on the coast of the Mediterranean Sea while having mountains which had snowfalls in the wintertime," Zoe said.

She added, "In Beirut, you can hear the Islamic call to prayer, adhan, and the church bells ringing at the same time."

Zoe was seven years old when Lebanon's own civil war began in the 1970s. The war continued for nearly twenty years, and thousands of people were killed. By the time it ended, Zoe said, her life had changed forever. The schools opened only during temporary cease-fires. Whenever missiles flew overhead, Zoe and her family took refuge in their basement or interior hallways where they were protected by walls on both sides. Even today, when she watches a movie with war scenes, she gets anxious. They remind her of the violence she witnessed in her home country.

"I used to hold my breath when I heard the whistle of a missile passing by," she said. "You hear the whistle first and then the explosion happens later. I only resumed breathing after the missile had passed by and landed far away, because then I knew we had survived the attack."

When the war started, the water supply to Zoe's neighborhood was cut. Her mother gave each child a bucket—its size depending on their age—and they walked to the local police station to fill them with water. Her mother stored the water in bathtubs, to be used for washing later.

"As time went by and the war continued, the buckets got bigger! Mine went from being a gallon in size to larger containers. That's how I knew I was getting older.

"You live in constant fear," she said. "Wars not only cost you years of your life, but kill your dreams."

Zoe recalls the divisions in Lebanese society as more political than religious. When Beirut was divided into two sections during the conflict that lasted from the 1970s until the 1990s, the Green Line separated Muslim West Beirut from Christian East Beirut. Zoe and her family, like many others, had to wait long hours to get through checkpoints to visit friends who were stuck on the other side.

"Once, we waited for nine hours. It was all the political parties fighting each other for power. Most people had no conflicts with each other."

Most of her neighbors were Christians, and the rest were Sunni and Shia Muslim and Druze families, all living next to one another.

"It really did not matter which religion you belonged to. My mom chose to send me to a Catholic kindergarten. Back then we never thought of religion as something dividing us. The war changed that. After that, you could get killed for belonging to one religion or another, and for being at the wrong place at the wrong time," Zoe said.

Zoe's family celebrated both Christmas and Easter, because her mother wanted the children to be familiar with other religions.

"There was a Catholic church near our house. My mother bought me a lace white dress to join the Easter procession that took place at the church. I remember holding a candle and walking with other young women, all of us in white dresses."

Even now when she goes to Beirut to visit family, she rides the aerial cable car, the Teleferique, to light a candle and pray at the Christian shrine on a mountaintop.

But, she observed, once-tolerant Lebanon, a country consisting of eighteen sects and denominations, had changed.

"The political parties used religion to divide and control us," she said. "They had their own agenda. To reach power and to fill up their pockets with money."

During the civil war, Druze fighters took over a warehouse in her neighborhood, not far from the family home. The militia used the place to detain anyone arrested for all kinds of infractions, from not having an identity card on them to being suspected of supporting a rival group.

"When there was a cease-fire and the guns and the rockets were silent, I could hear the detainees screaming in pain," she said. "We suspected they were being tortured. I had to cover my ears with my hands, to stop hearing them."

Zoe was relieved that she didn't know any of the prisoners personally, but she was still devastated that it was happening at all.

When the continuous fighting in Lebanon became unbearable, Zoe's father suggested they escape to Syria, a peaceful country at the time. Zoe's mother was against the idea.

"She used to say, 'I don't want to die outside of my home.' So, we continued to stay in Lebanon despite the violence."

The situation continued to deteriorate. Food became scarce shortly after the Syrian army laid siege to the city of Beirut on the pretext of defending their allies against Israeli invaders.

"My father paid a driver to smuggle bread through the blockade. The bread loaves were hidden on top of the car's engine—this way they were still warm when we got them," Zoe said.

After a while, some of the loaves started to turn green with mold.

"My mother removed the molded parts and washed the bread with water and aired it, before giving it to us to eat. I still can smell the molded bread to this day."

As the war raged on, life got even harder in Lebanon. At one point, young girls and women were forced to hide in their basements, with the men of the households guarding them.

"Still my mother refused to leave Beirut. She said she'd rather die in Beirut than become a refugee.

But as national security continued to deteriorate, Zoe's father finally convinced the family to leave Lebanon. He paid a middleman and a driver an amount equal to $2,000 to illegally drive the family across the border into neighboring Jordan. The family lived in Jordan, in a rented house, for the next four months before returning to Lebanon.

"My father had to pay cash to the guards in every checkpoint we came across," Zoe said. In the border area separating the two countries, Zoe saw tent cities, populated with Lebanese families who had abandoned their previous lives in exchange for safety in Jordan. Once Zoe witnessed the hostility of the locals, she understood why her mother was so against escaping to another country.

"Some Syrians were yelling at us: 'Go back to Lebanon! We don't have enough to feed our own families. Go back!'" Zoe said.

Zoe's father was a businessman and owned a successful import and export company. He often traveled to Saudi Arabia and Turkey on business trips. During one of the conflicts in Lebanon, his company's headquarters in downtown Beirut was destroyed. Despite the setback, Zoe's father continued doing well, opening offices outside of Lebanon. The import and export company still operates today, although it is now managed by Zoe's uncles and cousins.

When the time came to go to college, Zoe applied to the prestigious American University of Beirut to study medicine. She was accepted, but there was a catch: She had to join Hezbollah, the Shia-controlled political party that oversaw the university's security at the time. She refused to do so, and as a result, her dream of becoming a doctor was crushed.

Decades later and worlds apart, the same dream has been realized. Her firstborn, Khaled, is now a medical student.

Zoe came up with a new plan. She studied computer science at the Lebanese American University, which was established as a college for women in 1924. As a result, she and Walid attended the same university and even shared the same major. Like the American University of Beirut, the Lebanese American University had an academic connection to an American university, and all the courses were taught in English.

"Some Syrians were yelling at us: 'Go back to Lebanon! We don't have enough to feed our own families. Go back!'"

After Zoe and Walid graduated from university, they had to decide between finding employment in Lebanon or going abroad. They planned to marry once they had jobs and were financially stable enough to start a life together.

"We asked ourselves, should we stay, and hope things will improve in Lebanon, or should we go elsewhere to try our destiny?" Zoe said. She and Walid shared the dream of raising a family in a stable place that promised a good future.

"I wanted a normal life. We wanted to start a family somewhere other than Lebanon, where our children did not have to live in fear," Zoe said.

When it came time to decide, she thought of the hardships she had experienced growing up in the

middle of countless conflicts. She remembered the broken promises, ruined dreams, and years lost to wars.

"During the war, at times when we had power, my mother and I watched ballet performances shown on TV," Zoe said. "My mother would tell me, 'One day when normalcy returns and it is safe, I will sign you up for ballet classes.' But because of the war, she never did."

Now Zoe feels proud to see her sixteen-year-old daughter taking ballet classes in Portland. "That's why we left Lebanon, I say to myself at times like this."

The young couple decided to leave their beloved country, and their large extended families, to try their luck in North America. Walid found a job in Montreal, Canada. After working there for a year, he returned to Lebanon to marry Zoe. After their wedding, the couple left Lebanon for Canada, in 1991. It was a leap of faith—they were both twenty-seven.

Unlike Beirut, Zoe discovered, Montreal is cold, even in the summertime.

"I left Lebanon in June. I had bought curtains for the windows in the apartment in Montreal. When we arrived, the air inside the airport was so cold, I used the curtains to cover myself. Poor Walid tried his best to comfort me!" Zoe said.

Soon feeling cold gave way to homesickness. Zoe missed her mother, and often recalled saying good-bye to her mother at the airport when she left for Canada.

"I felt I was leaving behind my heart. My mother was the air I breathed. Leaving her was not easy. During the first few months being away, I cried, missing my family."

The young couple worked hard to start their new lives. As immigrants, they faced challenges.

"When you are an immigrant, you feel as if you are a bird trying to fly, but your wings are broken," Zoe said. "You know how to fly, but you just cannot seem to be able to do so," Zoe said.

"My mother would tell me, 'One day when normalcy returns and it is safe, I will sign you up for ballet classes.' But because of the war, she never did."

They had their first child, the same son who is studying to become a doctor, in Montreal. After six years in Canada, Walid landed a consulting job with a paper company in Maine. The couple picked up their son and moved to Maine in 1997.

Now, he works as an IT senior manager at IDEXX Laboratories.

Zoe is happy to have moved. She explained that she felt more isolated in Canada.

"Life in Maine compared to Montreal is better," she said. "There, not many people were familiar with immigrants. Mainers are interested to learn about us, our religion and culture."

While living in Maine, the couple had two more children. Their second son serves in the United States Air Force and their daughter is currently in high school.

In 2010, Zoe Sahloul saw an opportunity to help others like herself when Arabic-speaking refugees from Iraq arrived in Maine. Most of them were families with young children.

"I felt I had to do something. The mothers had no place to go to socialize and learn to speak English. They were socially isolated and felt lonely," Zoe said.

To combat this, she founded the New England Arab American Organization (NEAAO), a nonprofit with the mission of empowering immigrants to be more independent in their new environment, while connecting them to resources in the community.

"We want to give new Arab refugees and immigrants the tools to integrate into their new communities and prepare for a better future," Zoe said.

She is the executive director of NEAAO, which operates out of Westbrook, where the majority of Iraqi immigrants live, as well as in Portland. Her work has earned her praise and awards, including the United Women Around the World Award and the Westbrook Police Department Citizen Award.

Zoe still thinks about Lebanon. When she first moved to Canada, she would go home for short visits twice a year. Now that both of her parents have passed away, she goes less often.

After Zoe's mother died in Lebanon, Zoe felt an emptiness in her life.

"I really miss my mother. I want to freeze my memories of her and Lebanon in my head," Zoe said.

During her mother's funeral, Zoe and her siblings were surprised to see mourners whom they had never met showing up to pay their respects.

"Whenever in life, I fail in doing a task, I ask myself what my mother would have done next," Zoe said. "She was a giving person. For example, during the holy month of Ramadan, when we fasted, my mother would ask us children for the money we had saved, to go and buy shoes and clothes for the poor," she said. "She showed her religion by action rather than following it blindly."

Decades later, Zoe now sees Maine as her home.

"In Maine, I miss Lebanon. But when I go there, after a few days, I say I want to go home—meaning Maine! My relatives were surprised to hear me say that," Zoe said. "Home is where memories are made."

How about their love story that began in Beirut and continued in Maine?

"You know, Walid's love was and is unconditional," she said. "Even back then, I knew our love was strong enough to sustain us during the wars, the escapes, the migration, the settlement in Canada, and now, making a home in Maine."

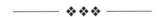

Rabee Kiwan

Lebanon
Population:
6.825 million
Distance from Maine:
5,250 miles

In elementary school, Rabee Kiwan felt a certain sadness about not having a playmate. He was the only boy in an all-girls school—with some two hundred of them—located in Beirut, Lebanon. His situation was caused by one of many civil wars in Lebanon, which forced his family to move. The year was 1985, and he was seven years old.

"During recess, I'd sit by myself in the schoolyard and curse my fate for not having boys for classmates!" Rabee remembered. He attended the school on a temporary basis, thanks to his aunt, who was the principal. "One day, I saw a student with a short haircut, with their back to me. I ran to the student, thinking I had finally found a boy in the school to be friends with," Rabee said. "She turned around. It was a girl with a boy-like haircut!"

Rabee grew up in Lebanon, a country largely known in the United States for its civil wars and sectarian conflicts. Rabee, in an effort to change the perception of his country of birth, enjoys pointing out Lebanon's beautiful landscape, food, music, and hospitality, rather than the hostility and conflict. According to him, Lebanon has historically been the cultural heart of the Middle East. During peaceful times, the country's capital, Beirut, was known as the "Paris of the Middle East." But by the time Rabee was born, the peaceful era had ended, replaced by violence and strife. As home to a large community of Palestinian

refugees, Lebanon has faced invasion and occupation by its powerful neighbors, Israel and Syria.

As a child, Rabee witnessed violence and atrocities that would leave most ordinary people with long-lasting trauma. But Rabee Kiwan is anything but ordinary. At sixteen, he was the youngest student attending the American University of Beirut's prestigious pre-med program. After completing his studies there, he went to Cincinnati, Ohio, where he trained in internal medicine and geriatrics and then stayed in America.

Rabee's memories of Lebanon are of a multiethnic, multilingual, and multi-religious nation, where most people were accepting of others' ethnic and religious differences.

"As a baby, I was breast-fed by a neighbor who was a Druze. She, too, had a baby close to my age. My Sunni parents had no issue with it. That's old Lebanon for you!" Rabee said.

Indeed, when living in the same building with his Sunni Muslim family, Rabee recalled living next door to Druze, Shia Muslim, and Christian families.

"We got along fine. There were twenty-one kids living in the same building. We played together. We didn't care who was what," he said with a smile.

Rabee's family lived in a one-bedroom apartment on the second floor of the three-story building. It belonged to a Druze family, who lived on the top floor. On the bottom floor, two Shia families lived next to one another. One of the households included a Shia man married to a Sunni woman. All of them had young children.

"Since my mother was a teacher and she would still be at work when we got home from school, the neighbors fed us and took care of us until one of our parents came home," Rabee said. He identified the contrast he sees between himself and his own young sons, who have grown up in America, pointing out that they have fewer playmates, and certainly no neighbor's house to visit and stay at for hours in their Portland neighborhood.

"In Lebanon, the kids go in and out of neighbors' houses day and night," he added.

Rabee was born at the American University Medical Hospital in Beirut in 1978. Years later, as a medical student, he would roam the same hallways at the hospital where he was born. Rabee saw his own birth record and even got to meet the doctor who attended to his mother when she was giving birth to him.

He recalled how the same hospital received negative publicity after Brigitte Bardot, the French actress known for her sensual films in the 1960s and animal rights activism today, sued the institution for allegedly conducting unethical medical experiments on cats.

Rabee was the youngest student in his class at the American University. Noting that it is considered the "Harvard of the Middle East," he added that the medical school is well known for its high-quality education and for being extremely competitive.

Rabee did not belong to a political party when he was in medical school, which was unusual in extremely politicized Lebanon, where youth—and university students in particular—are heavily

involved in politics. Even at the American University of Beirut, student associations with connections to different domestic political parties and factions were active when Rabee was a student. "The groups recruited students all the time. I was asked to join one group or another. 'Join us for the sake of the country's youth and the revolution!' they'd say."

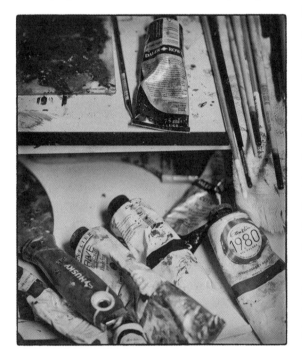

But Rabee was there to study, and he successfully managed to stay away from politics.

According to Rabee, out of the seventy-five medical students in his cohort, some fifty have ended up leaving Lebanon to work in the United States.

Rabee's mother, who taught English to middle and high schoolers, was from Beirut, while his father, a journalist and book editor, came from the mountain village of Chehime. Rabee said his family was secular, but his father was particularly drawn to Marxist ideology.

Three years prior to Rabee's birth, Lebanon was once again mired in a civil war. Rabee was used to witnessing conflicts when living in Lebanon. He recalled how in 1982, when the Israeli army invaded Lebanon, there were military checkpoints everywhere. Lebanese civilians were asked to provide identity cards and were questioned by heavily armed Israeli guards. Everyone was always on edge.

Rabee and his family were once driving home when they reached one such military checkpoint. Young Rabee was terrified, expecting the worst. When they stopped to show their papers to the Israelis, Rabee was surprised to see a young Israeli soldier smiling at him as their car was searched by other military personnel. Rabee remembers the encounter to this day.

As the war continued, Rabee's family had no choice but to flee. They had heard that the local Christian militias, who were supported by the Israelis, shot civilians at will. Nobody was safe.

"We were visiting friends in Beirut when we got the news we'd be slaughtered if we were to go back to our house in Naameh," Rabee said.

One of the Christian militias, Al-Kataeb, had taken over their hometown and their house had been occupied by a Maronite Christian family. Later, when the militia leaders discovered that Rabee's father was apolitical, the family was allowed to return to their former residence and gather some

of their belongings. Rabee went along with his parents. He was five years old.

While his parents were busy packing what they could find, Rabee went outside to play with the neighborhood boys he had known for so long. Rabee missed his old playmates, most of them still living in the same building where he had lived before. He noticed the boy from the Christian family that occupied their apartment was playing with a Matchbox car that Rabee was certain was his. Rabee walked up and asked the boy if he could have his toy car back. The boy refused, insisting that the toy was his.

Desperate to get his toy car back, Rabee asked an old playmate, a Muslim boy, to back him up. "You remember my car, don't you? Will you tell him it's mine?" Rabee recalled asking his old playmate. His pleas were ignored.

He left the boys behind, feeling a heavy weight in his heart. He did not know it at the time, but the burden he felt was grief—for everything he was to leave behind.

Once his parents had packed as many belongings as they could carry, they left.

Later the Druze-led militia, the Lebanese Socialist Party, took back Rabee's hometown, Naameh, a town of some five thousand people located near Beirut, from the Christian militia. Once control had changed hands, the Christian families who occupied the formerly Muslim homes packed up and left. Rabee's family felt safe to go back to reclaim their home.

"During the Druze control, we could move freely from one side of town to another," Rabee said. However, the Druze militia expected the town's households to pay a new form of tax. This went on until the early 1990s, Rabee said. The town's population was mostly Maronite Christian, with the rest being Druze and Sunni Muslims.

Rabee has scattered memories of his childhood due to the constant migration caused by ongoing civil wars. His best childhood memories include playing soccer with the neighborhood kids and climbing fig and mulberry trees to pick their fruit. He would compete informally with soccer teams from nearby towns. "We were sixteen or seventeen years old. We played competitive games, and the losing team had to buy the winning team Pepsi-Colas," Rabee said.

Rabee's father was in the book business. When he was eleven, Rabee started working with his father, helping him translate and make books. Initially, he helped during summer vacations. With help from his mother, Rabee assisted in translating English literature books, including classics such as *Don Quixote* and Charles Dickens' *David Copperfield*. The books were published in England and the United States and then imported. Rabee's father reprinted the books after the stories were translated. In some cases, Rabee and his father added original artwork. The books would tell the story in English on one page, while the opposite page presented the translated text in Arabic.

His father also reprinted instructional manuals on subjects such as drawing and oil painting. Rabee

and his father would provide additional instructions in Arabic, adding tips and tricks of their own. Although the books were sold domestically, some copies were exported to oil-rich Gulf states with large bilingual populations.

"I am an artist," he said. "Through artistic expression, one can understand life better. Most people tend to see the world in black and white, but artists choose to see things in color."

"We published some forty to fifty classic novels together. Plus, books on art. That's how I learned to draw and work with oil paint," Rabee, a gifted artist, recalled.

Rabee has not received any formal training in painting, but has enjoyed drawing since childhood. He remembers sitting in a classroom, drawing his teacher rather than listening to him. When he was called to answer a question, Rabee failed to respond.

"The teacher became angry. He asked me to show him what I was doing. When he saw my drawing of him, he was very pleased! He didn't punish me, and instead praised me and asked that I draw more."

Rabee used to paint mainly with watercolors, but these days he enjoys oil painting more. He said he mostly paints to relax after seeing patients during his arduous ten-day shift at the hospital— he works for ten days straight before having a few days off between shifts.

"I paint almost every day when I am not working at the hospital. Some days, I paint for six to seven hours," Rabee said.

As a child, his father gave him a watercolor set and encouraged him to paint. Rabee grew up in a house with no television, no video games, and at times, no electricity. He said he had no choice but to entertain himself. When he wasn't painting, he read books.

"There was a bookstore near my grandmother's house, where I spent time browsing and buying books to read," Rabee said. Now he tries to pass his love of reading and drawing on to his two sons. Rabee often draws pictures for his ten- and eleven-year-old sons to color.

Rabee has exhibited his paintings in many galleries in Maine. He has had several solo and group exhibitions in Portland and Waterville, as well as in Maine's Down East region, where he used to live and work prior to moving to Portland.

"I am an artist," he said. "Through artistic expression, one can understand life better. Most people tend to see the world in black and white, but artists choose to see things in color," he said.

According to Rabee, creating art helps him to sustain himself as a healthcare provider. Rabee is disheartened by the management of the US healthcare system and the insurance companies' control over it.

"In the beginning when I became a doctor, I felt I was on a mission to help my patients be cured. Now I feel I am part of a system that sees the patients as numbers," he said. "But I feel I have more power when making art."

He drew some parallels between the US healthcare system and that of his country of birth. His insights were sobering.

"In Lebanon, we offered healthcare services at no cost to those with no money. Here in the United States, private insurance companies stop you from doing so. There are barriers to helping those with no health insurance," Rabee said.

He explained, however, that the healthcare delivery system in Lebanon was far from perfect.

"There was no equity in accessing the best care in Lebanon," he said. "The best was reserved for the wealthy and the powerful."

One of the weaknesses he saw was that many of Lebanon's private hospitals hired doctors and nurses solely based on their religious affiliations.

"For example, the hospitals run by the Christian groups hired Christian healthcare providers and the Hezbollah-run hospitals and clinics hired doctors and others who were Shia Muslims," Rabee said.

Some Lebanese citizens have health insurance plans provided to them by their employers. Others, if they have the means, might purchase health insurance coverage offered by private insurance companies.

"Regardless, the government hospitals treated you for free if you had no insurance," Rabee said.

He discovered the lack of equity in access to healthcare in Lebanon when he was a medical student. At the American University Hospital in Beirut, one of the best medical facilities in Lebanon, the ward that treated the insured patients, or those capable of paying for the cost on their own, were managed by the most qualified specialists and the most experienced medical staff. In contrast, the low-income patients with no social or political connections were treated by medical students and interns in residency.

"The American University Hospital in Beirut had three separate floors. The lower floor was where the low-income patients were seen, while the middle floor was for those with insurance or who were able to pay. The top floor, staffed with the nation's best doctors, had rooms that resembled five-star hotel suites, with well-furnished living rooms and all. These were reserved for the VIPs, government officials, politicians, and foreign diplomats," Rabee said.

He added that, as a medical student, he had heard how good the top floor was, but he only got to see the modern and luxurious ward for himself after graduation.

Because Rabee was born in the month of March, he was named after spring. His last name is Arabic for the planet Saturn.

"I like my first and last names because they mean something, unlike the more common names in Lebanon, such as Joseph or Ali," Rabee said.

His unique first and last names were helpful for other reasons, too.

"In Lebanon, your identity card, which you must carry all the time, mentions your religious affiliation. My last name is common among many different religious groups, so unless someone checked my ID card, they did not know what religion I belonged to," Rabee said.

"I like living in Maine because I want to live in peace and be treated well."

Rabee Kiwan's decision to leave Lebanon was as complicated as the politics of the country. The main reason Rabee left his beloved country, which he misses terribly, was its problematic national politics, rooted in ethnic, religious, and sectarian differences. He disliked the political and economic uncertainty.

According to Rabee, in Lebanon each religious and ethnic group had its own quota for government jobs. Having a name without a religious affiliation helped him navigate the country's complicated sectarian and religious preferential system.

"To find employment in Lebanon, you had to have the right connections. You had to be part of a political party or a group. In Lebanon, everything is political," Rabee recalled.

Rabee described how one could get physically assaulted, but the authorities would do nothing because the perpetrator might belong to a powerful clan or a political party.

"When driving, you could get hit by another car and even if the other driver is at fault, the police might look the other way out of concern the other driver might have a political connection," Rabee said.

Rabee had more reasons for wanting to leave Lebanon.

"I wanted to enjoy having basic human rights as a citizen and did not want my family, if I were to be married in Lebanon, to be treated like second-class citizens. Without political and religious connections, you were nobody," Rabee said.

That said, he misses the pace of life in Lebanon, and the social life.

"We used to go to visit friends and relatives at all times of the day and night," Rabee said. He described the relaxed socialization over coffee in a Beirut café, or sitting on a friend's balcony or in their garden.

Rabee still feels homesick for Lebanon, even though he considers Maine, where his two boys were born, home.

"I like living in Maine because I want to live in peace and be treated well," Rabee said.

He has no regrets, though he does wish that his sons could have experienced some of the happier times that he had growing up in Lebanon, such as going in and out of neighbors' houses, climbing fig and mulberry trees, and playing competitive soccer, with Pepsi-Cola as the grand prize.

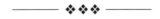

Tae Chong

South Korea
Population:
51.78 million
Distance from Maine:
6,723 miles

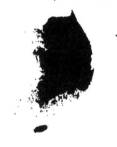

Tae Chong was born into postwar poverty in Korea before immigrating to America with his parents and brothers. Tae battled racism, economic discrimination, and depression before finding his calling: strengthening Maine and the United States by forging connections with immigrants like himself.

The Korean peninsula extends from the northeast border of China into the Pacific Ocean. Tae's homeland, the Republic of Korea, otherwise known as South Korea, occupies the southern end of the peninsula, with the People's Republic of Korea (North Korea) between South Korea and China. Tae was born in Uijeongbu, a city to the north of Seoul, the capital of South Korea. More than twenty-five million Koreans—nearly half of all South Koreans—live in or around Seoul. The population of Seoul itself is more than ten million.

"My town is a small town of half a million people," Tae jokes.

Uijeongbu is slightly south of the demilitarized zone, a strip of land created to separate North and South Korea at the end of the Korean War. Since the end of the war in 1952, there has been a heavy American military presence in the city. The US Army's Second Division currently has its headquarters in Uijeongbu. They have even influenced local cuisine. *Budae-jjigae*, or "army base stew," is a dish that includes hot dogs and Spam.

Tae's mother and father, Chong Yae Chong and Chi Hwa Chong, were born in Korea while it was a Japanese colony during the first half of the twentieth century, leading up to World War II. His father often spoke about how Koreans were not allowed to speak their native language during the Japanese occupation.

"Koreans have spent a millennium trying to avoid being eradicated, whether that is by the Chinese, the Japanese, the Mongols—trying to occupy and get rid of the Koreans," Tae said.

The Japanese occupation, World War II, and the Korean War left the country in ruins, as one of the poorest countries in the world. Tae's oldest brother remembers standing in lines for food rations in the 1960s before Tae was born. The family members did the best they could to stretch what little food they had.

"I remember as a kid that if you had an egg you would mix it raw with hot rice. That was a treat," Tae said. He explained that "basically, like a lot of poor countries, you eat something that is super salty, super spicy, and something bland. That was your meal. We would have super spicy kimchi to offset the blandness of the rice. That's how you would stomach eating something. Super salty meat drenched in soy sauce that was basically beef jerky. You would just take little nibbles of it because it would be so salty."

As a child, Tae was well aware that his family was poor, but was comforted by the fact that everyone else was as well.

"Looking back and comparing to what I have now, we were poor," he said. "We couldn't afford daycare and couldn't afford kindergarten, so, at age four, my parents would leave me to go off to work, and my two older brothers would go off to school."

When Tae began Korea's equivalent of first grade, his teachers were shocked. He did not know the Korean alphabet and could not read or write.

"I remember as a kid that if you had an egg you would mix it raw with hot rice. That was a treat."

Although the Chongs were poor, there was a period of time when they were able to succeed. "My parents were successful businesspeople in the 1960s. They owned a restaurant and grocery store, but the US military took their land through eminent domain because it was a military area," he said.

Losing their business was a major blow. The family lost the small amount of financial security the store had provided, and they had no safety net. They were poor and lived in a country still devastated by decades of war and occupation.

"My parents lost everything and were in debt, so they just cobbled together whatever jobs they could get," Tae said. "My dad was a self-taught blacksmith. My mom sold Avon products. My dad did all odds and ends. My parents didn't even finish

elementary school. My dad might have finished sixth grade. My mom only finished third grade because of World War II."

Tae felt the American military presence in every aspect of his life, recalling how martial law kept everyone off the streets. The South Korean government and the US military declared martial law because of a series of cross-border raids by North Korean soldiers and spies.

While the military took away their store, an American soldier from Maine offered the family a new opportunity. As a teenager, Tae's uncle had worked on an American base and had befriended a soldier from Windham, Maine, named George Bartlett. Before George returned home, he asked Tae's uncle if he would like to come to Maine and work at his store.

> While the military took away their store, an American soldier from Maine offered the family a new opportunity.

"So when my uncle was a young man, seventeen or eighteen, George was like, 'Hey! I see you working really hard. You're studious. You're a hard worker. I could use you at my business back in Maine," Tae said.

Bartlett sponsored Tae's uncle to come to America.

"If he had befriended another GI, like from Birmingham, Alabama, then I might have a different accent," Tae joked. "I would be talking to you in a Southern drawl right now. It just happened to be a GI from Maine."

The American Dream

Tae is still impressed with how his uncle managed in the United States, with little knowledge of the English language and no money.

"My uncle is a rags-to-riches story. He came to the United States, worked as a custodian at the Orthodox Presbyterian Church that brought him in on Neal Street in the West End," he said. His uncle then became a custodian at Fairchild Semiconductor and quickly rose through the ranks at that company.

"My uncle, being an outgoing and affable person, started work in sales, in particular selling silicon microchips to East Asia, in particular Korea, Japan, Taiwan, and Singapore in the 1970s, '80s, and '90s, before these countries became the Asian fiscal tigers," Tae said. "He worked his way up to be a manager and then was courted to work for Advanced Micro Designs [a semiconductor company, and Intel's main competitor]. He attended night school to get his GED and then his college degree from the University of Southern Maine.

"My uncle ended up being the vice president of AMD, and he now lives in San Jose in a gated community, and one of his neighbors is John Chambers, the founder of Netscape, and another

is Joe Montana," Tae said. "You know that's the American dream. Start as a custodian and work your way up."

"I had never seen so much candy and sugar in my life. I remember holding that bag of candy . . . never saw that much child gold before."

In 1976, seven years after he arrived, Tae's uncle was able to bring the rest of the family to Maine. Tae's father, Chi Hwa, joined him as a janitor at a church. It was the first time Tae had met his American cousins. They did not speak Korean, and Tae and his siblings did not speak English. "We kind of just looked at each other like, 'All right, we are family now, but I can't talk to you,' which is a unique experience and different from most families nowadays," Tae said.

Tae vividly recalls arriving in America around Halloween.

"There is no Halloween in Korea. It was a surreal moment," Tae said. As a child, Tae was excited to see so much candy, which he could not have in South Korea. His family was too poor to buy it.

"I was like, 'What? This is crazy,'" Tae said. "I had never seen so much candy and sugar in my life. I remember holding that bag of candy . . . never saw that much child gold before."

Tae and one of his brothers did not have costumes, so they handed out candy at the door instead of going trick-or-treating. The entire custom was completely foreign to them.

"The first kid knocked on the door and my brother is like, 'Oh, it's some kid dressed in a costume,' and my bratty cousin is just saying 'Candy, candy, candy—give him candy,' so he's like 'All right,'" Tae said. But when Tae's brother handed out candy, he dropped a huge handful in the bag. It did not take long for other children in the neighborhood to show up at the house that was giving out handfuls of candy.

"All of a sudden there was like this epiphany in the neighborhood, like somehow kids had heard this abnormal clunk falling into this kid's pot and we're swarmed by all these kids," Tae said. "And my brother kept on giving handfuls and all of a sudden it was gone. So he was like, 'What do we do now?' So he took my bag of candy and he gave that away."

Tae and his brother then learned what Halloween is like after the candy has run out.

"We were introduced to the American tradition of pretending we are not there," Tae said. "Turn off all of the lights. Pull down the shades. Literally, we don't speak English, go away."

While Tae had just arrived in America, his father had been in the United States since that July, working as a welder and at several odd jobs, paying off debt and earning money for when his family could join him.

"My father is brilliant. He's a genius," Tae said. "If he had schooling he would be amazing. He's one of those guys who had a sixth-grade education. No

English. He would rewire a house. You know the scoreboard in the [Cumberland County] civic center? He helped put that up there. You know the time and temperature building? You know how it looks vertical, but it's actually on a lean? He welded the brackets for that. I see my father's thumbprints all over Portland when I see that."

Chi Hwa built homes in Korea. "He built a two-story building in Korea and you know they probably had no codes, but it is still standing," Tae said. "I can't even put together IKEA furniture, and he put together a two-story building."

Chi Hwa was able to raise enough money to fly his wife and three sons to Portland. They moved to 59 West Bracket Street in Portland's West End. Tae and his brothers enrolled in the Portland school system. In the 1970s, Portland had few immigrants and no English Language Learner (ELL) program. Luckily the school found a couple who had served in the Peace Corps in South Korea that were willing to teach the language to Tae and his brothers.

"The three of us would sit at the steps of the cafeteria at the Reiche School and they would have flashcards with American words and would teach us how to speak English," Tae said. "My experience was I had no formal education in Korea because everybody worked . . . They put me in first grade and realized, 'Oh, he can do math because it is not in English. He can add and subtract, but can't read.' So they sent me to kindergarten."

Though he did not have much schooling, Tae was smart and worked hard. "I was smart enough to get the alphabet," he said, "and then they put me in first grade.

By third or fourth grade I had caught up and I was in honors classes by my middle school years."

Tae and his family were among a smaller Asian American Community living in Portland at the time, which was isolating and at times uncomfortable for Tae. "Back then, in 1976, there were almost no kids of color. No immigrants and refugees," Tae said.

Overcoming Discrimination

At Deering High School, Tae experienced racism. There was an incident during his senior year that he has never really gotten over. Tae ran for class co-president and won, but quickly faced a backlash. He and his co-president didn't go to the Homecoming football game, which broke with the tradition of the class president attending. As a result he was tried for impeachment and received criticism, but his white co-president did not.

"That was my first taste of racism and first taste of discrimination," he said. "Where I was accepted enough to be class president, I wasn't accepted enough to be everyone's equal. I grew up playing Little League. I did all kinds of stuff, but they turned on me," Tae said. He felt publicly humiliated.

Tae applied to Bowdoin College his senior year and got in. He was excited for a new start, but quickly realized he would face a new type of discrimination. The heavy workload and not feeling like he belonged increased his depression.

"I fell into a pretty severe depression, and then when I went to Bowdoin, I experienced a different form of discrimination, which is the wealth gap,"

he said. "So race and wealth discrimination just kind of hit me. For some reason I thought I could escape high school if I went to Bowdoin. When I saw that, I was like, that's the same thing. So I fell into a deeper depression. My sophomore year, I lost fifteen pounds in one semester. But I was smart enough to pass everything. Smart enough to get by, even though I was depressed."

Tae said it was hard for other students of color at Bowdoin College during this time period, especially those coming from more diverse places that were not used to being in an almost entirely white state like Maine.

"I don't know how many kids of color there were. In my head, I think there were like ten kids, but four of us left early because it was just such a weird place to be, because you always stuck out," Tae said. "I was used to being that kid of color growing up in Maine, but as a kid of color from California or New York City, that was really hard for them."

Tae eventually dropped out of Bowdoin College and entered the University of Southern Maine. For the next eight years, Tae worked the second shift at Jordan's Meats on India Street, took classes at USM, and battled his depression.

"I didn't know what I was doing because I was still trying to figure out the whole mental health stuff," he said. He eventually graduated from USM with a bachelor's degree in political science and a master's in business administration.

He also found ways to cope with his depression.

"What works for me now is physical activity and good nutrition," he said. "That, coupled with all the other things you pick up, like having a positive attitude and being around people that make you happy and letting go of people who don't make you happy; letting go of situations that don't make you happy. Those are skills you pick up as you get older."

He particularly likes lifting. "My favorite thing in the whole world is having a 250-pound weight and benching," he said. "You concentrate because this might kill me. So you become really Zen and, like, really present. I just forget everything."

Tae also began volunteering with youth groups in Portland, even teaming up with Bowdoin College. "I worked at Kennedy Park, which is a housing project in Portland, and I helped kids with their homework," he said. "And I connected with Bowdoin College. I had Bowdoin students come down to volunteer, which they are still doing today."

Tae would soon come face-to-face with racism again.

The students he volunteered with in the late 1990s and early 2000s spoke about a racial divide between them. Recent immigrants and refugees were separated from the rest of the student population. "And then the kids that I worked with talked to me about the racial divide between ELL students and mainstream kids. Back then, all the ELL students were in the basement of Portland High School," Tae said.

He decided to investigate. "I went there and saw it with my own eyes. All the ELL kids and the poor kids were in the old cafeteria and all the white kids and affluent kids were in the new cafeteria."

Tae did not want these students to go through what he went through.

Fighting for Equality and Healing

In response to what he had seen, Tae got involved with the NAACP and started documenting everything that was wrong. They went to Maine Public Radio, which covered the story. The Portland NAACP chapter filed a complaint with the Civil Rights Office of the Department of Education.

> Tae had found his calling. He has worked with immigrants and refugees on access to education, economic development, and English language classes ever since.

"We sued the Portland school system for creating two separate, but unequal education systems," Tae said. "And we won, which led to a reformation of ELL, which led to the resignation of the superintendent and assistant superintendent in the 1990s, and helped create the multilingual department and make it more prominent."

Tae had found his calling. He has worked with immigrants and refugees on access to education, economic development, and English language classes ever since.

Tae also helped to create *Incomer*, a digital magazine focusing on success stories of immigrants to southern Maine, and now works as the director of Multicultural Markets and Strategies for the Maine State Chamber of Commerce.

Tae currently lives in Portland with his wife, Susan Burns Chong, and his two daughters, Olivia and Caroline, where he continues to help new Mainers feel welcome and part of a more diverse and inclusive community. He is currently the first Asian American to serve on the Portland City Council.

Tae sees a direct correlation between his own experiences as a young immigrant in Maine and his current work. "I think everyone tries to heal their pain and prevent pain, you know, from others who might be experiencing that," he said.

Tae is also concerned that changing attitudes and laws in the United States means fewer opportunities for "immigrant stories" like his, believing this could harm both the immigrants and the United States as a whole.

"In today's world we wouldn't have come," he said, "but the United States would have missed out on three kids who all have at least a master's degree. One person became a colonel in the US Air Force and medical director at Bagram Air Base, the largest military medical hospital in Afghanistan. He saved hundreds of American veterans' lives. My parents wouldn't have passed the English test and the country would have missed out on a doctor, an engineer, and a business counselor of economic development."

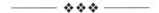

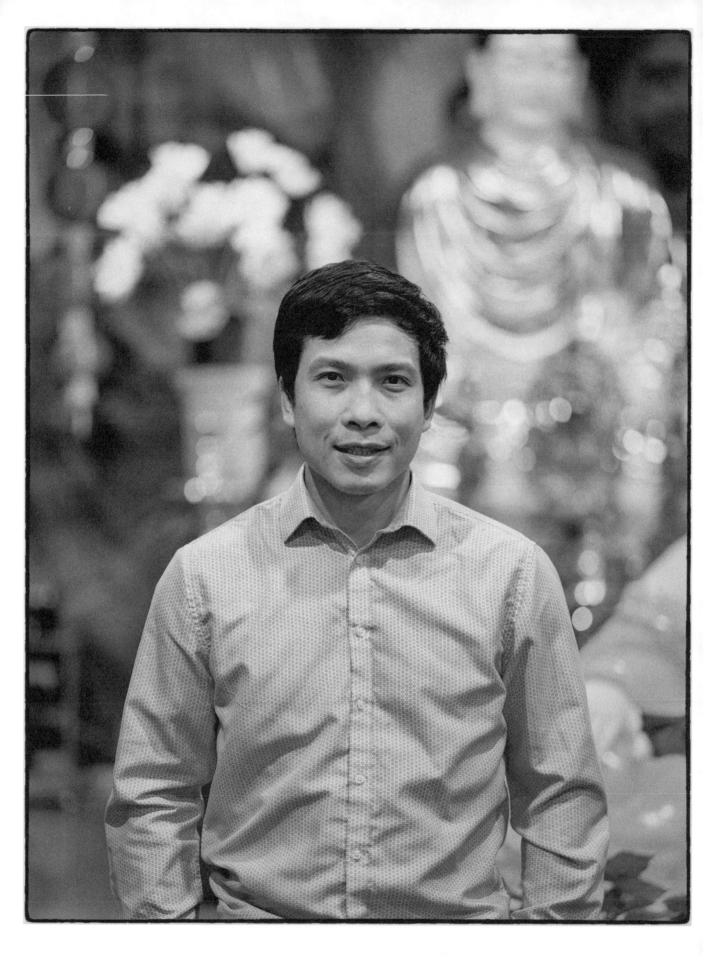

Quang Nguyen

Vietnam
Population:
97.34 million
Distance from Maine:
8,331 miles

Quang Nguyen left Vietnam for Maine, but ended up in the wrong Portland by mistake. After his flight landed in Oregon, he waited by the baggage claim, expecting his uncle to pick him up. When he called his uncle, who was waiting for him at the Portland International Jetport in Maine, Quang realized he was three thousand miles from his new home.

"I'm by Gate 10," Quang remembered telling his uncle. Portland's small jetport has just one arrival gate.

"My heart dropped," he said. "I knew I was at the wrong airport. I knew little English, so it wasn't an easy start."

As a result of the mix-up, Quang caught different flights to reach the correct Portland and spent long hours waiting at airports. He was confused, anxious, and hungry. Although he had American money, he did not know where to buy food. Worst of all, the air-conditioned terminals left him shivering. It was August and he was wearing a T-shirt. Exhausted after the long flight and hours of waiting, Quang curled up for a nap on the terminal floor, only to be woken up and questioned by a police officer.

"After a while I found a McDonald's inside the airport, stood in line, and not knowing what to order, asked for whatever the guy in front of me was having."

The sandwich that came included meat and cheese.

"We don't eat cheese in Vietnam. The meat looked unfamiliar. So, I threw away the meat and the cheese and just ate the bread!"

Although Quang's first meal in America was disappointing, he has yet to feel disappointed in his new country. His dream to become a successful businessman in America is materializing, one business at a time, but at a speed that invites envy.

Since coming to Maine to study business in 2007, his list of achievements, measured by the number of small businesses he has started and maintained, is impressive. Quang owns one nail salon, and sold a second one to his cousin. He owns a retail seafood business and a financial advisory firm. At one time he also owned a convenience store, but recently sold it to his uncle. On top of his businesses, Quang holds investments in residential properties in Portland, Biddeford, and Old Orchard Beach, as well as a Chinese buffet restaurant near the Maine Mall. Outside of business, Quang is active in the Vietnamese community. He established Maine's first Vietnamese Buddhist Temple.

But before Quang's successes as a businessman and leader, he was an immigrant on an F-1 student visa. Back in August 2007, eighteen-year-old Quang arrived in Portland to attend Southern Maine Community College (SMCC). He planned to live with his uncle, Anthony Le, who had lived in America, first in California and then in Maine, since 1992. Quang selected SMCC because of its low tuition cost. While enrolled as a full-time student, he supported himself by cooking at a local Thai restaurant for fifty to sixty hours a week. He did not have a car and was unfamiliar with the public bus routes, so he biked from Portland to the campus in South Portland, twenty miles each way, every day.

Determined to succeed, Quang studied hard. During his first semester, he took three English for Speakers of Other Languages (ESOL) classes and one business course.

"We don't eat cheese in Vietnam. The meat looked unfamiliar. So, I threw away the meat and the cheese and just ate the bread!"

"I didn't know much English," Nguyen said. He added, "I got a C in one of the ESOL classes, and it's the only C that I got in college."

For Quang, mastering the new language was personal. Coming from poverty, Quang was determined to become rich one day. He was willing to take risks, even if it involved speaking improper English.

"It was not about learning to speak a new language. You must be willing to be wrong, take risks before you can become better. Same with business." Quang said.

He got involved with student groups at his college, leading the International Student Group and becoming the vice president of the SMCC Student Senate and the Phi Theta Kappa honor society of

New England. These efforts earned him respect and the nickname "Mr. SMCC." He maintained a 3.8 GPA while working long hours at his job. He fought stereotypes about his country, educating fellow students on Vietnamese culture and postwar Vietnam. He was mindful of the preconceptions that some Americans had about Vietnam, a country that had been in a long and costly war with America that ended in 1973.

He describes postwar Vietnam as a modern society, with the standard of living rising for most. "Only rich people used to fly to go here and there," he said. "Now most Vietnamese use flights to get to their destinations," he said.

International tourism is big, with most tourists coming from China, South Korea, and Russia. Domestic tourism is increasing. American chains like Marriott and Hilton have opened hotels in Vietnam.

Quang saves praise of his home country for its educational system. He describes the love he still has for his former teachers.

"In Vietnam we have a day called Teachers' Day when we go to visit our former teachers to pay our respect," he said. "We take gifts to give to them."

To this day, when he goes home to visit, he calls his old classmates and they go as a group to visit their former teachers. While studying at SMCC, Quang was surprised to see his American classmates put their feet up and eat with the instructor in the classroom.

In 2010, Quang graduated with an associate's degree in business administration and found a job working as an insurance agent. He focused on making contacts in the community to buy businesses, while volunteering with the local Vietnamese community. He taught young children born to his fellow community members how to read and write in Vietnamese. He advised his community members on insurance issues and became a homeowner.

Every week he arranged for transportation, renting a van to carry some twenty members of the local Vietnamese community to Lawrence, Massachusetts. They visited the Buddhist temple there because Maine did not have one of its own. During one visit, the monk in charge suggested Quang organize Maine's Vietnamese community and establish a place of worship, to save them the hardship of traveling to Lawrence. The monk pledged his financial help.

That same night Quang went online to search for a property. A week later he signed the papers to purchase a former church in South Portland. Quang's efforts led to Maine's first Vietnamese Buddhist temple, Peace Buddhist Center. These days the temple is visited regularly by more than two hundred community members who gather to worship and celebrate cultural events. The temple even holds classes to teach children of Vietnamese immigrants the language and culture of their parents and grandparents. The elders accompany the younger ones, to teach or mentor them.

"It is lovely to see the elders in the community join the kids in the temple. It gets them out of isolation and helps them feel useful," Quang said.

According to him, there are some four thousand Vietnamese immigrants living in Maine.

While studying and helping the Maine Vietnamese community, Quang promised himself that he would become a millionaire in five years.

To understand what motivates Quang, it helps to understand his childhood aspirations.

Quang was born in 1989 in Cam Ranh, a coastal city in the south-central region of Vietnam, where most residents depend on seafood for their livelihood.

"In some ways, Portland reminds me of Cam Ranh. Both are on the ocean, close to mountains, and they are known for their seafood," Quang said. "Of course, no snow there!"

During the Vietnam War, Cam Ranh was the site of a large US military base, before it was turned over to the South Vietnamese government near the end of the war. In 2019, the travel and tourism website Lifestyle Asia praised the city, stating, "Cam Ranh feels incredibly under-the-radar, but that is exactly its appeal. Located in the Southern Khanh Hoa Province off the South Central Coast of Vietnam, the town boasts an Indochina charm that can easily capture the heart of the independent and curious explorer."

Quang grew up with two entrepreneurial parents and says he always wanted to be a businessman. Quang watched his father, Hung Nguyen, and his mother, Hoa Le, work hard to survive. After their fishing and seafood business was wrecked by criminals, they started fish farming, working long hours in the hot and humid climate. They raised sea bass, tiger shrimp, and escargot. Quang's grandparents also raised fish. As the oldest of four boys, Quang helped his parents earn extra money. He recalled that when he was in the fifth grade, he would sell homemade sweets in the market while his mother sold the fish they raised.

> "In some ways, Portland reminds me of Cam Ranh. Both are on the ocean, close to mountains, and they are known for their seafood," Quang said. "Of course, no snow there!"

"Market people there still remember me! When I visited my hometown a few years ago, I went to the same market after twenty years and some people remembered my name," Quang said.

He credits his parents' strong work ethic and entrepreneurial spirit for his success. Quang remembers their struggles, and his own, as well as the bitterness toward the fishing industry's middlemen, who bought the fish cheap from farmers and sold them for a large profit.

"The middlemen enjoyed a monopoly and manipulated the prices," Quang said. He added that he decided to become rich, in part, to stop the middlemen's excessive influence. In order to do that, he needed a good education.

Quang was an excellent student in high school. He liked studying math. He learned to read and write in English and he dreamed of continuing his education in the United States. Quang heard people praise America as the land of opportunity. In contrast, Vietnam offered fewer opportunities. In order to succeed in his country of birth, he needed societal connections that his poor fishing background could not provide.

Quang's life changed when his uncle Anthony Le, who had moved to the United States more than a decade earlier, visited the family in Vietnam. Quang was in the eleventh grade when his uncle suggested studying business in America and working to send money home to his parents.

There were many obstacles to this idea. Quang's family did not have the money to buy him a plane ticket, pay for tuition, and cover the cost of living in the United States. They decided to take out a loan to fund Quang's dream, and his uncle offered free accommodation in Maine.

In his first job as an insurance agent, Quang faced some bigotry. He recalled how, for example, when he cold-called potential clients, his accent became an issue. He did not let the incidents dampen his spirit.

"As immigrants, we adjust well with situations," he said.

While he was working as an agent, a Vietnamese American client mentioned a plan to sell her nail salon in Windham, a town north of Portland. Quang was intrigued. The price was $100,000, but Quang only had $1,500. He went to the bank to take out a loan, offering his twelve-year-old Chevy Camaro with 200,000 miles on it as collateral, but was politely denied. The bank gave him a loan of $35,000. Quang borrowed the rest from his uncle and the seller herself. He paid back the loans in one year.

Soon, Quang started an investment-advisory firm, Win Financial Strategies, in Falmouth. In 2016, Quang purchased Cape Nails Hair & Spa in Cape Elizabeth.

In the same year, a commercial real estate agent mentioned that a vacant variety store in South Portland was up for sale. Quang purchased the store and renamed it Le Variety, after his maternal grandfather. One day as he drove along Forest Avenue in Portland, he stopped by Fishermen's Net, a long-established seafood store. He introduced himself to the owner, an Asian immigrant herself, and asked if the business was for sale.

"You have to understand, in Asian culture it is rude to ask a business owner if they want to sell their store," Quang said. He added, "She rolled her eyes and said no. I think she was offended."

Quang gave the owner his business card and asked if she would call him if she were to change her mind. The call came a few weeks later. Quang took over the business in 2018.

Now Hung Nguyen, who joined his son in Maine with Hoa after they received their immigrant visas, runs the store. Under the new ownership the business has improved. The store's revenue has tripled, in part because of Quang's idea to receive

orders and ship Maine's famous lobsters to Vietnamese families across the United States.

"The pandemic has been bad for my other businesses, but good for my seafood store. The volume of sales has gone up as more families cook at home rather than going out to eat," Quang said. During the Fourth of July in 2020, the store shipped some three hundred lobster packages to its customers.

Quang's vision to succeed financially while helping others is demonstrated by the way he transfers the ownership and management of his successful businesses to family members. Except for his investment firm, all his other business ventures are now run and owned by his relatives.

"When I see a business opportunity, I ask relatives and friends if they're interested," he said. "If they are, I help them to buy it. This way they can be successful, too," Quang said.

Quang's commitment to community building is exemplary. After purchasing a variety store in South Portland and buying the empty lot next to it, he went to look for a community partner to develop an apartment complex with street-level retail space. Some of the units were set aside for low-income housing. Quang partnered with Avesta Housing, a Portland-based nonprofit affordable housing provider with a portfolio of ninety-eight properties. After the complex is completed, it will include Quang's Le Variety store and a community center.

"Coming from Vietnam as an immigrant, and here I was, collaborating on a $13 million project," he said.

The COVID-19 pandemic has significantly impacted Quang's businesses. His prized business venture, Super Great Wall Buffet, with an estimated annual revenue of $2 million, has been hit the hardest. Quang, who took over the business in recent years, doubts the family-friendly business will survive the pandemic.

"No regrets. I just feel bad we might not be able to bring it back to what it used to be," he said.

"Coming from Vietnam as an immigrant, and here I was, collaborating on a $13 million project."

Quang is also determined to give back by volunteering and has joined many boards, including that of the Greater Portland Immigrant Welcome Center, a nonprofit dedicated to supporting Maine's immigrants.

In 2016 he became a naturalized citizen. He recalled raising his right hand, swearing the oath, and, being a busy businessman, going back to work. For Quang, becoming a citizen was both solemn and joyful.

"It was a pivotal moment. One step closer to my American Dream. I thought now I could bring my family here," Quang said of the ceremony. He followed through on that goal. He has sponsored his parents, who came to Maine in 2017, and his brothers, who arrived later.

Quang believes the current anti-immigrant sentiments expressed by some are misplaced.

"The image of immigrants is one-sided. Some Americans say immigrants come here to ask for help. But most of us are here to work hard. We want to make money and to give back to society," Quang said. He added, "We do jobs that other people won't do. I want to create jobs and help others."

Quang's love for his family is immense, and he wants to ensure that his younger siblings do well in the United States.

When his younger brother came out as gay, he went to Quang. His brother was concerned about how their parents, who come from the traditional Asian society, would react. Quang takes pride in saying how well his brother's husband has been welcomed into the family. Hung speaks English to his son's American husband, and Hoa cooks for them all.

Despite his modern outlook, Quang can also be traditional. He still lives with his parents and younger brothers, part of a Vietnamese tradition of extended family living under the same roof. According to Quang, living with your parents is normal in Vietnamese culture.

Quang and his family celebrate Vietnamese festivals, including the Vietnamese Lunar New Year, or Tết, which is their most important celebration. *Tết* means "Feast of the First Morning of the First Day," and is celebrated for three days or more. Families wear new clothing, cook, and eat dishes that are special to the New Year. Some of the dishes are displayed at altars to honor their departed ancestors. As part of the festivities, the Vietnamese visit their elders, relatives, and friends. Children are given envelopes filled with cash as gifts.

"We do jobs that other people won't do. I want to create jobs and help others."

In Maine, Quang still goes to the South Portland temple that he helped found. There he prays for his ancestors, and meets with fellow community members. Quang also takes the time to reflect on his accomplishments.

"It was never about accumulating wealth," he said. "My aspirations are rooted in my Buddhist faith. It guides my personal and professional life."

While Quang is happy to be an American citizen, he does miss his relatives and the Vietnamese culture.

"I miss my mother's mom, who's eighty-six. I miss spending time with her. I miss the culture. I miss my friends and my relatives," Quang said. "I love this country, but Vietnam is in my heart."

Filip and Gordana Manjencic

Bosnia
Population:
3.281 million
Distance from Maine:
4,060 miles

On the eve of war, Gordana Manjencic and her husband, Branislav, escaped Bosnia on the last plane out, the first leg of a frightening and often dangerous journey that took them through Serbia, Greece, and Germany—places where they were often unable to speak the language, struggled to find work, and lived under the constant threat of deportation. When the couple and their young son finally reached Maine and what seemed like a happy ending, Branislav suffered a heart attack and died, leaving Gordana in a still-strange land trying to find work and raising Filip as a single mother.

Filip, now in his twenties, looks back at his mother's journey and is both humbled by her sacrifices and in awe of her perseverance.

"She is probably the hardest-working person I know. I don't know how she did it," he said. "One thing she told me that I will never forget, that stays with me always, is that when something happens, you can't do anything about it. There is no sense in crying over spilled milk, so you might as well make the best of it."

Bosnia Before War

Gordana was born and raised in Sarajevo, the capital of Bosnia and Herzegovina when it was part of Yugoslavia, a communist-controlled state. Following the end of World War II, Yugoslavia was set up as

a federation of six republics, with borders drawn along ethnic and historical lines—Bosnia and Herzegovina, Croatia, Macedonia, Montenegro, Serbia, and Slovenia. In addition, two autonomous provinces, Vojvodina and Kosovo, were established within Serbia. After longtime dictator Josip Broz Tito died in 1980, the government could not cope with the escalating economic and political instability of the 1980s, a decade that served as a run-up to the collapse of communism in Eastern Europe in 1989, symbolized by the fall of the Berlin Wall.

"If for some reason they lost their jobs, they knew they were going to get help. Here I am terrified if I cannot work for three months."

The turmoil prompted many Yugoslavs to rally behind their ethnic and religious groups, and the growing independence and nationalist movements helped to increase the turmoil in Yugoslavia and in Bosnia. Several republics declared independence in 1991 and 1992, and then, following a series of inter-ethnic incidents, the Yugoslav Wars erupted, first in Croatia and then in Bosnia. Before it ended, the Yugoslav War and the Bosnian genocide would claim the lives of more than 100,000 people and displace millions as refugees. The war's economic and political damage and tensions are still felt there decades later.

The Yugoslav War was still years away when a young Gordana and her family lived in a cramped apartment in Sarajevo. While she did not enjoy much privacy while growing up and the family didn't have much money, she said that because of their circumstances, she learned to appreciate what she had and to share with others.

"Nobody was happier than me when I got my bicycle," she said. "My parents invested in that and I took care of the bicycle. Here, you buy toys and tons of things, but they are worth nothing."

Like many families in Yugoslavia, Gordana's family learned to carve out small measures of freedom under communist control. As long as she did not question the Communist Party, Gordana felt she could mostly do what she wanted. As a young adult, she listened to rock 'n' roll music and partied with friends without getting into trouble.

While Yugoslavia was a communist country, it was not dominated by the Soviet Union like East Germany or neighboring Hungary. Bosnia was a historically diverse region. The Yugoslav Communist Party provided job security and some guaranteed income.

"We were all feeling supported," she said. "I was never scared because my parents were never scared. If for some reason they lost their jobs, they knew they were going to get help. Here I am terrified if I cannot work for three months."

Gordana graduated from college in Sarajevo with a degree in civil engineering. When she could not find a job in her field, she worked a variety of

temporary but interesting jobs. She worked at a resort on the Adriatic Sea, in what is now Croatia, and as a hostess at the 1984 Winter Olympics. When her sister called about potential work at an electrical company, Gordana returned to Sarajevo. It was there that she met her future husband, Branislav.

"He saw me," she said. "He wanted to meet me and I didn't know that."

Some friends at work eventually introduced them. "He was calling me constantly and I finally said 'Okay.'"

Over time, Gordana fell in love. Branislav was different from other guys.

"I was a little different, maybe," she said. "I always loved mysteries, history. I loved legends. I was interested in space and stuff like that. And that was what I read." She was surprised that Branislav shared her interests. "That's something I had with Filip's dad," she said. "We would talk and talk about that stuff."

Last Plane Out

The stability Gordana had prized was shattered when war finally erupted and ripped Yugoslavia apart, forcing the couple to flee for their lives. When the war started on April 6, 1993, Gordana did not want to leave Sarajevo, the city she calls the most multi-cultural in all of Yugoslavia. She and her friends did not believe that the war would reach Sarajevo.

"This won't play here," she thought. "We are tight. We don't hate each other. But it kind of just started happening. You know, people get desperate."

They only stayed two weeks, and Gordana's hope for peace was dashed over a single weekend.

"Friday, when I came from my work, we were joking about 'See you Monday, hopefully,'" she said. "We didn't know what was going to happen."

Gordana did not go to work on Monday. "The snipers started working," she said. Her husband was nearly shot while on the balcony of their apartment. As the city quickly devolved and became increasingly dangerous, Gordana and Branislav decided to flee the violence. They escaped on the last plane to leave the country. Behind them, nothing worked. There was no electricity, and UNICEF was coming with a flight to Sarajevo.

The two almost missed their flight when their taxi driver initially refused to drive through heavy street fighting. After much pleading, he took them to the airport and they caught a flight to Belgrade, Serbia.

Even as things crumbled behind them, Gordana believed the war would not last long. "Maybe a few weeks, and, you know, we will all go home," she said.

That didn't happen. It was April 16, 1993, and they wouldn't return. It would be another four years before she knew if her parents had lived or died.

This was only the beginning of the couple's escape. They were nowhere near safe.

They arrived in Serbia, where Branislav had family. Even so, they knew he would be deported back to Bosnia if Serbian police stopped them. They both spoke Serbian and were Eastern Orthodox, but Serbians distrusted any Bosnians who entered their country.

Many Serbs were fighting in Bosnia. One woman, who was supposed to approve their visa papers, shouted at Branislav, "Shame on you! My husband is fighting there and you fled," Gordana recalled.

Branislav's relatives in Belgrade suggested they go to a small resort town in Greece. A family friend, who worked there as a hotel manager, could help Gordana and Branislav find temporary work. With only a couple hundred dollars, a twenty-five-day travel visa stamp to Greece, and the address of the manager's hotel, Gordana and Branislav fled.

Finding the hotel manager was nearly impossible.

"We took that name and we went to Greece and stayed at a hotel for a couple nights, trying to find him," Gordana said. "The money was almost gone and we started asking around about that gentleman and that little village, and finally one guy told us."

But when they found the old man, there was another problem—he could not understand them. Luckily, his son had studied in Yugoslavia and spoke their language.

"Could you imagine that luck?" Gordana said.

Gordana and Branislav were not asking for much. "Just help us find a job. That is all we are asking for," she said to the man. Through some phone calls and negotiations, the old man's son found them temporary jobs at a local restaurant.

Still, they had nowhere to live.

They slept in a small tent behind the restaurant that smelt of "stinky manure." After working a sixteen-hour shift from eight a.m. to two a.m.,

Gordana waited for her husband to return so they could share a meal in their tent. Gordana worked in the hotel and restaurant's kitchen, but said she had no clue what she was doing—the chefs spoke Greek, and she was not accustomed to Greek food. Branislav worked as a carpenter.

They slept in a small tent behind the restaurant that smelt of "stinky manure."

Because the couple was working illegally, they had no labor protections and were at the mercy of their employers. They worked sixteen-hour shifts every day and were paid very little.

And Branislav's boss also sexually harassed Gordana.

"His boss came to me and started making moves on me," she said. She never told her husband, who was fired the next day. When Branislav went to collect his final paycheck, the boss said he had never seen Branislav in his life.

"We didn't get paid a dime," Gordana said.

When their tourist visas expired, the couple's stay in Greece also became illegal. When the old family friend checked in, Gordana told him the story.

"He was pissed," Gordana said. "He went to my bosses and started telling them off."

After that, she received a little more money and her husband was allowed to find work.

Gordana and Branislav lived in Greece illegally for six months, and each day the risk of being caught and deported increased. Greek police began to round up Yugoslavs, Albanians, and Bulgarians living and working illegally in the area and deporting them. "There was always, every morning, police looking around, coming with big buses catching Albanians, Bulgarians, without papers," Gordana said. "I was scared every day."

Gordana told the old man that she and Branislav wanted to go to Germany, where his sister lived. His sister had left for Germany before the war on an employment exchange program.

The old man asked how much the two made at work, to see if they could afford the move. "When we said how much the boss was paying us, his face got red," Gordana said. "So he bought us tickets." Surprised by this act of generosity, Gordana asked him why he had bought them the tickets to Germany.

"I am doing this because if there is war in my home country, hopefully someone would help my sons," he said.

But plane tickets were not enough—they also needed visas. The old man accompanied them to the airport and bribed the police and passport officers to let Gordana and Branislav on the plane. Gordana knows that they never would have escaped without his help.

"If it wasn't for him, they would have taken us into different prisons," she said. "Who knows where, and if we would have found each other? He saved us."

After Gordana and Branislav earned their first paychecks in Germany, they sent him a thank-you note and repayment for their tickets.

After landing in Stuttgart, a city in southern Germany, the couple still had to navigate German customs without being deported. When they got off the airplane, Gordana and Branislav had the option of joining two lines: one for Germans and one for foreigners. With no plan for how they would pass through German customs without visas, they chose the line for Germans.

Luckily, the German officer did not examine their passports carefully and waved them through. "Me and my husband, we had the wrong color of passports," Gordana said. "I'm telling you, angels exist, and God, and that same moment when it was my turn the other guy came up and started talking. And he's not looking at us, and just waving . . . and I stopped and my husband pushed me."

Gordana and Branislav settled in Solingen, Germany, near Branislav's uncle. They lived in a garage that belonged to a friend of Branislav's uncle until they moved to Freiburg, to be close to Branislav's sister.

Once again, Gordana and Branislav felt isolated because they could not speak the local language. Gordana studied German in school, but did not know enough to communicate effectively. "We were looking for jobs and we found a Greek restaurant because we could speak some Greek," Gordana said.

They both worked as cooks at the restaurant and eventually obtained refugee visas. They had to

renew the visas every three months or get deported. Despite the refugee visas, the couple still lived in fear—the German government would occasionally deport Yugoslavs, saying there was no more danger in Bosnia and other former Yugoslav states, despite the continuous conflict and accounts of genocide.

Gordana had no idea where Maine was; she was just glad to start a new life in America.

A New Life in America

When Gordana and Branislav had their child, Filip, they hoped he would be a German citizen, but the country had recently changed its laws. Filip was technically a citizen of Bosnia. When the conflict in Bosnia concluded, they received a notice from the German government with a deadline to leave the country.

"You know they will come and get you if you don't go," Gordana said.

She and her husband did not want to raise Filip in war-torn Bosnia. They started seeking asylum.

"We had to pay a lawyer to give us thirty more days," Gordana said. "We tried Norway, we tried all over Europe."

Despite rejection after rejection, they hoped for a better result from Canada. They used the little money they had to pay for the application and received an assurance that their fees would be reimbursed if the country rejected their application. Canada denied their application, and also failed to reimburse them.

"We will never forgive them," Gordana said.

After New Zealand also rejected their application, the couple's attorney told them that the United States was taking former prisoners, or those in mixed marriages, according to Gordana. Because Gordana's mother was a Catholic and held a Bosnian passport, while Branislav held an old Yugoslavian passport, they claimed to be in a mixed marriage, although they are both Eastern Orthodox Christians and came from Bosnia.

"That was our last hope," Gordana said.

Gordana, Branislav, and baby Filip traveled to Frankfurt for a visa interview at the American consulate.

Filip, who was only a child, eased his parents' anxiety during the interview by walking around and laughing. The embassy staff laughed too. "'Look at this one! He is already a real American,'" Gordana remembers them saying. "I think Filip's charm helped," she said. "He was always bubbly."

The desperate family was overjoyed when their visa was approved. They were initially going to be resettled in Detroit, but the United States informed them of a change just ten days before their flight. They were redirected to Portland, Maine.

Gordana had no idea where Maine was; she was just glad to start a new life in America.

On March 20, 1998, Gordana, Branislav, and Filip landed in New York City, where they waited

anxiously for hours to board a flight to Portland International. At the Portland Jetport, Catholic Charities welcomed them and helped them adjust to their new home.

Even though the family had attended a seminar on culture shock at the US consulate in Frankfurt, their new surroundings required a major adjustment.

Food was the most noticeable difference for Gordana.

"Everything tastes different," she said. "I couldn't eat bread here. Mayonnaise, chocolate, everything." She was also shocked by the low-income housing in Portland, noting that apartments in Germany are nicer. The first apartment they moved into had cockroaches.

In 1999, Channel 8 interviewed Gordana and Branislav about being refugees from the former Yugoslavia. During the interview, Branislav spoke about leading Sunday school and Serbian language classes for the Yugoslav community at an Eastern Orthodox Church in Portland. Branislav also was a poet. Some of his poetry has been published by *The Cafe Review* and *Technology of the Sun*.

Things were initially difficult, but the family quickly adjusted to life in Portland. In 2000, they moved to Westbrook. Gordana briefly worked in retail before landing a job at Dolley Farm retirement home as a caretaker. Branislav worked as an ELL teacher at the Reiche School in Portland and for Lutheran Social Services in Windham, where he helped care for people with autism and other mental disabilities on the weekends.

While they both liked Westbrook, Gordana and Branislav dreamed of moving somewhere warm and tropical. They decided to move to the Virgin Islands and start a Bosnian bakery there. They were planning on visiting St. Croix when Branislav fell ill.

Losing Branislav

Their travel plans for February 2002 fell through when Branislav mentioned it might be nice to use the money to bring her parents to America instead.

They bought Gordana's parents plane tickets to arrive on May 15, 2002. Five days before they arrived, Branislav suffered a heart attack and died. Gordana was devastated, but thankful that her parents were there when she needed them the most. It was the first time she had seen them in almost a decade.

Gordana believes that Branislav somehow knew she would need them. "It was like he knew," she said. "Like he prepared everything, which is not possible." Pausing to reflect, Gordana said: "We had down moments and we had up moments. A lot of plans, but everything changes like this. Not complaining."

Despite losing Branislav, Gordana was determined to make sure her son had a normal life in America. She also wanted Filip to learn Bosnian. "We wanted to keep our language and keep our traditions," she said. "So me and him had a deal. Inside the house we would talk in our language. Outside with other people, we can speak in English."

Gordana and Filip also learned English together by watching *Barney* and *Sesame Street*.

"I was learning both Bosnian and English ABCs at the same time," Filip said. "I remember my mom watched *Sesame Street* with me so when they were teaching the ABCs, she was learning them with me.

"I think she kind of realized that if she was going to get anywhere here, the language barrier would have to go away," Filip said. "I think both of my parents realized that. They bought tapes and videos that taught English because I don't think they had time with the jobs they were working to go to night classes."

Filip and his parents also practiced English with each other.

They helped him with his homework so they could learn English. "I remember my mom said to me once that when you are learning a language, you have to immerse yourself in it," he said.

Making the Best of Life

Filip has a lot of respect for his mother, who has persevered and remained positive through hardship. In addition to losing Branislav and leaving Bosnia, she had to make a living, starting all over when she could not use her university degree or architectural experience.

"Her degrees weren't transferable so she was working at an old Ames retail store, and ever since then, she has been working at an assisted living home," he said. She started off as a general staff member and worked her way up to manager, running the facility. His mother's work ethic inspires Filip.

Gordana says she tried not to remain stuck in tragedy, but to view each new day as separate and unconnected to the difficulties that had already

In addition to losing Branislav and leaving Bosnia, she had to make a living, starting all over when she could not use her university degree or architectural experience.

occurred. "Because a new chapter starts that day," she said, "nothing is connected anymore."

Filip has always been humbled by his mother's sacrifices—working long hours and on weekends, learning English, and raising him as a single mother. "I realized one thing, maybe something I don't fully understand, but when you have to support someone, the human endurance to work hard shines at that point," he said. "It's definitely influenced me a lot to be as ambitious as I can."

Filip and Gordana became American citizens in August 2013. Filip has big plans for the future and says he "wouldn't be content with something small."

After graduating from Westbrook High School in 2014, he studied kinesiology at the University of Southern Maine. He graduated in 2018 and plans to attend graduate school to become a physician's assistant and to help people overcome their injuries.

Since fleeing Bosnia, Gordana has made the best of many difficult situations. Through hard work, she has given Filip the opportunity to achieve his dreams in America. In return, Filip plans to help those in need.

"Although we encountered many who misused us and mistreated us, there were always great people that sincerely wanted to help," Filip said. "Everywhere—in Greece, Germany, and here in the United States. We learned it's important to give back and support other people without expectations of rewards. Except for the reward of helping others."

Before he passed away, Branislav wrote "The Wolf Is a Favored Creature of the Gods," a poem dedicated to the memory of refugees around the world.

The final lines of the unpublished poem read:

So long, my dear, so long. I
am leaving tonight and running to
the ancient valley hoping to see
you soon. It is the night of the full
moon and you will hear my howl in
those moments when I am running
uncontrolled on the well-known
paths, placing my wolf's omen all
over. The omens of freedom.

———— ❖ ❖ ❖ ————

About the Authors
Morgan Rielly

Morgan Rielly is a Maine state representative and a member of the Legislature's Veterans and Legal Affairs Committee. He grew up in Westbrook and is a graduate of Westbrook High School. While in high school, he served two years on the Westbrook City Council as a student representative.

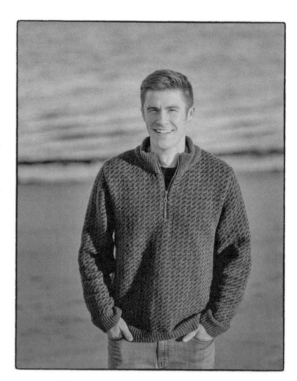

In 2014, Rielly wrote his first book, *Neighborhood Heroes: Life Lessons from Maine's Greatest Generation*, which features interviews with Maine veterans of World War II.

He is the recipient of the 2021 State Leadership Award presented by America's Service Commissions (ASC) in recognition of his commitment to public service, volunteerism, and helping to develop and pass legislation to establish Maine Service Fellows, a state-based rural service corps, and the Maine Climate Corps.

Rielly is a graduate of Bowdoin College, where he double-majored in religion and government. At Bowdoin, he received a fellowship to work for a nongovernmental organization in Amman, Jordan, where he worked alongside Syrian and Iraqi refugees.

About the Authors
Reza Jalali

Reza Jalali is an academic, a noted writer, and former refugee. He was recognized in *Making it in America: A Sourcebook on Eminent Ethnic Americans*, a sourcebook on eminaent ethnic Americans by Elliott Robert Barkan. Jalali's books include *Homesick Mosque and Other Stories*, a children's book, *Moon Watchers: Shirin's Ramadan Miracle* and a play titled *The Poets and the Assassin*. His essays, short stories, and poems have been published in literary magazines and anthologies. He's the executive director of the Greater Portland Immigrant Welcome Center.

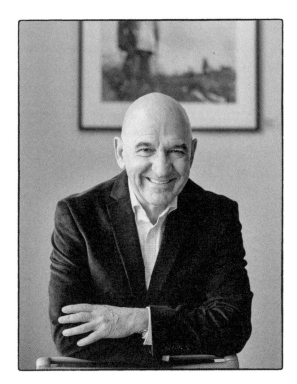

About the Photographer
Lilit Danielyan

Lilit (Lilo) Danielyan is a visual artist currently based between Armenia and the States. She was born in Armenia but grew up in Central Kazakhstan, where her family moved shortly after the collapse of the Soviet Union. Lilit studied international relations at the Karaganda State University in Kazakhstan. Her knowledge of three languages afforded her the opportunity to work as an interpreter for journalists at the OSCE Summit in the capital of Kazakhstan and the Economic Forum during her years as a student.

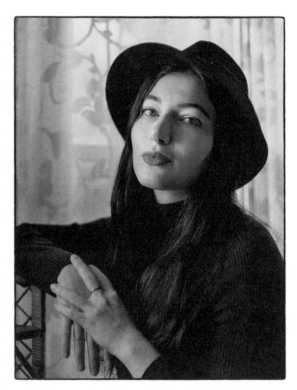

In 2012, Lilit moved to the United States, looking to further her education. Since 2017, she has been working on documentary projects exploring the subjects of identity, immigration, belonging, and nostalgia. In 2017, Lilit's photo-essay *Tátik* received an Honorable Mention at the International Documentary Photography Competition for students. In 2018, she became a Sam Abell Endowed Scholarship recipient at the Maine Media Workshops + College. Lilit studied documentary photography at the School of Contemporary Photography Docdocdoc. She is now a student of psychology at Smith College.

Acknowledgments

I first want to thank my co-author and friend, Reza Jalali. It has been an honor to work alongside him on this project. I couldn't have done this without his support, guidance, and collaboration. I want to especially thank our editor, Dean Lunt, assistant editor Piper Wilber, and the staff at Islandport for working with Reza and me to make this book a reality.

I want to thank my alma mater, Bowdoin College, for supporting me as I began working on this project during the summer of 2015. Thank you to Bowdoin's Alumni Council for providing me with funding through the Alumni Council Grant. Thank you also to Professor Russell Hopley for your interest, and for providing feedback on early drafts. Thank you to Professor Robert Morrison, Professor Elizabeth Pritchard, and Lynn Brettler of the Religion Department for providing me with a space to work on chapters while still a student, and for your support and encouragement.

Thank you to Marpheen Chan for introducing me to Chanbopha Himm, and to Betty D. Robinson of Tree Street Youth for connecting me with Prosper Ishimwe.

Thank you to my parents, Brendan and Erica, my sisters, Shannon and Maura, and my grandparents Jeanne and Edward, for your love and support, and extra pairs of eyes on drafts.

Lastly, and most importantly, I want to thank those we profiled and the people I got to interview personally. Prosper Ishimwe, Itza Bonilla, Tae Chong, Deqa Dhalac, Mohammed Al-Kinani, Amarildo Hodo, Filip and Gordana Manjencic, Natália Dyer, Masha Kolovskaya, and Chanbopha Himm. Thank you for trusting me to share your stories. I can't articulate how much you have impacted my life.

–Morgan Rielly

This book is the result of collaboration with many wonderful human beings. I thank Morgan Rielly for his friendship and trust. I appreciate the generosity of New Mainers, who trusted us with their stories, their trails, and triumphs. We owe them our gratitude. Without their cooperation this project could have not happened.

I am grateful to Lilit Danielyan, for her artistic contribution in photographing our new neighbors. Hers is an example of a New Mainers adding to the richness of our state.

Phuc Tran's powerful foreword sets the tone for our book to tell the stories of courage and

tragedies and triumphs, big and small, that today's immigrants experience in coming to America. I thank him for accepting our invitation to be part of this book.

I also want to thank Dean Lunt and his team at Islandport Press, for giving us the opportunity to tell these powerful stories.

I thank Tarlan Ahmadov, Mary Allen Lindermann, Zoe Sahloul for their kindness and generocity. The immigrant-funded nonprofit, The Greater Portland Immigrant Welcome Center's support has been valuable.

Additionally, we appreciate receiving financial contribution from Androscoggin Bank, Catholic Charities Maine's office of State Refugee Coordinator, Coffee by Design's Rebel Blend Grant, and New England Arab American Organization.

Finally, I want to thank my spouse, Jaleh, for her patience. I dedicate this book to her and our son and daughter, Azad and Setareh, who were born in Maine. May they feel at home in Maine.

—Reza Jalali